PIRKLE JONES

CALIFORNIA
PHOTOGRAPHS

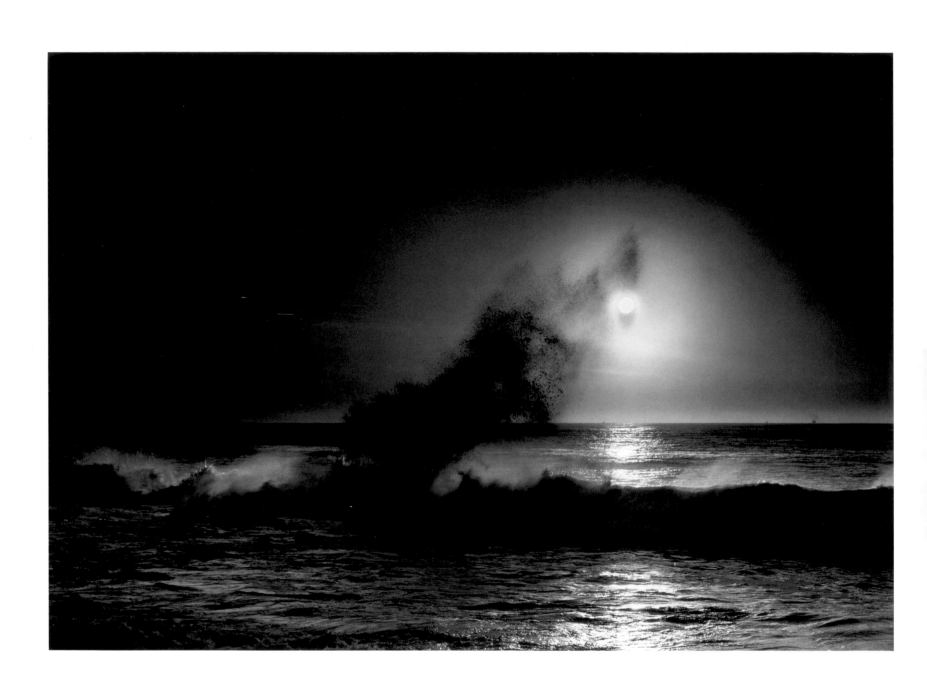

SUN AND WAVE, SAN FRANCISCO 1952

PIRKLE JONES

CALIFORNIA PHOTOGRAPHS

APERTURE

ACKNOWLEDGMENTS

Pirkle Jones: California Photographs
is made possible by the generous support of
Robert Yellowlees

For their friendship and support I would like to
acknowledge: Etel Adnan, Bob Anthoine, Ruth Begell,
Margery Benjamin, Rita Bottoms, Mark Citret,
James Dietz, Meris Delli-Bovi, Richard D. Ehret,
Simone Fattal, M.R.C. Greenwood, Stephen Goldstine,
Jeff Gunderson, Rich Hoertkorn, Michael E. Hoffman,
Bob Holmes, Sam and Jay Jackson, Judy and Don
Jones, Dona Lantz, Brian and Jan Matas, Jennifer
McFarland, Barbara and Dave Myers, Lynn and
Michael Nasco, Mary Nisbet, Tony Page, Ken Pedersen,
Tim Shiels, Dale Stulz, David Travis, Phyllis Thompson
Reid, Karen Sinsheimer, Al Weber, Bruce Weber,
Margaret and Bill Wellington, Tim B. Wride and
Robert Yellowlees.

—Pirkle Jones

CONTENTS

SAN FRANCISCO

The tourist, looking at the city for the first time, shakes his head in a puzzled way and sighs: 'This San Francisco— it sort of gets to you. There's something about it. I don't know quite what it is, but it's something.'… It's a jumbled, kaleidoscopic picture that no artist can ever capture, for only the mind's eye can see it: the golfer in Lincoln Park, silhouetted against the Golden Gate Bridge; the girl with the flowing blonde hair, standing at Land's End to watch the setting sun…the vagrant, upstairs strain of an accordion in North Beach, the creak of an old fishing boat at the Wharf—these are some of the secret treasures that a San Franciscan hides in his heart…. The elusive charm that you can never quite pin down; something you feel when you least expect it…in the grim, warehouse-studded wastes beyond Third Street, where the railroad tracks wander in aimless patterns and the backwash of the Bay lifts a stale smell along the rotting shoreline… On a street of rickety stairs clinging to the bony ridges of Telegraph Hill, leading to wooden shacks that seem to be hiding from those who would tear them down in the name of progress and improvement.

Herb Caen, 1953

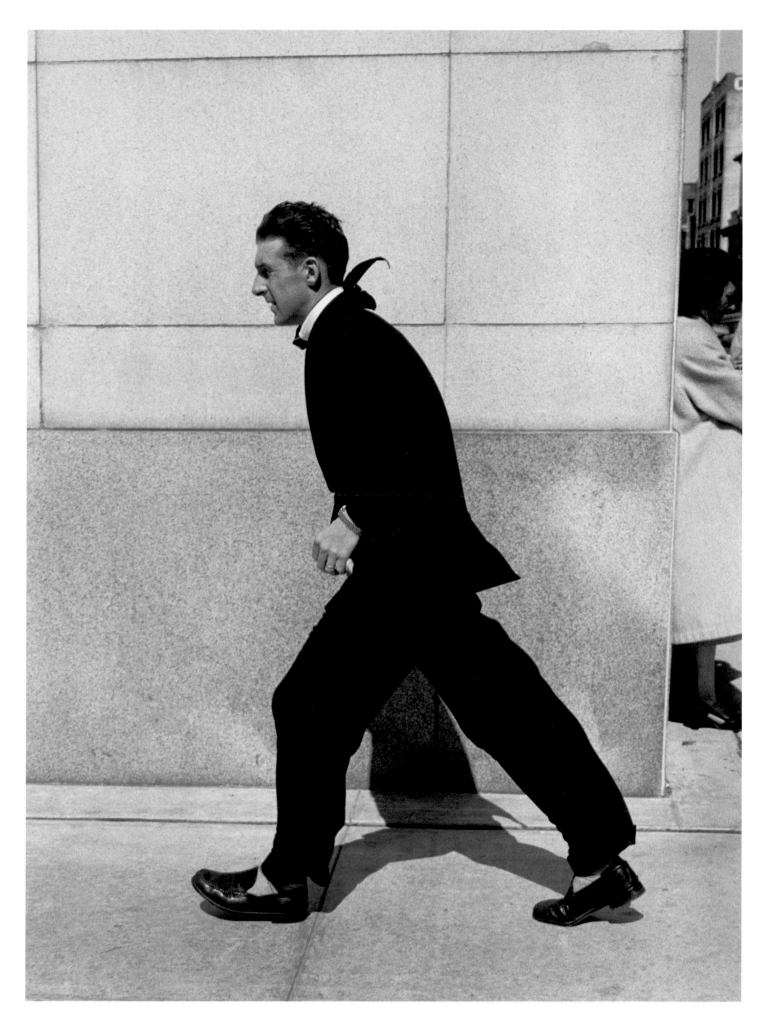

7 *SAN FRANCISCO 1956*

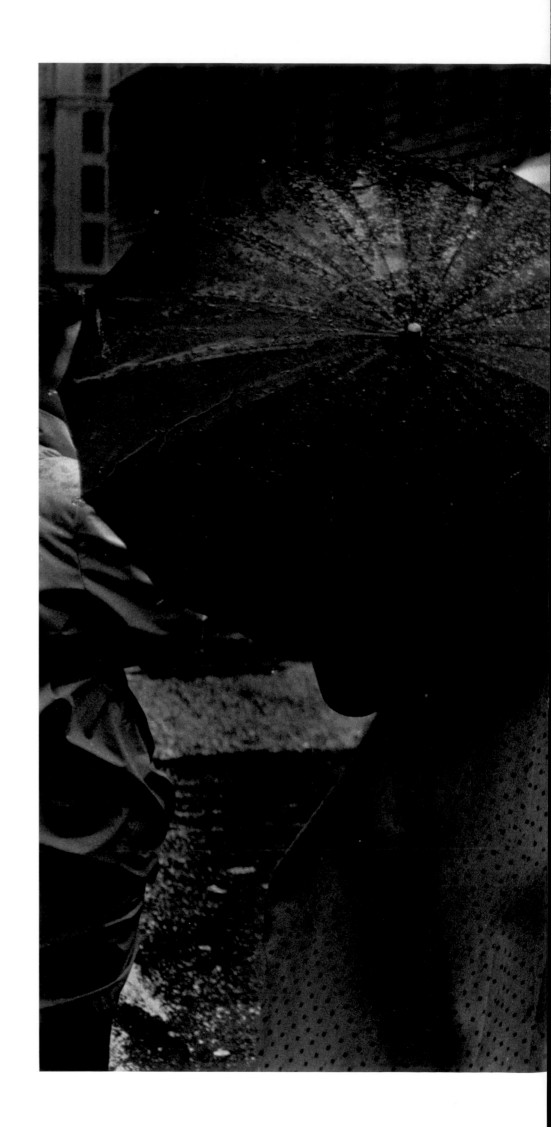

FIGURES IN THE RAIN,
SAN FRANCISCO 1955

8

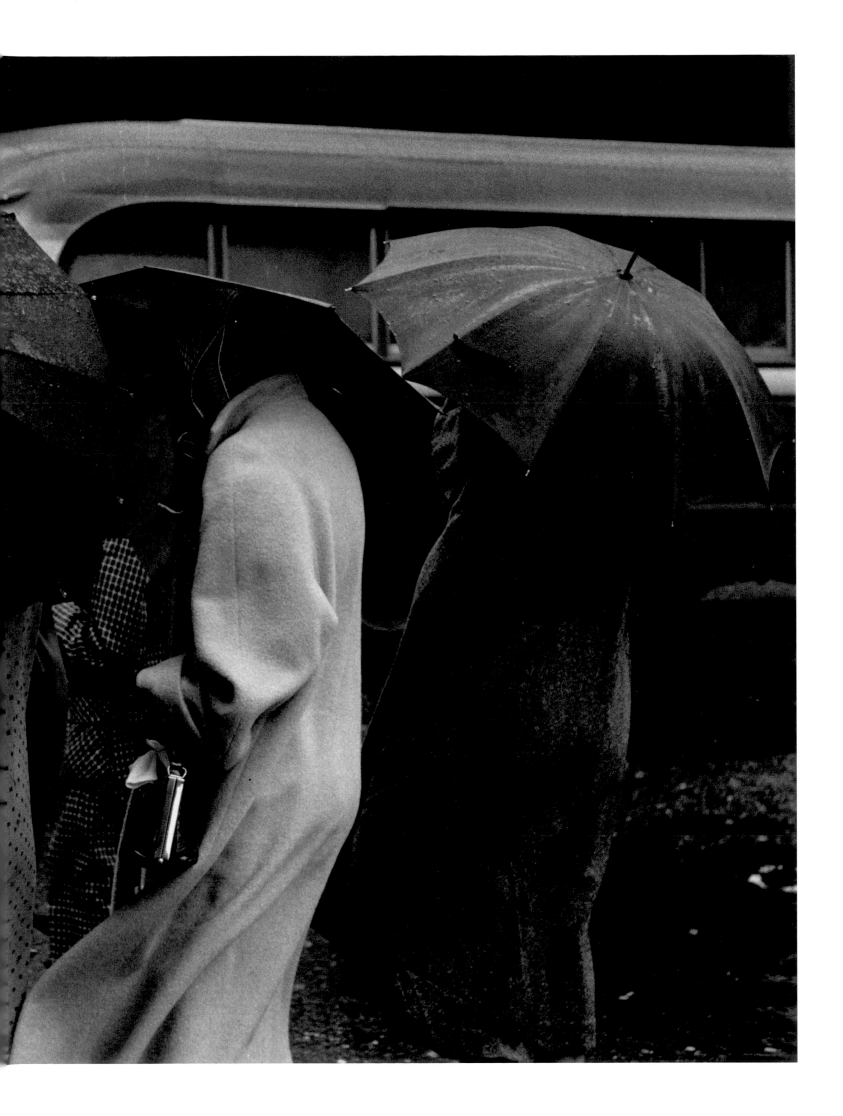

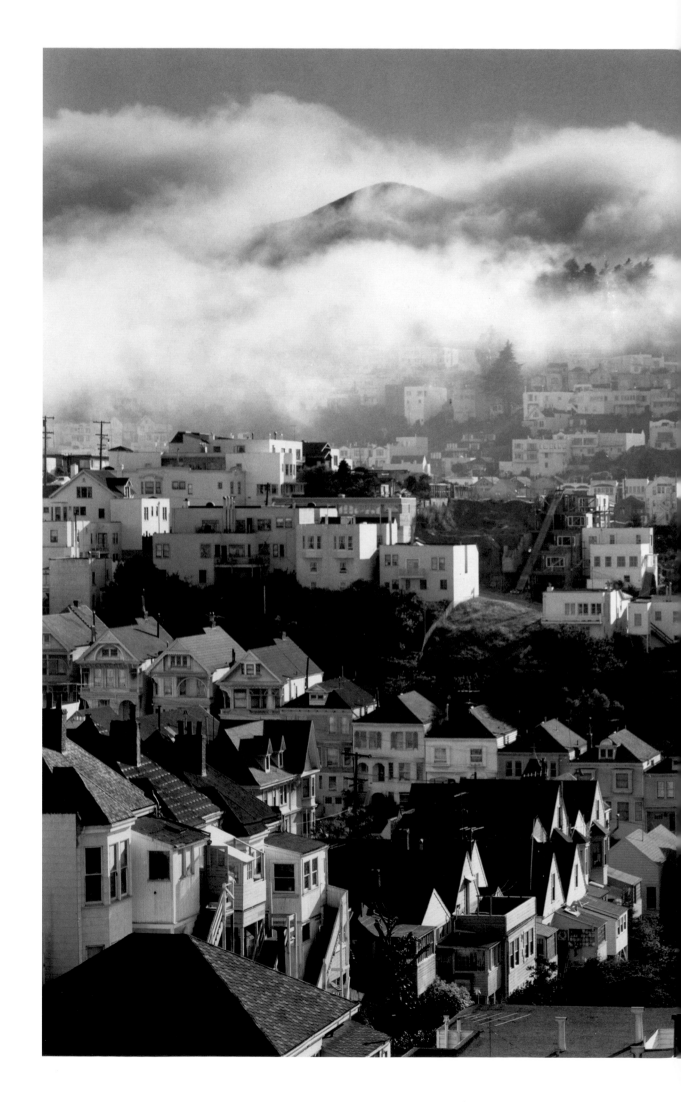

TWIN PEAKS 1,
SAN FRANCISCO
1955

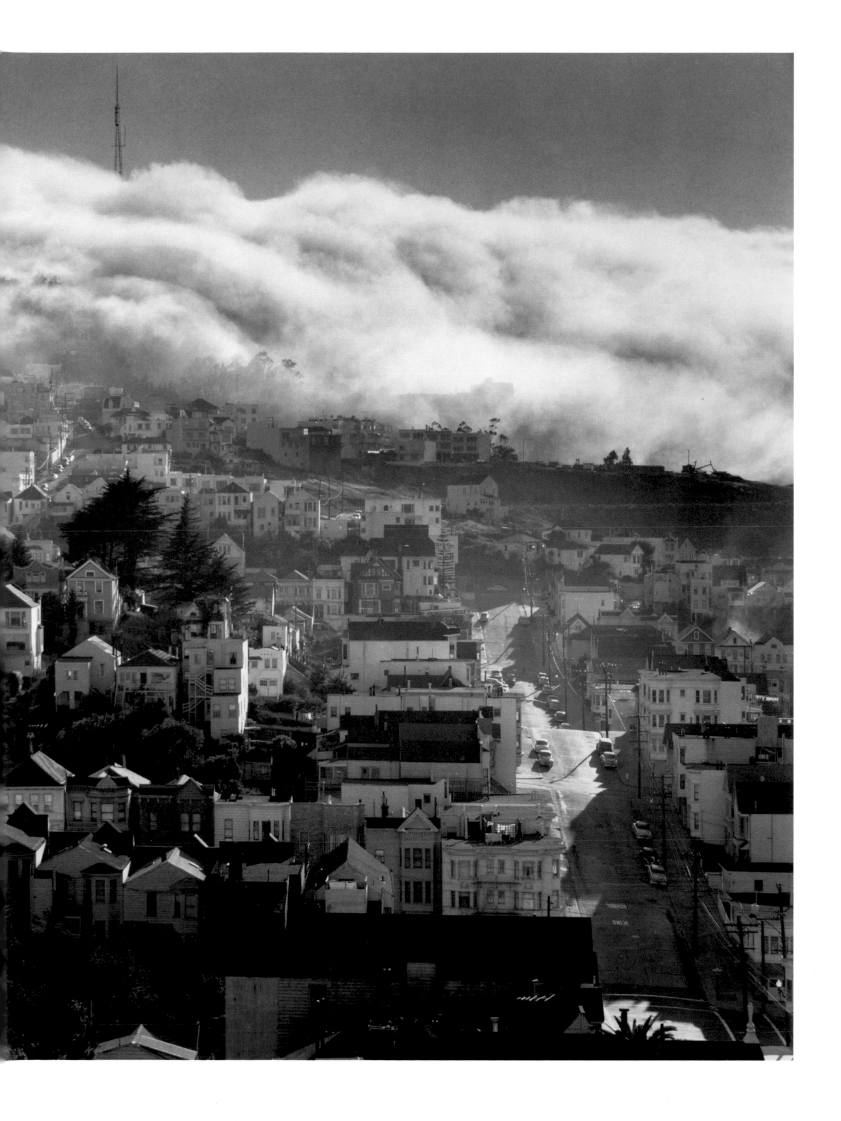

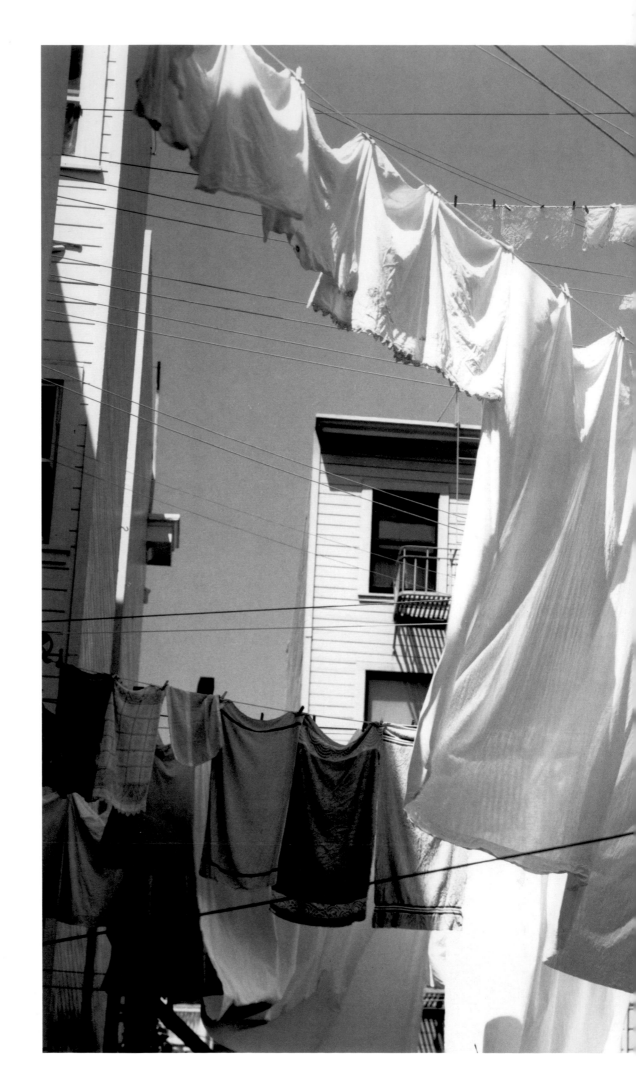

NORTH BEACH,
SAN FRANCISCO 1955

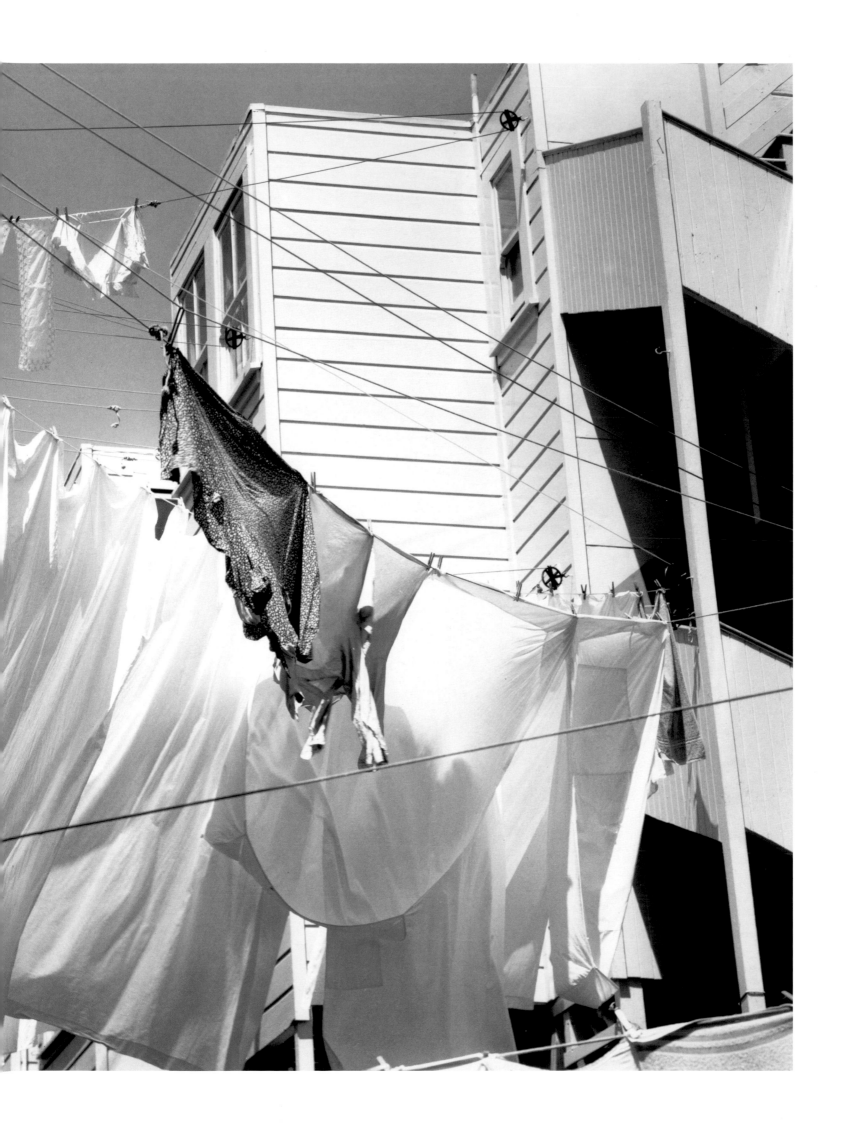

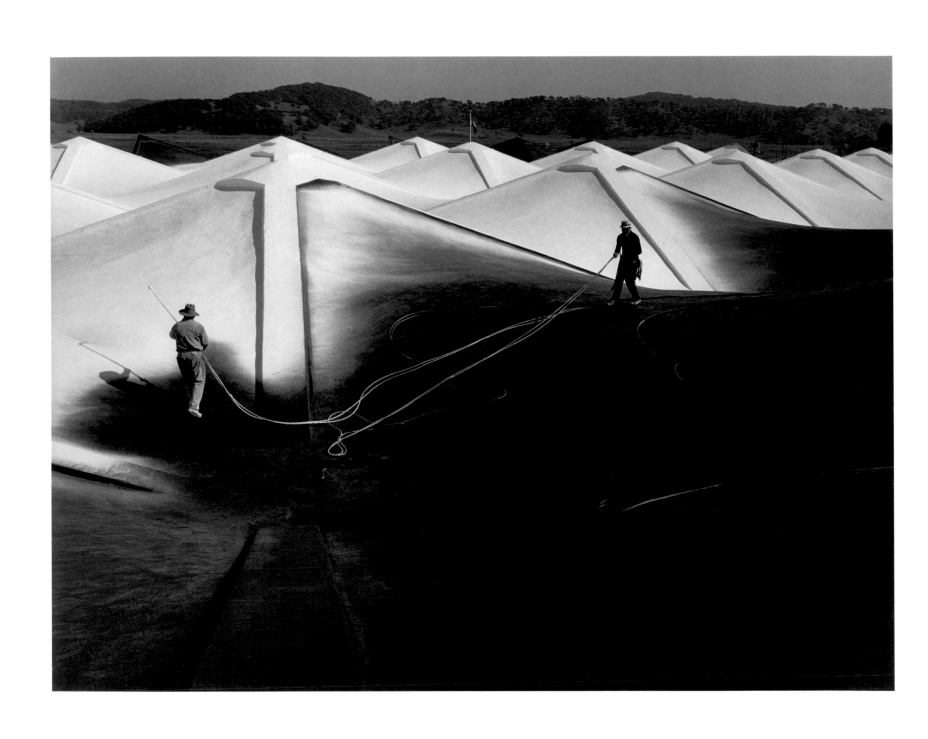

14 WORKERS, NOVATO 1966

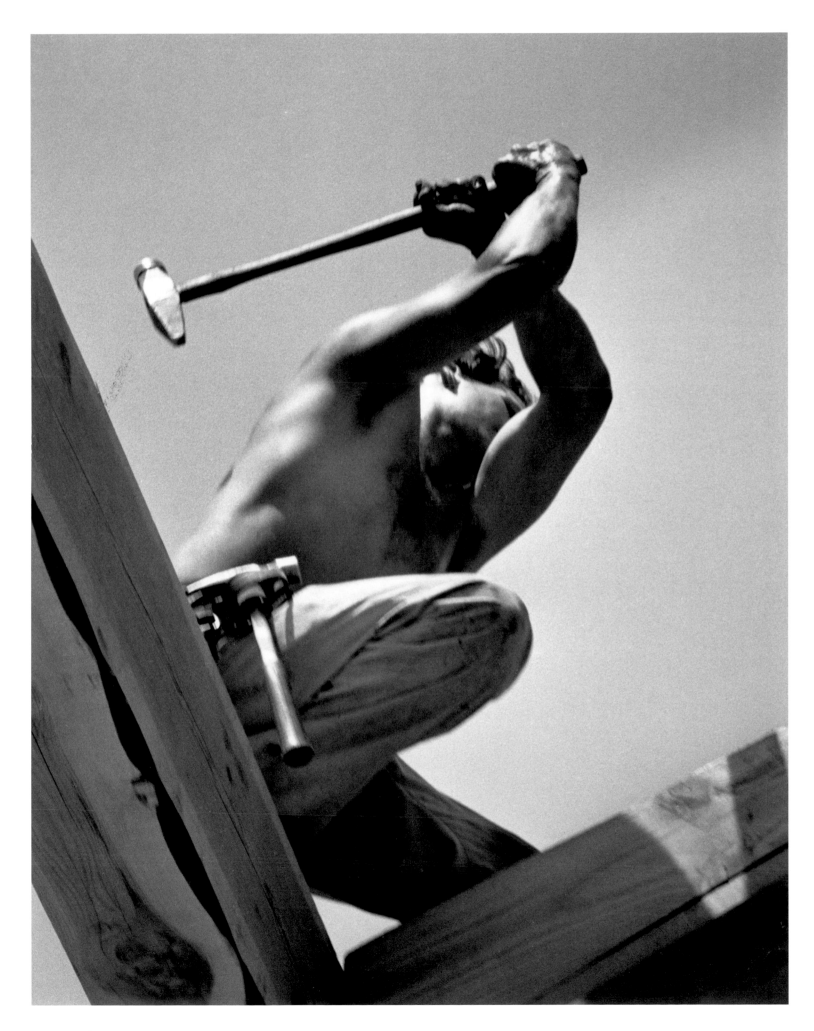

15 *WORKER, SARATOGA 1958*

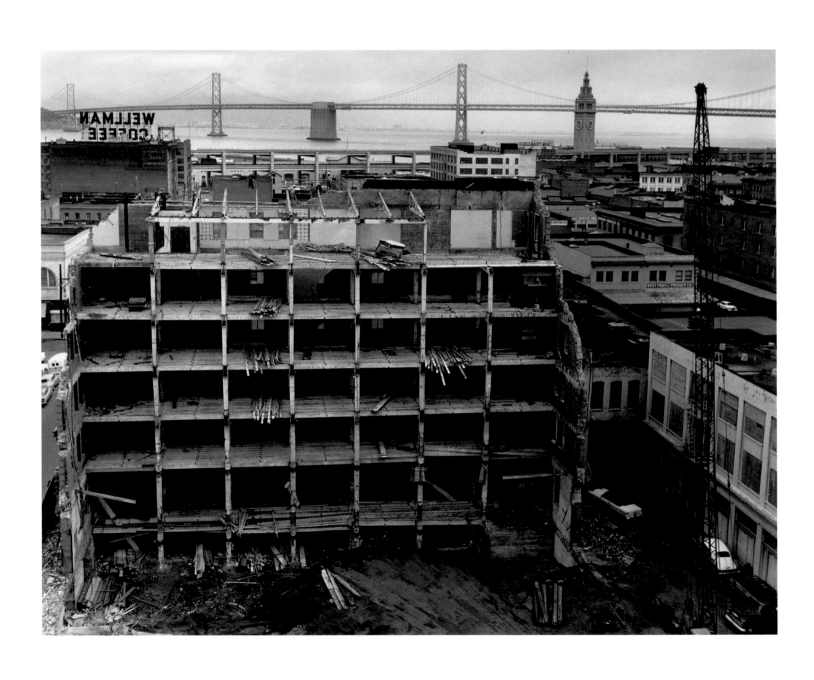

16 REDEVELOPMENT, SAN FRANCISCO 1960

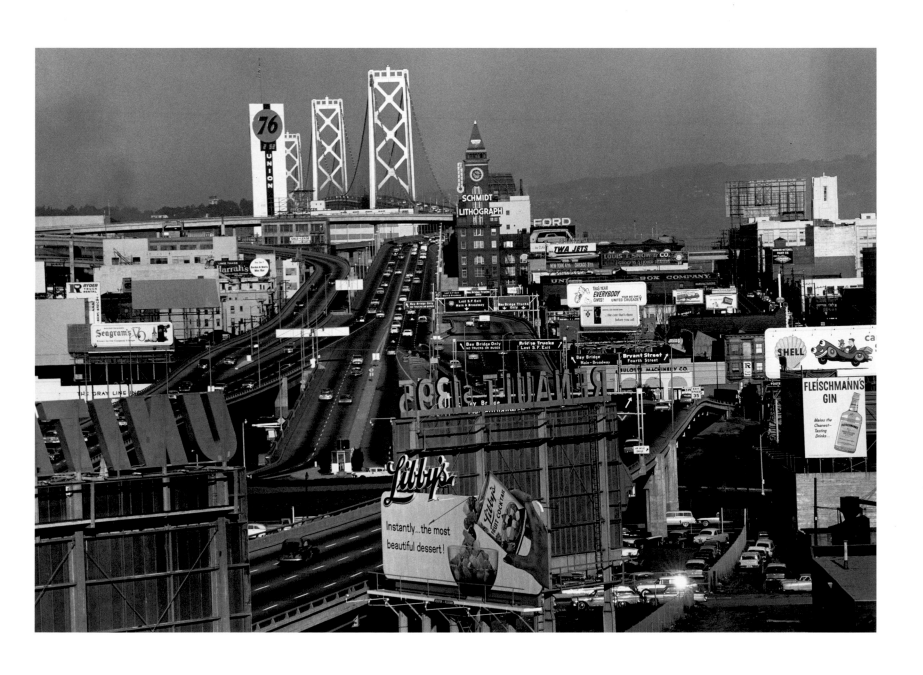

17 *BAY BRIDGE, SAN FRANCISCO 1961*

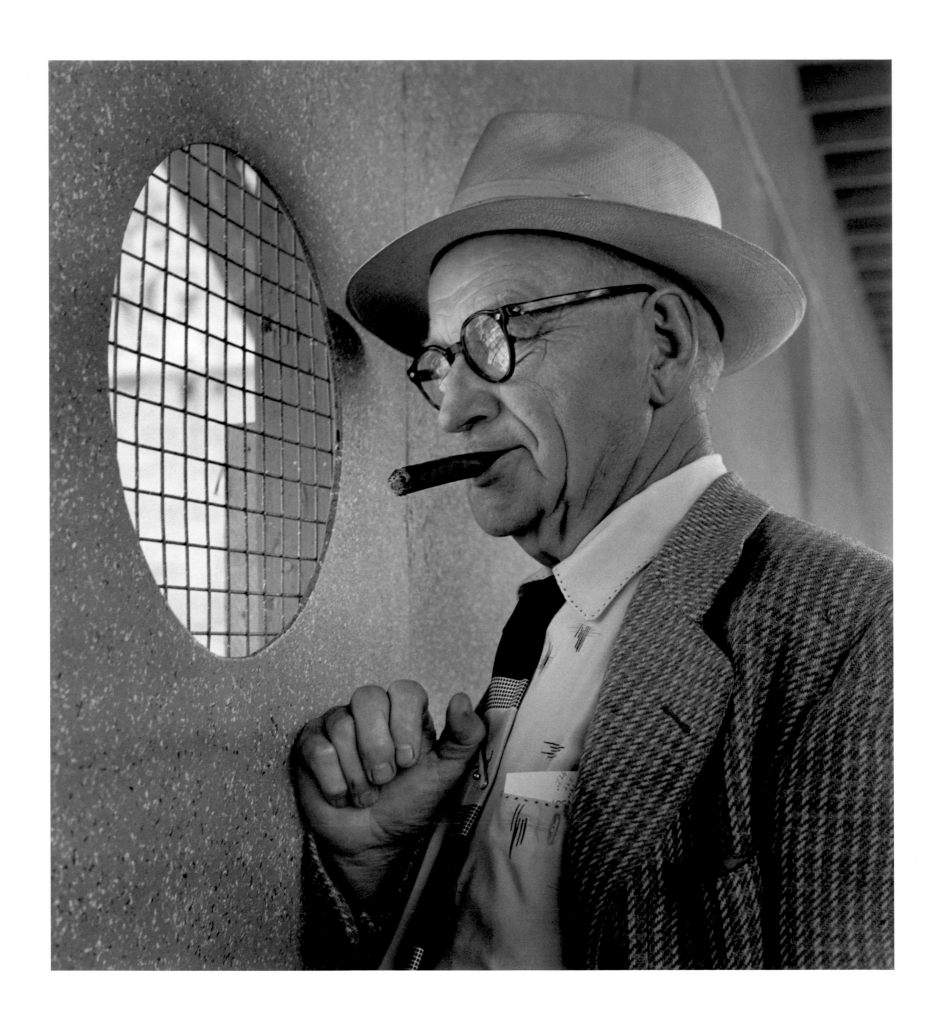

SIDEWALK SUPERINTENDENT, SAN FRANCISCO 1956

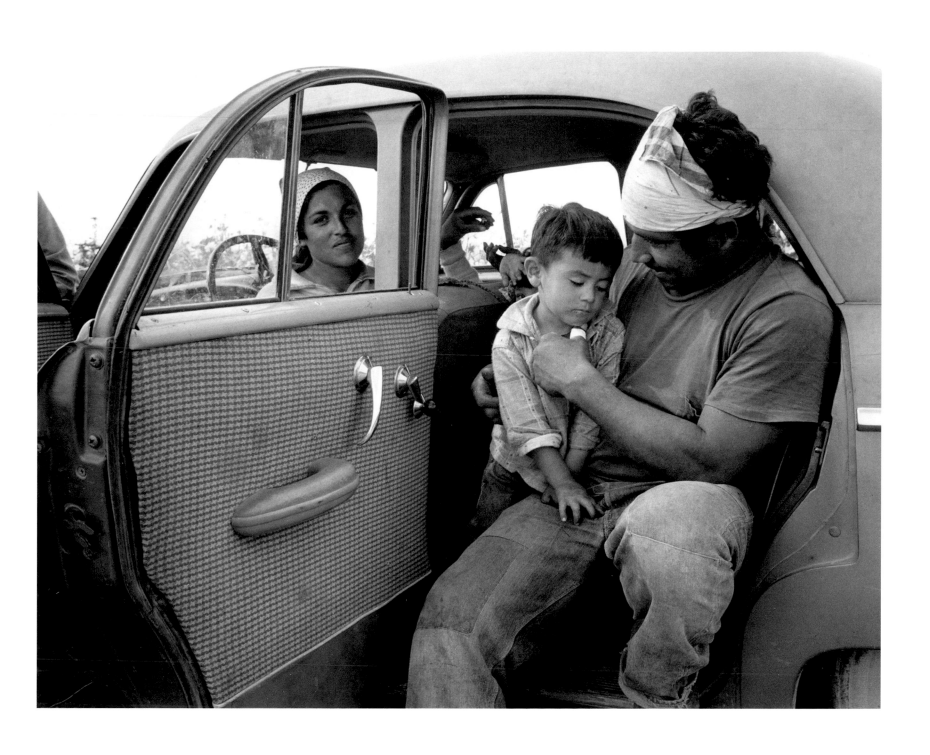

19 *FARM WORKER FAMILY, BAKERSFIELD 1957*

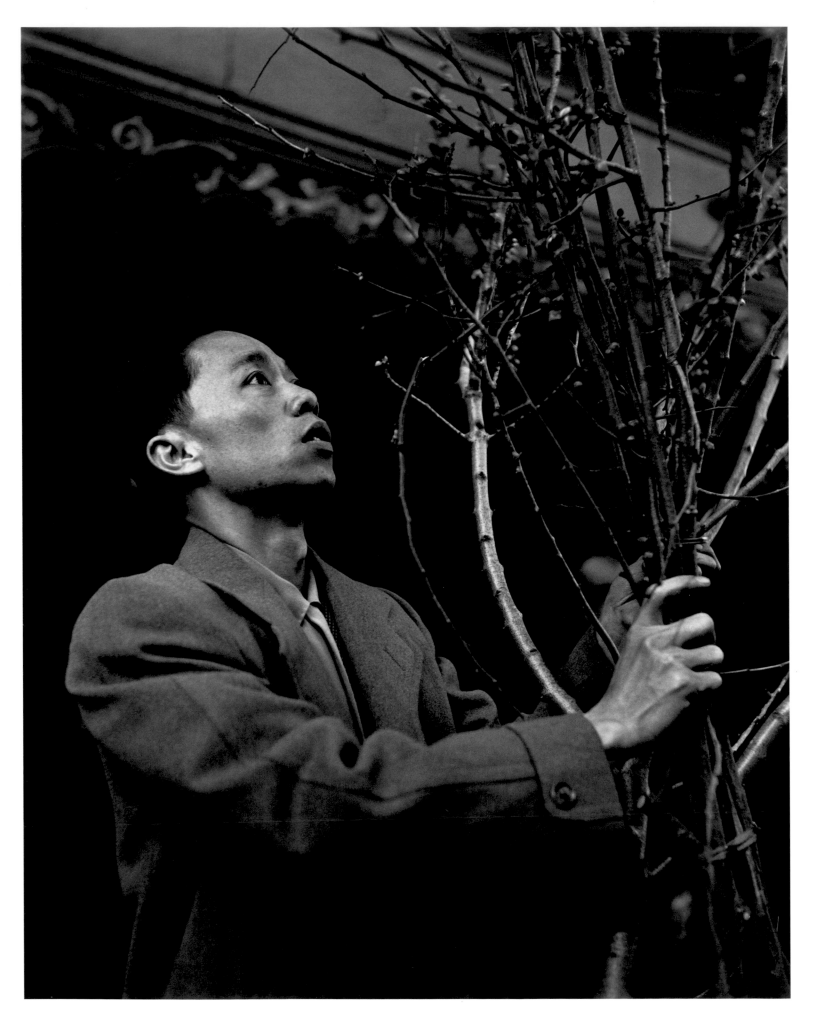

CHINESE NEW YEAR, SAN FRANCISCO 1955

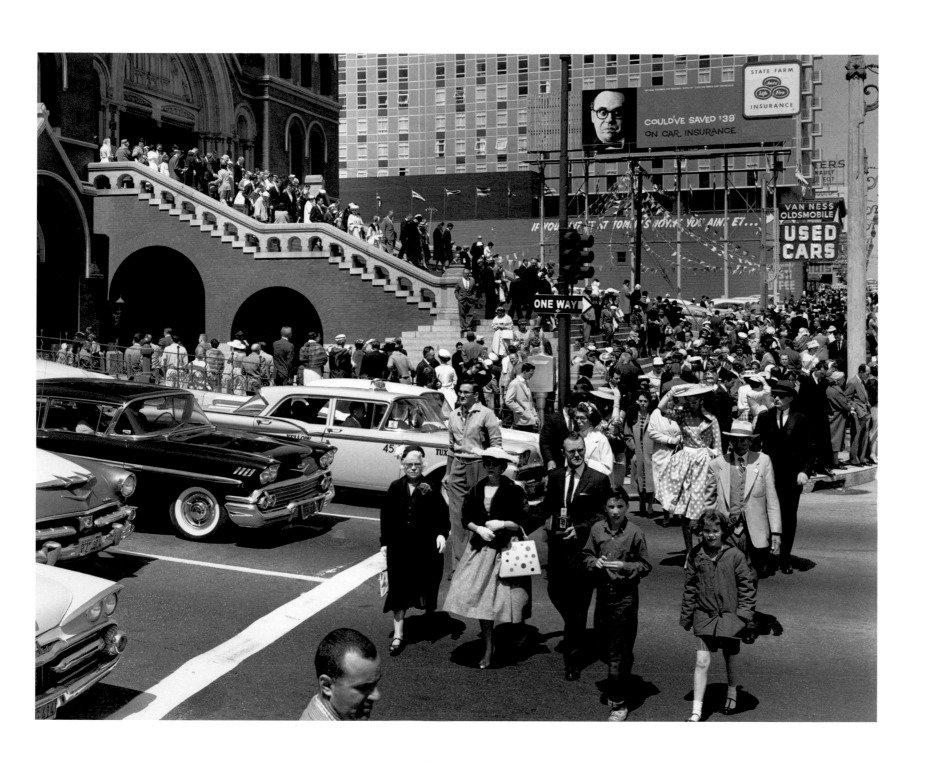

EASTER SUNDAY, VAN NESS AVENUE, SAN FRANCISCO 1960

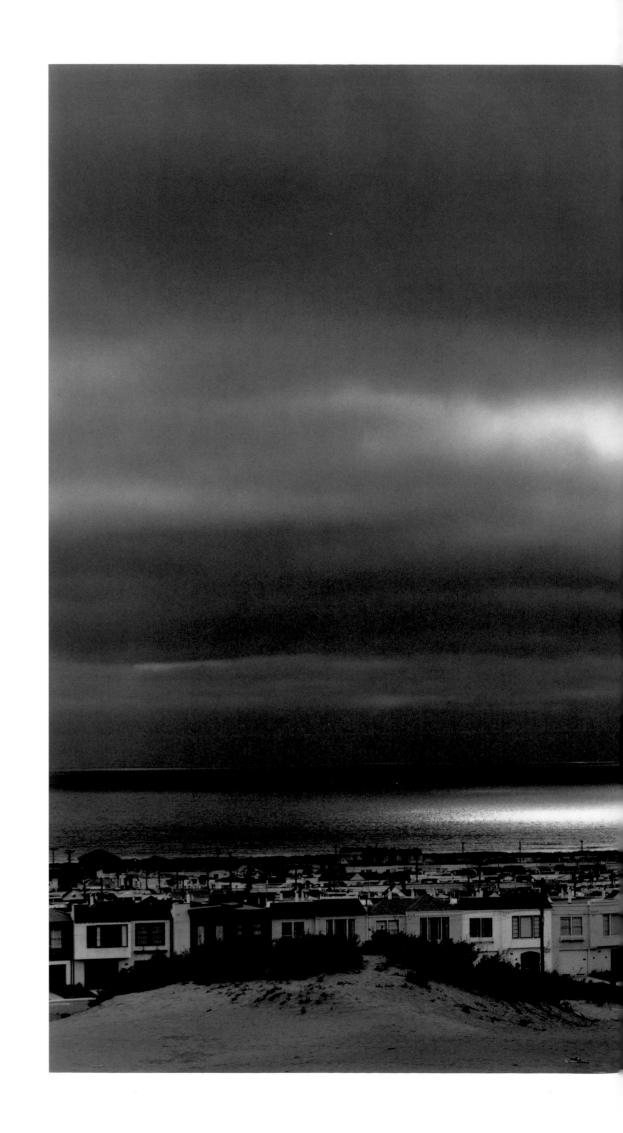

SUNSET DISTRICT
AND PACIFIC OCEAN,
SAN FRANCISCO 1951

22

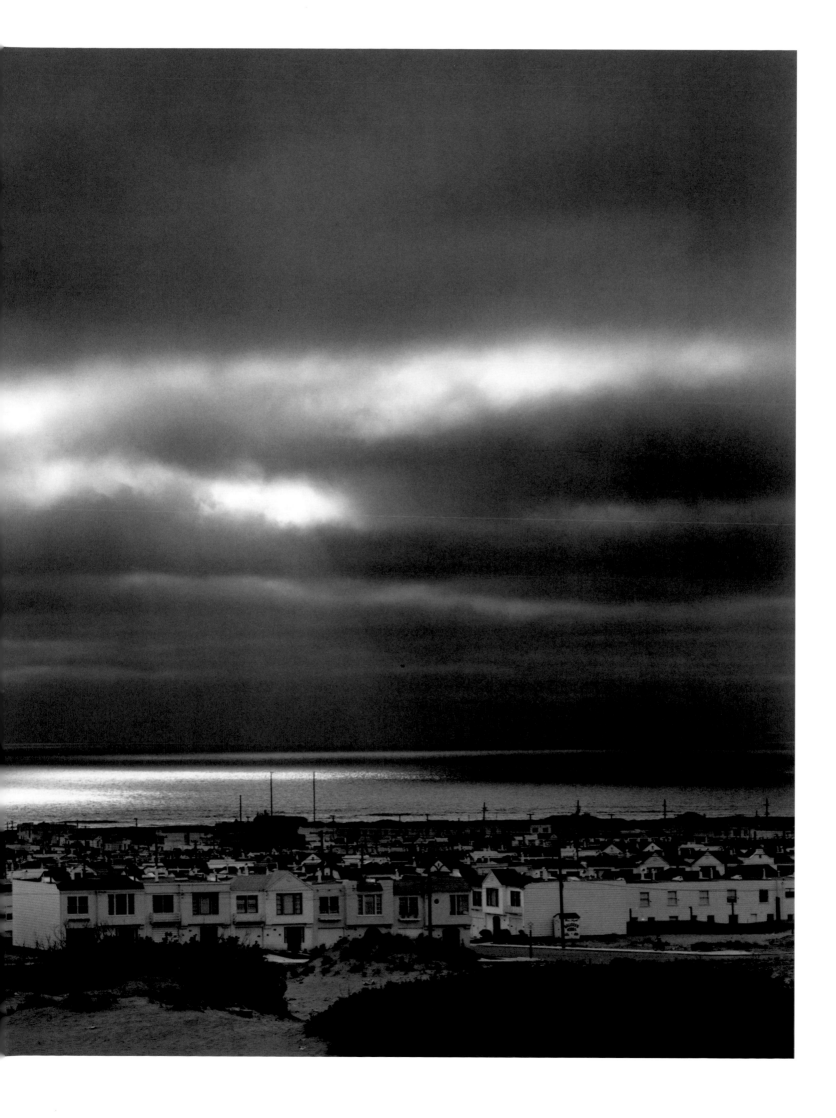

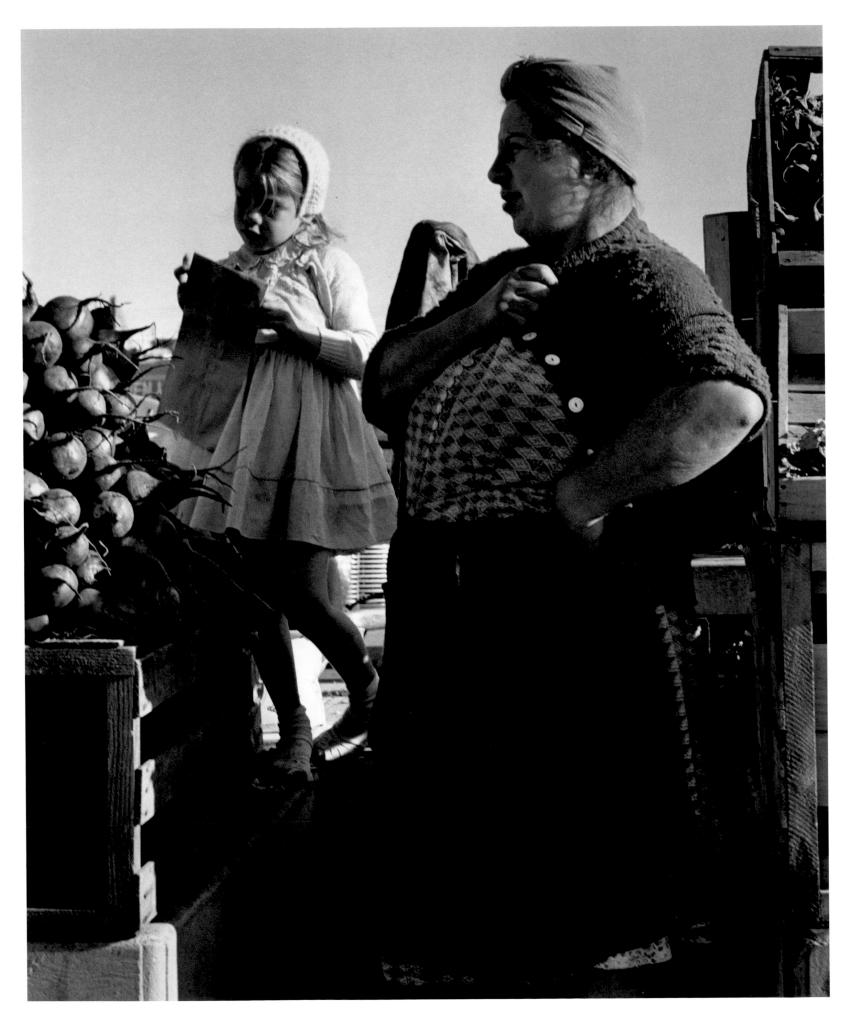

FARMERS' MARKET, SAN FRANCISCO 1949

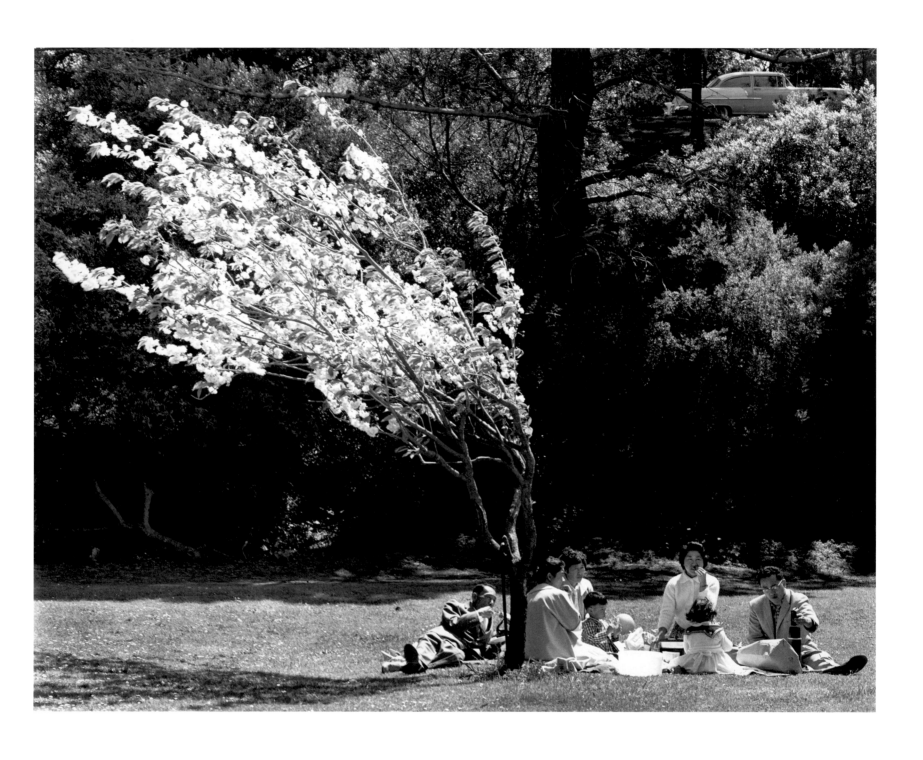

25 *EASTER SUNDAY, GOLDEN GATE PARK, SAN FRANCISCO 1960*

DEATH OF A VALLEY

The development, distribution, and control of water has become California's biggest problem. The new California is coming in with a roar and the new people are bringing with them the greatest population increase ever witnessed in the history of the United States. Everywhere farms and ranches are being torn up and made over into tract sites; orchards are being converted into industrial sites.

[Overheard in a roadside hamburger stand, a construction worker speaking: 'Dammit, it's getting so a person can't stand still in one of these here fields without you get mowed down, raked up, or painted.']

Demands for more water caused the death of the Berryessa Valley. It disappeared 125 feet deep behind a dam in order to store water for irrigation in the bigger valleys below and to provide industrial water for the expanding cities.

The accompanying set of pictures deals with this episode. In it there are certain overtones with which we are also concerned. They have to do with changing values. The old life in this small valley was part of the California legend. We attempted to reveal this, and in addition, to lightly remind our viewers of the price of progress.

Voices: 'Everyone said they'd never flood it. Even when they talked about it, we never believed they'd flood it.'
'This valley and this land was good to us, but the water over it will be good for the majority of the people. We have to think that way.'…

Pirkle Jones and Dorothea Lange, 1960

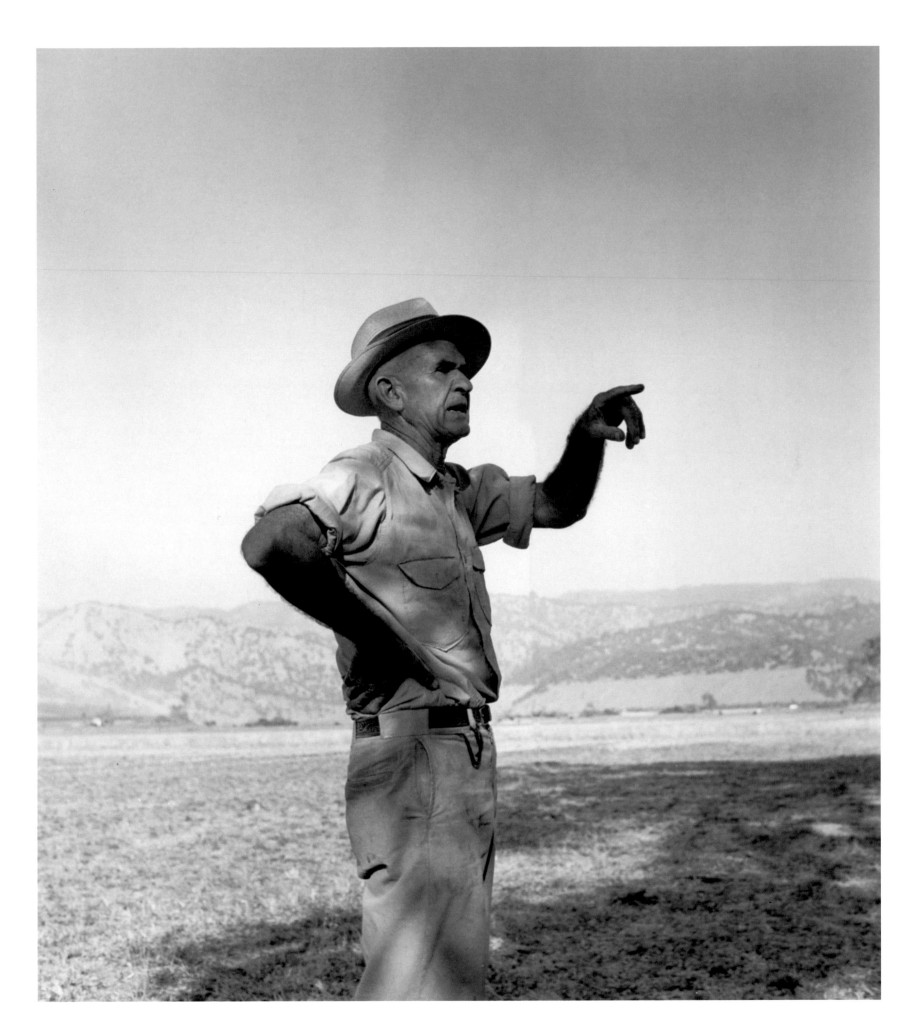

GOVERNMENT MAN, DEATH OF A VALLEY 1956

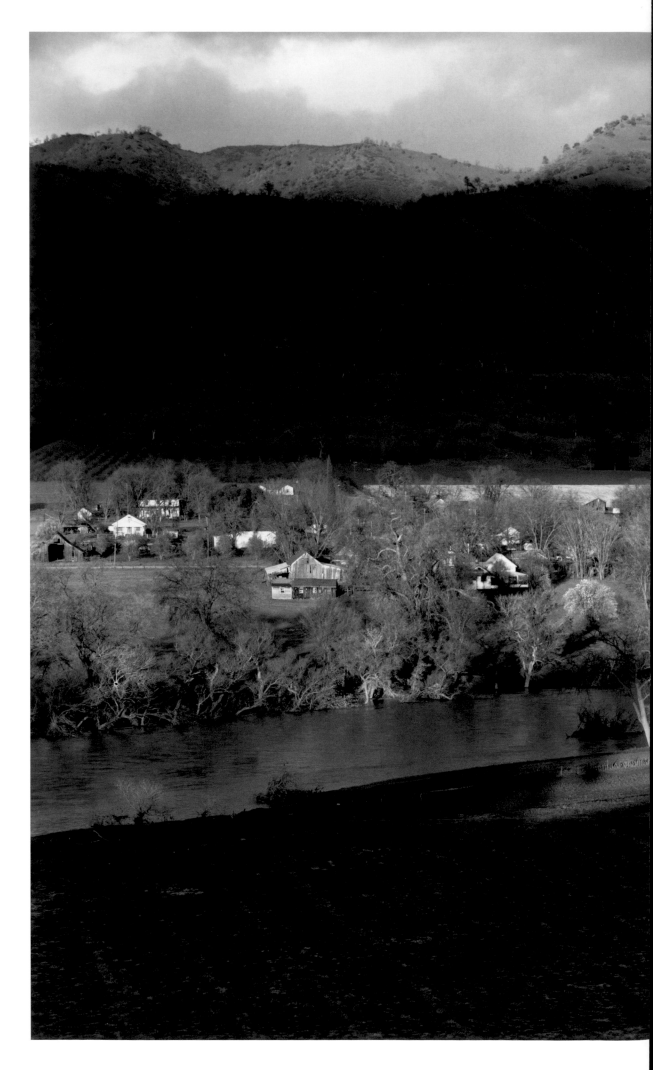

MONTICELLO,
DEATH OF A VALLEY
1956

28

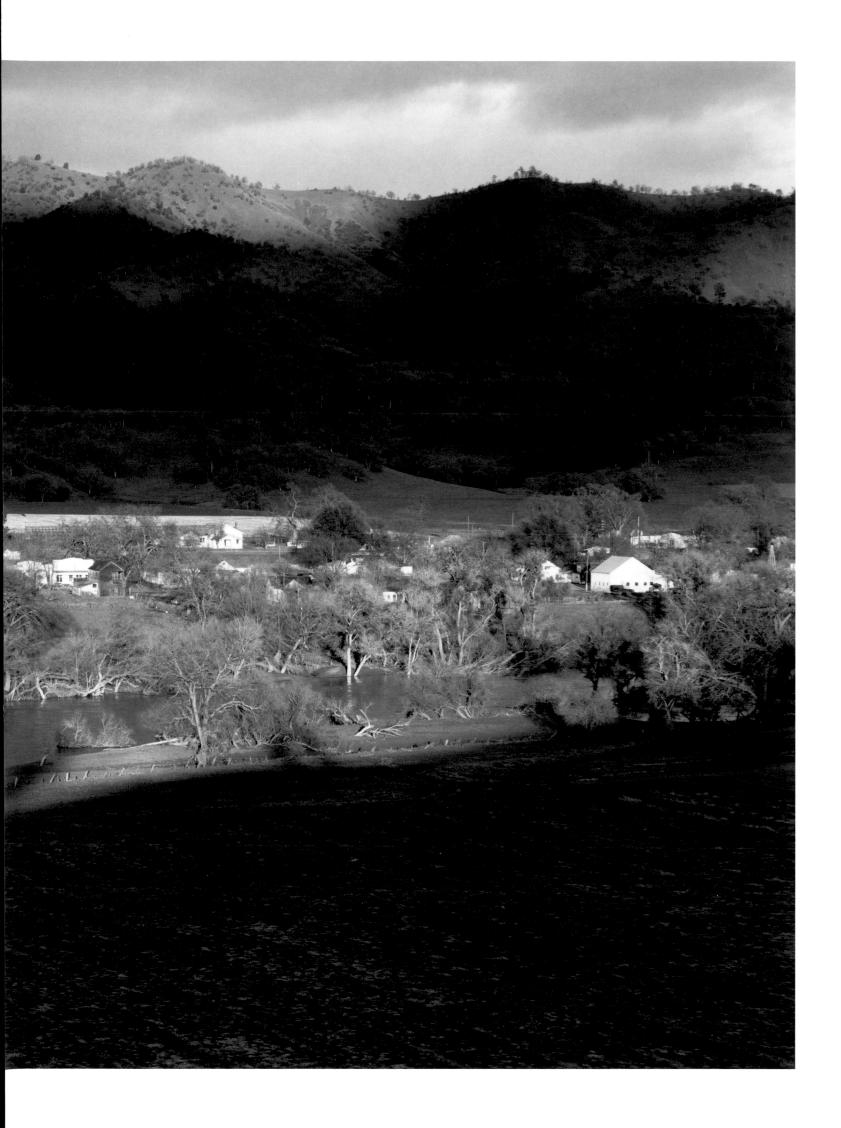

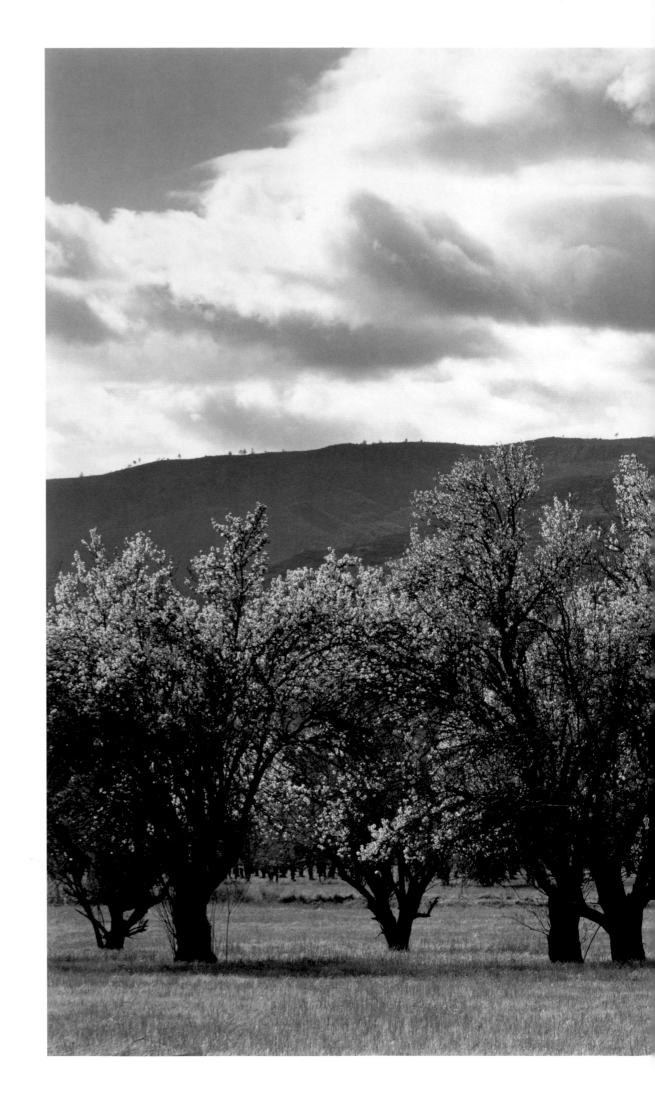

ORCHARD,
BERRYESSA VALLEY
1956

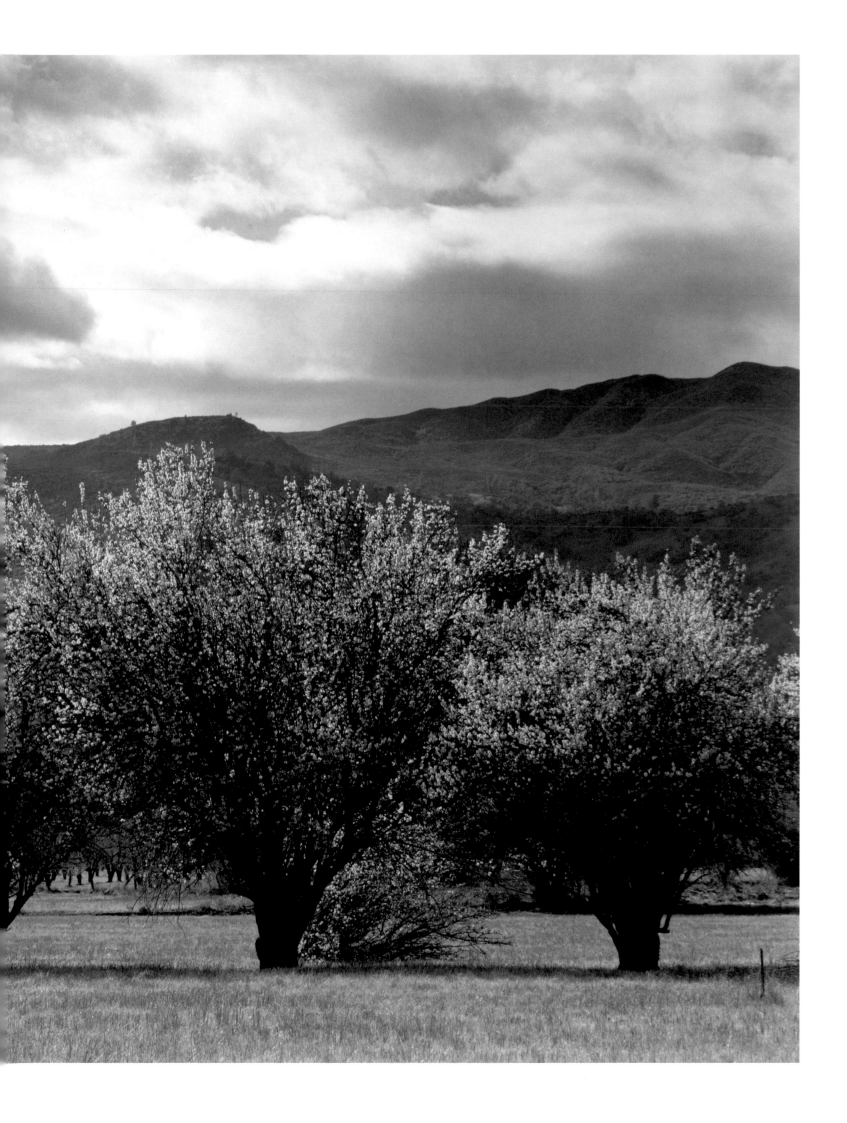

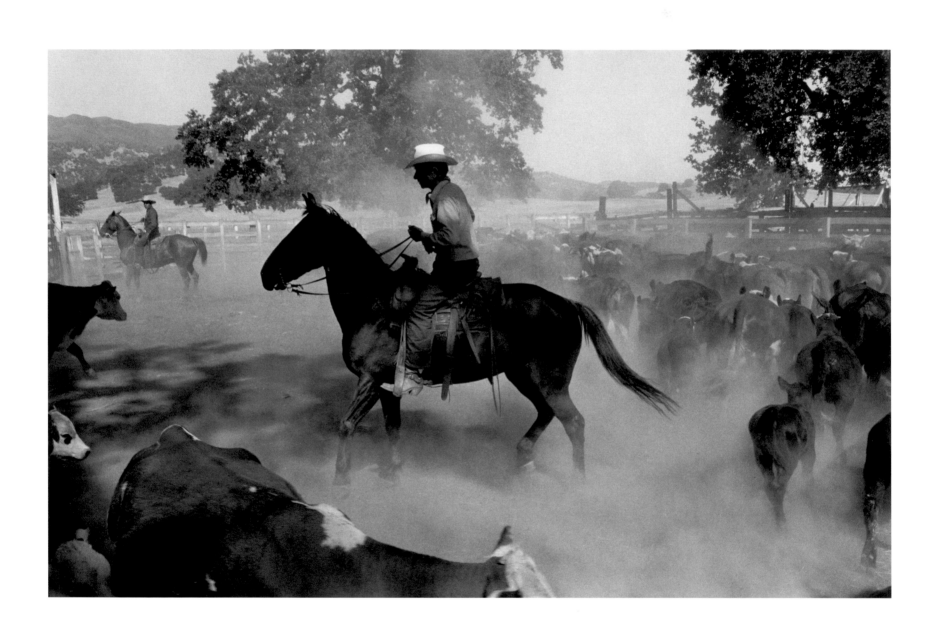

BUCK HANNACKLE, BERRYESSA VALLEY 1956

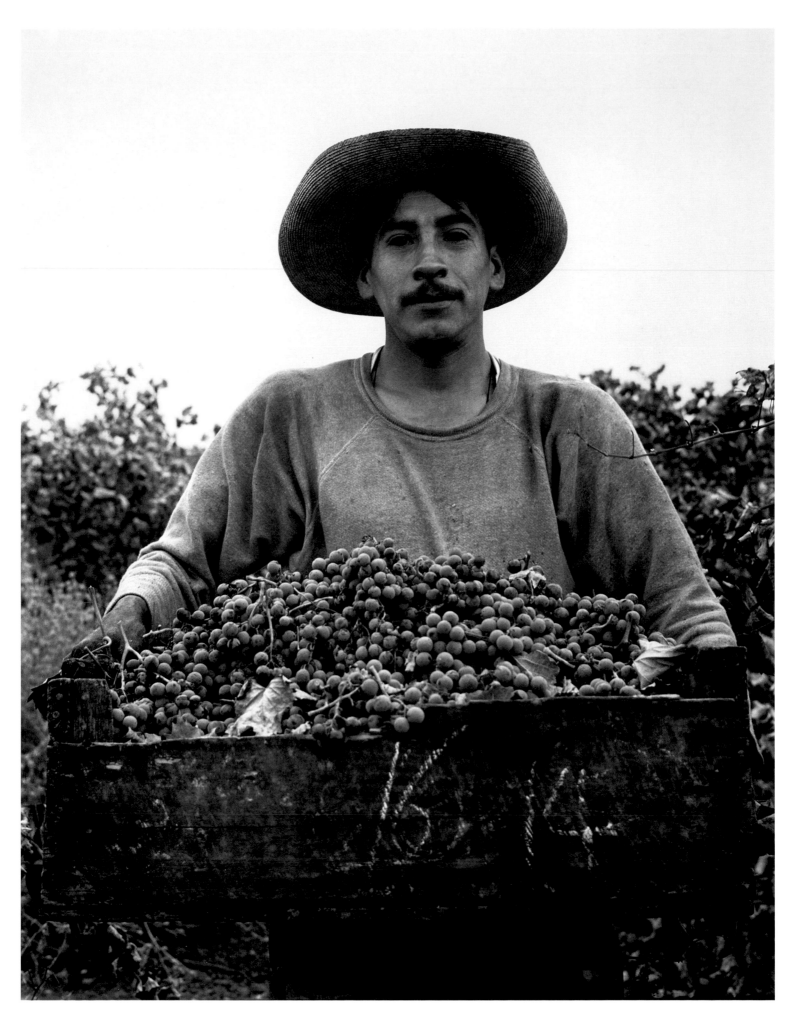

33 GRAPE PICKER, BERRYESSA VALLEY, DEATH OF A VALLEY 1956

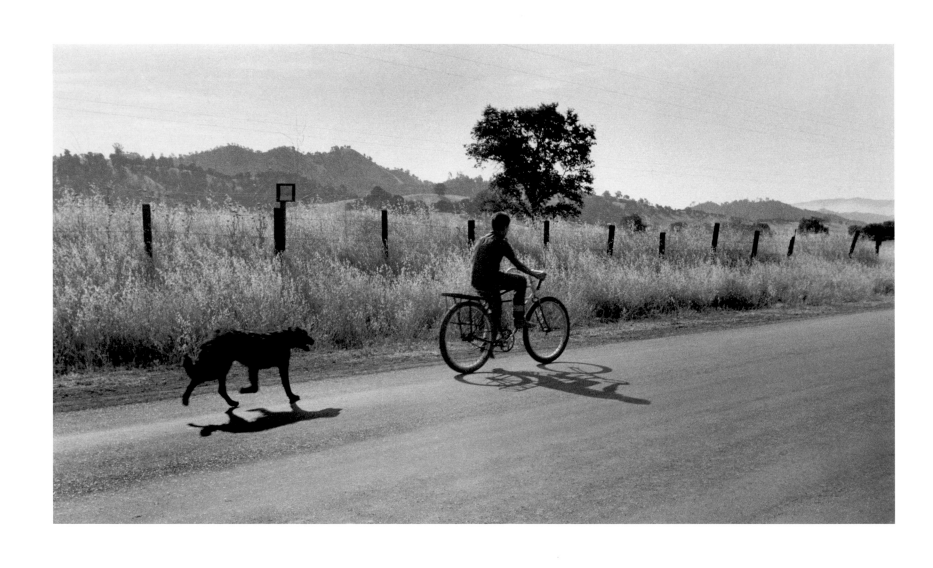

34 *BERRYESSA VALLEY 1956*

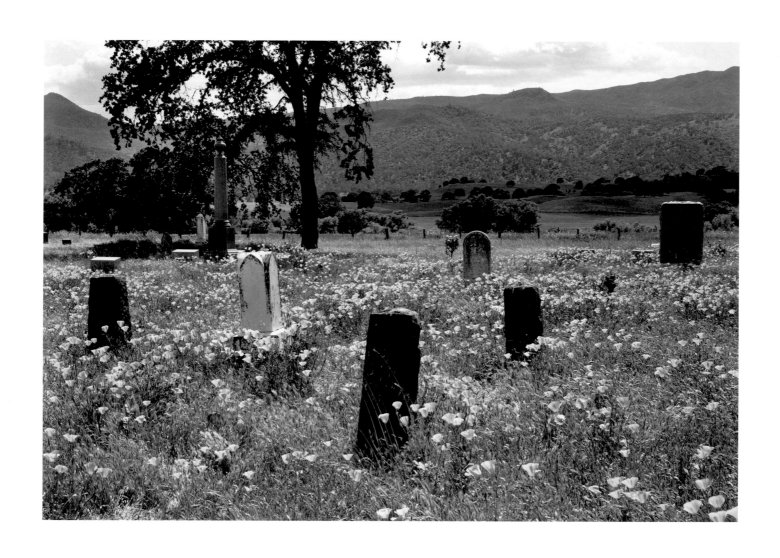

MONTICELLO CEMETERY, DEATH OF A VALLEY 1956

The Berryessa Project was one of the most meaningful photographic experiences of my professional life. When Dorothea Lange, friend and colleague, invited me to collaborate with her on this project in 1956, I looked forward to the experience. It was a privilege and a pleasure to work with her.

My response to the people and the events that unfolded as I photographed in the valley were influenced both by my background of living on a farm when I was a youngster and the sense of urgency that Dorothea and I felt as we worked to record the events of this last year in the valley. The people in the valley were being dislocated, their homes destroyed or moved, and the way of life as they had experienced it for a generation was coming to an end. We knew that we were seeing and recording for the last time—the orchards in bloom, the beautiful home with its mature, leafy walnut trees, the McKenzie Store, the harvesting of the pears, grapes and grain....

Some of the experiences have remained vividly in my memory— witnessing the cutting of an ancient oak tree and the sudden flight of a flock of birds from its branches as it crashed to the ground and at the end of the project, photographing in the valley alone in the rain... everything was gone.

It is important to document before change is made to make a record of what no longer exists. Perhaps humankind can learn from this record and reconsider before irreversible changes are made.

Pirkle Jones, 1994

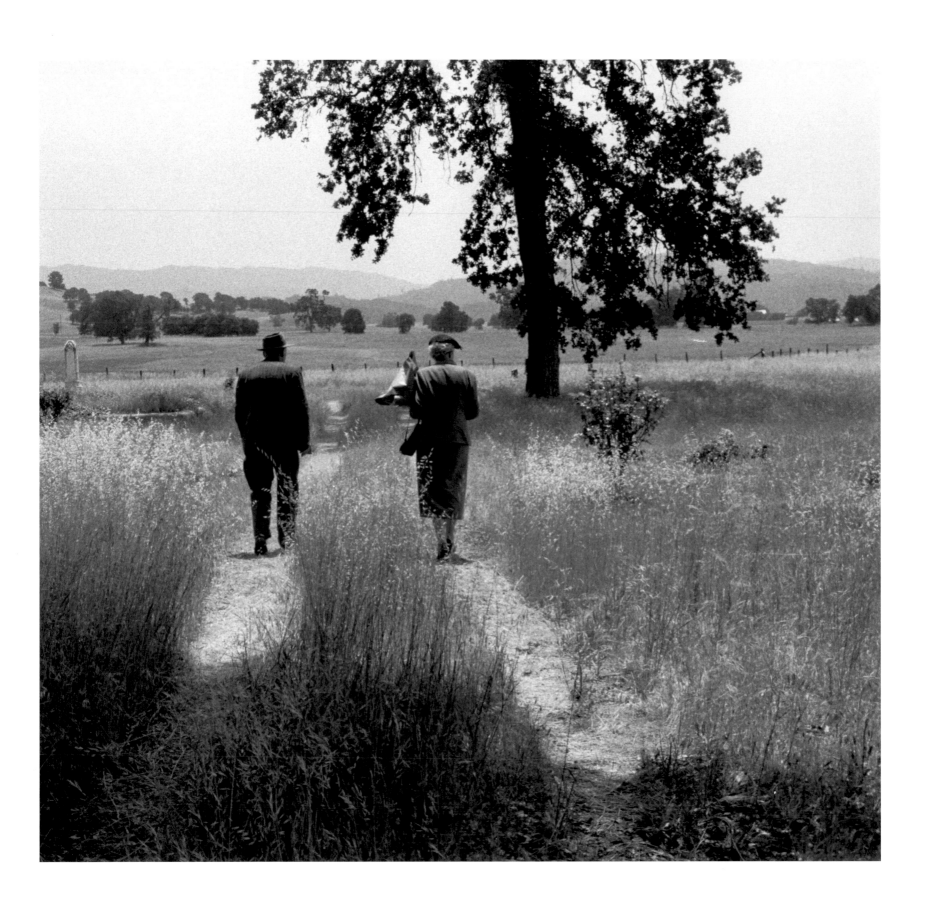

37 *LAST MEMORIAL DAY, BERRYESSA VALLEY 1956*

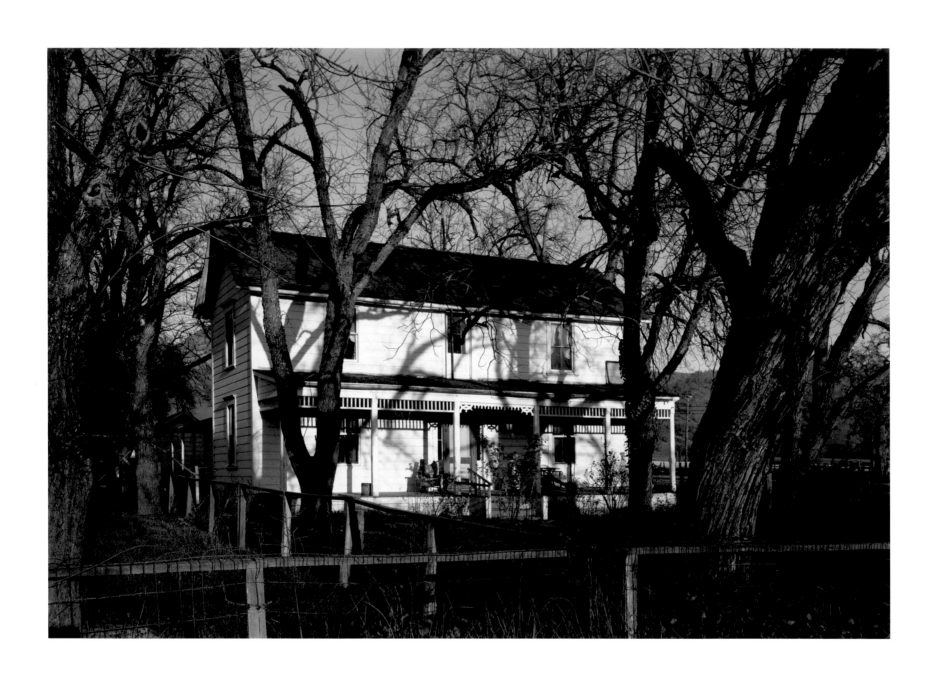

McGINNIS HOME, MONTICELLO, BERRYESSA VALLEY 1956

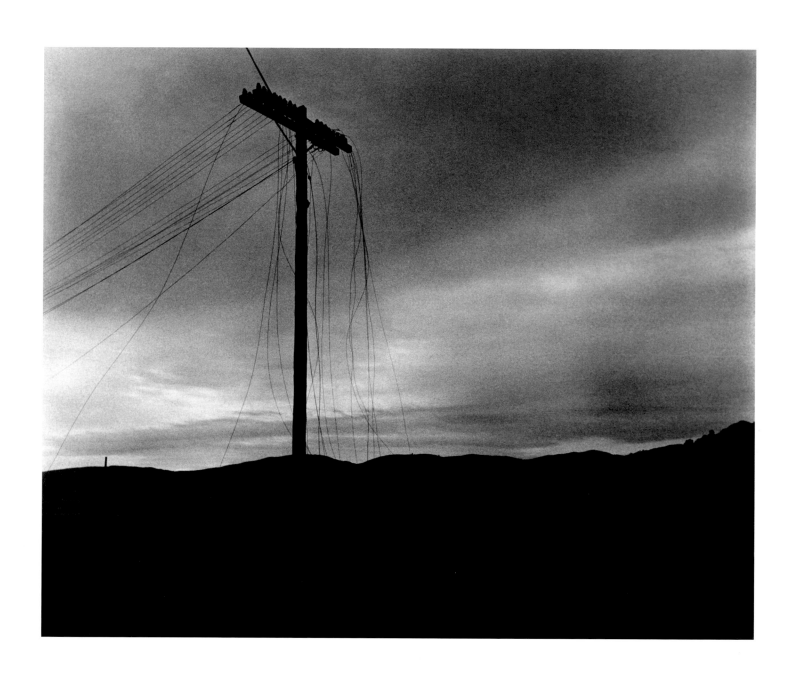

39 SEVERED POWER LINES, DEATH OF A VALLEY 1956

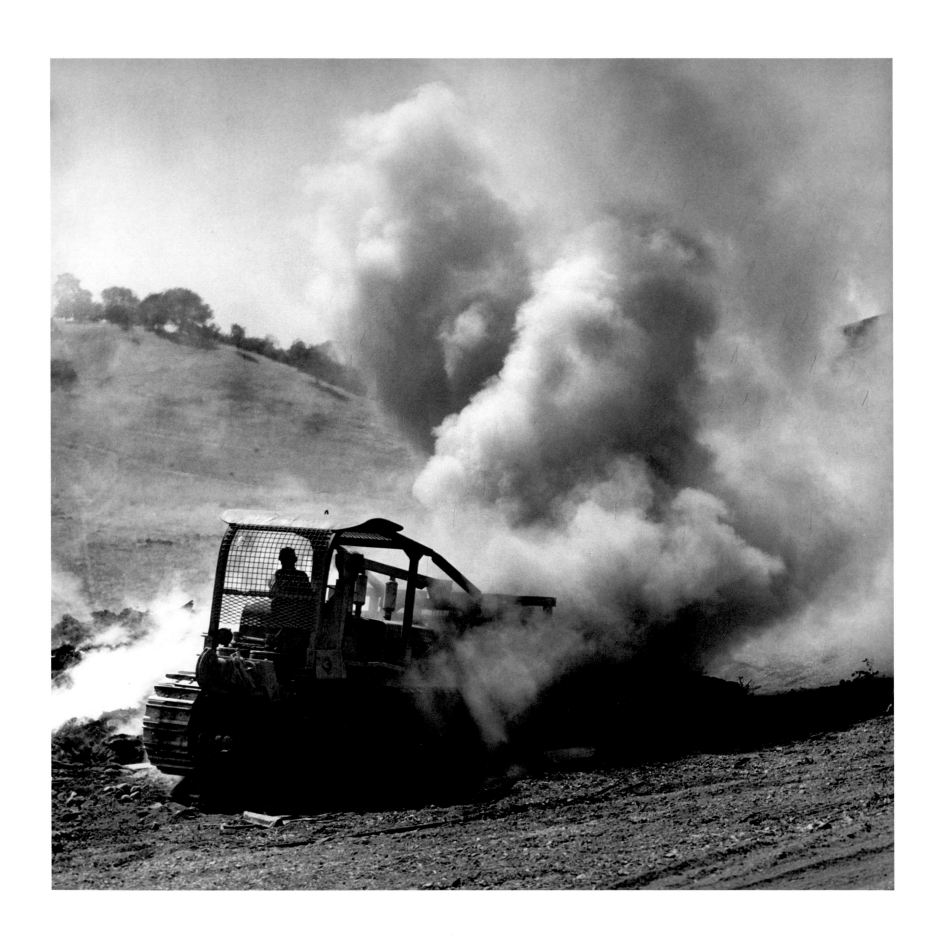

BULLDOZER, DEATH OF A VALLEY 1956

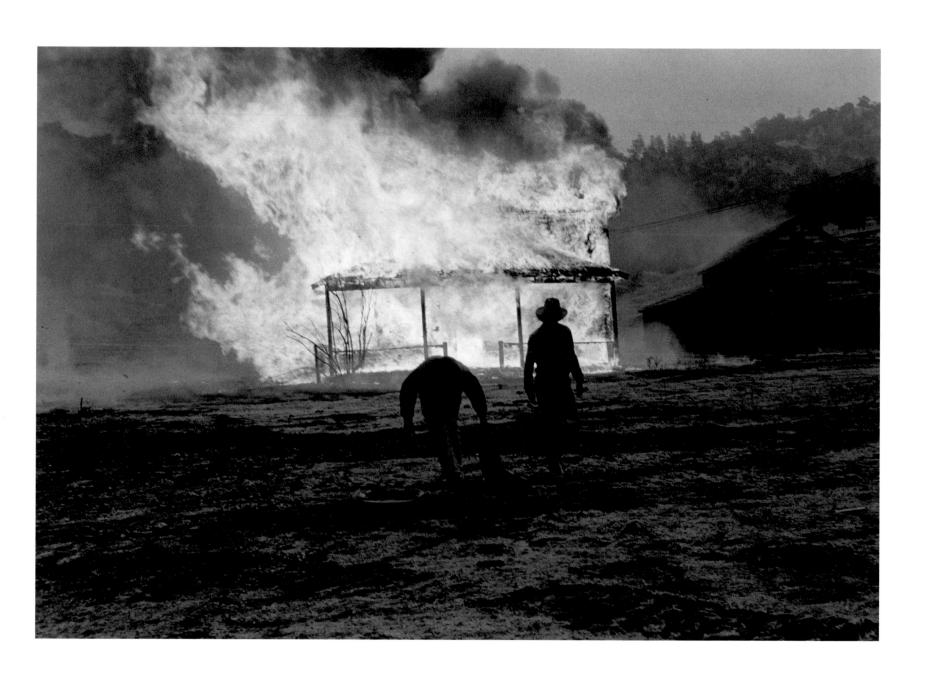

BERRYESSA VALLEY, DEATH OF A VALLEY 1956

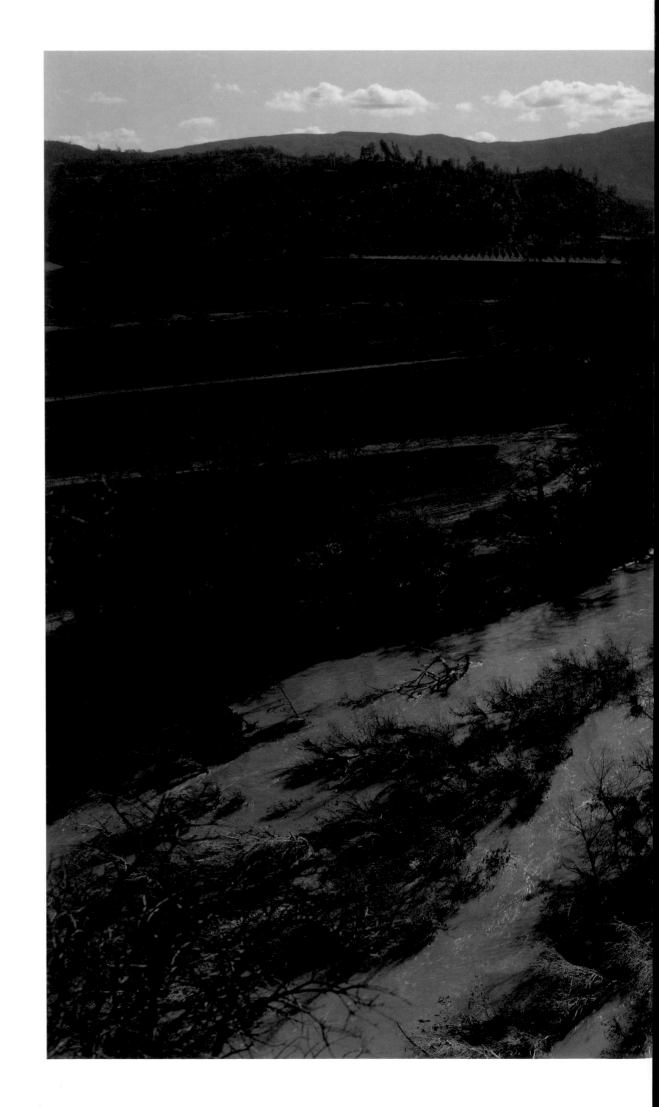

PUTAH CREEK,
BERRYESSA VALLEY
42 1956

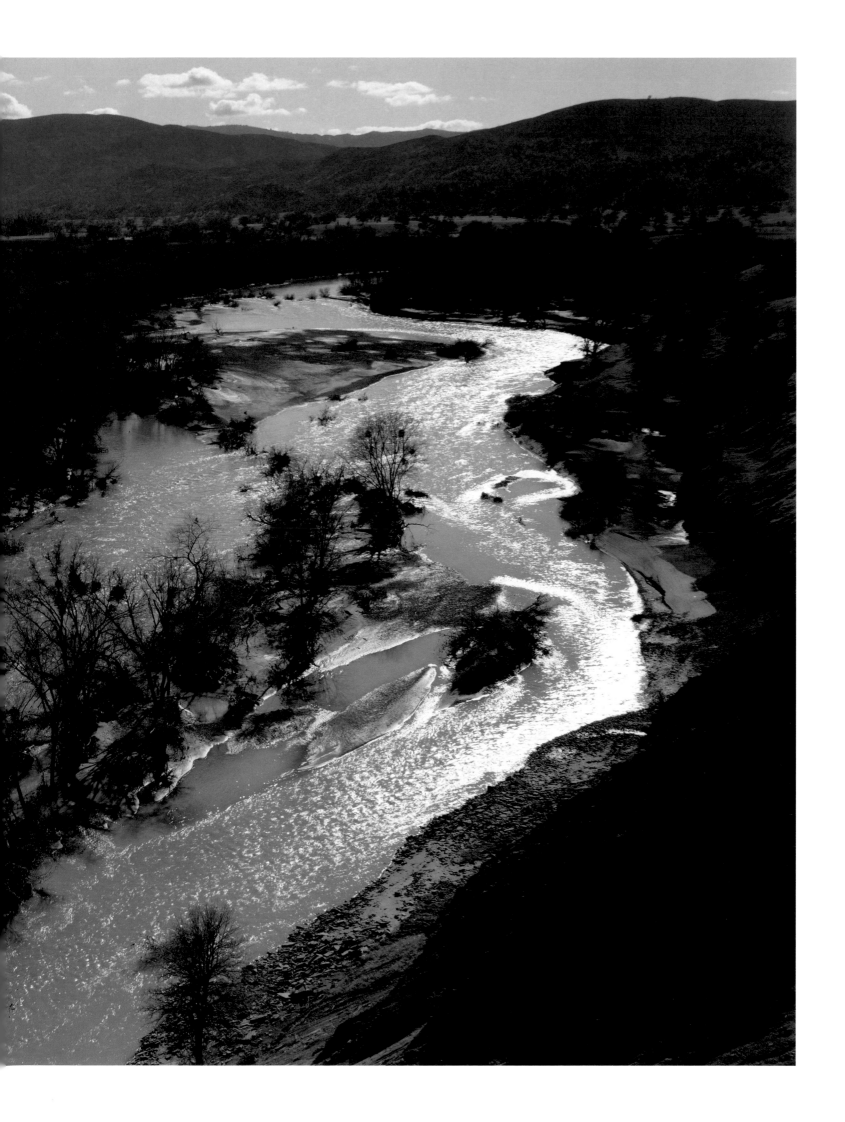

WALNUT GROVE

Walnut Grove is a California river town. It is ill. Touching the banks of the Sacramento River, it lies within the Delta Region, twenty-nine miles south of the capital city of Sacramento, and seventy-six northeast of San Francisco. It is surrounded by a vast system of waterways that cut the region into a cluster of islands, forming a landscape unique in California.

Walnut Grove was founded about 1850; disillusioned miners came in hopes of growing a little food. The soil proved to be extremely fertile, and by 1870, the town was flourishing on agriculture—and on gambling, for it was the gateway to the gold country, only forty-seven miles from Jackson.

Originally, the town was by passed by water traffic that traveled Steamboat Slough to and from Sacramento. But by 1871 ships were taking the main channel of the river and the town began to enjoy its position on an important link between San Francisco Bay and the capital. And Walnut Grove had a Pony Express stop, a stagecoach station, a steamboat landing, and a railroad depot.

Disastrous floods and fires failed to erase the town; but the gold gave out in the hills; and when the automobile came it changed everything.
Now the waterways are almost obsolete.
And the railroad is all but dead.
The fertile soil is not sustaining the town.
When gambling was shut down, the spirit of the town's people was all but shut down too.

Today, it is a stage set, empty of visitors, unknown.
An American town comes to a period of vacancy; it's a forgotten place; it must face a transition because its central reason for being has disappeared.
This is the portrait of such a town.

Ruth-Marion Baruch, 1961

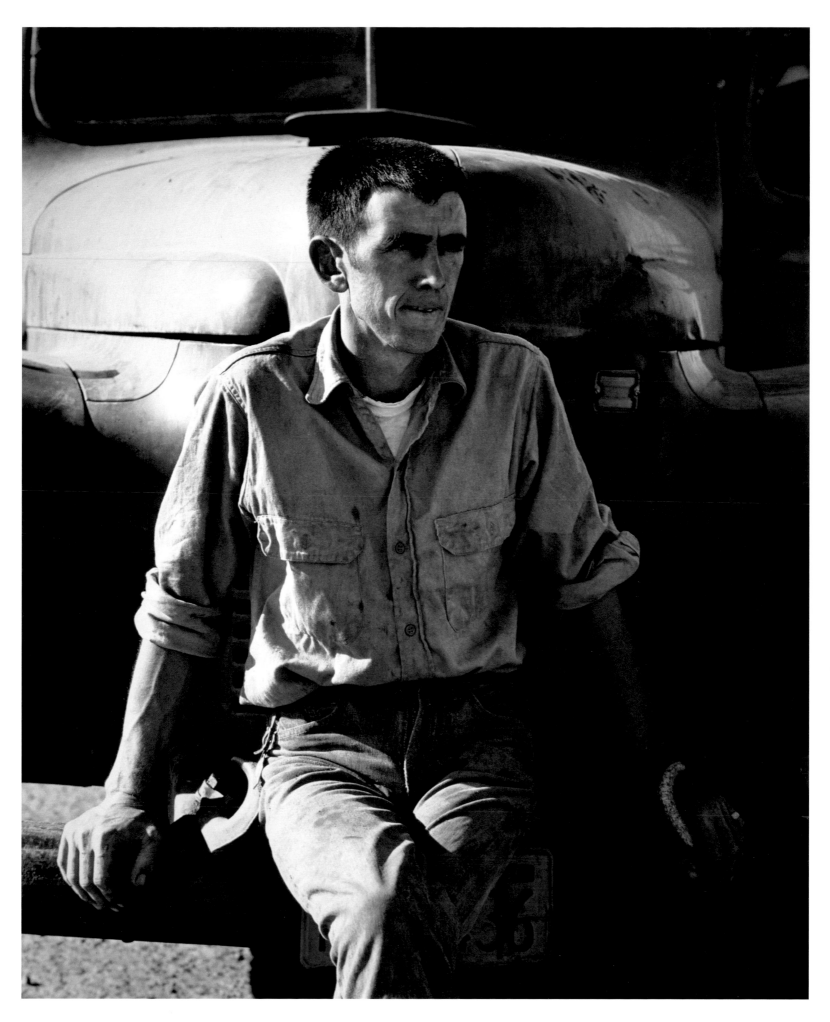

WORKER, WALNUT GROVE: PORTRAIT OF A TOWN 1961

WALNUT GROVE: PORTRAIT OF A TOWN 1961

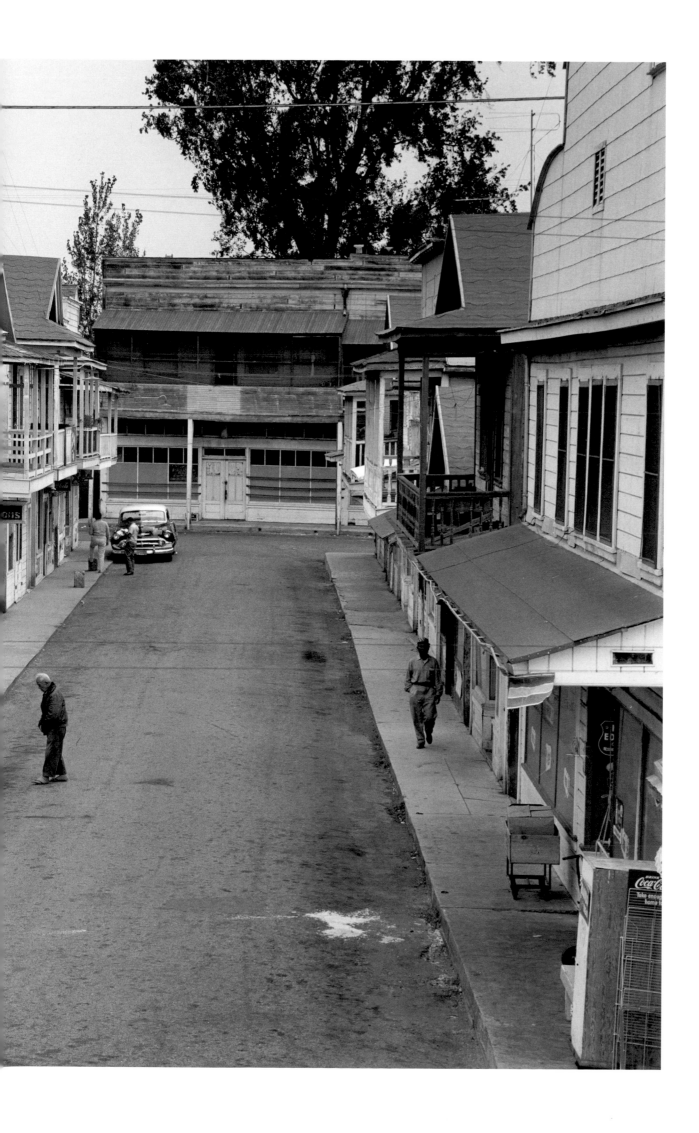

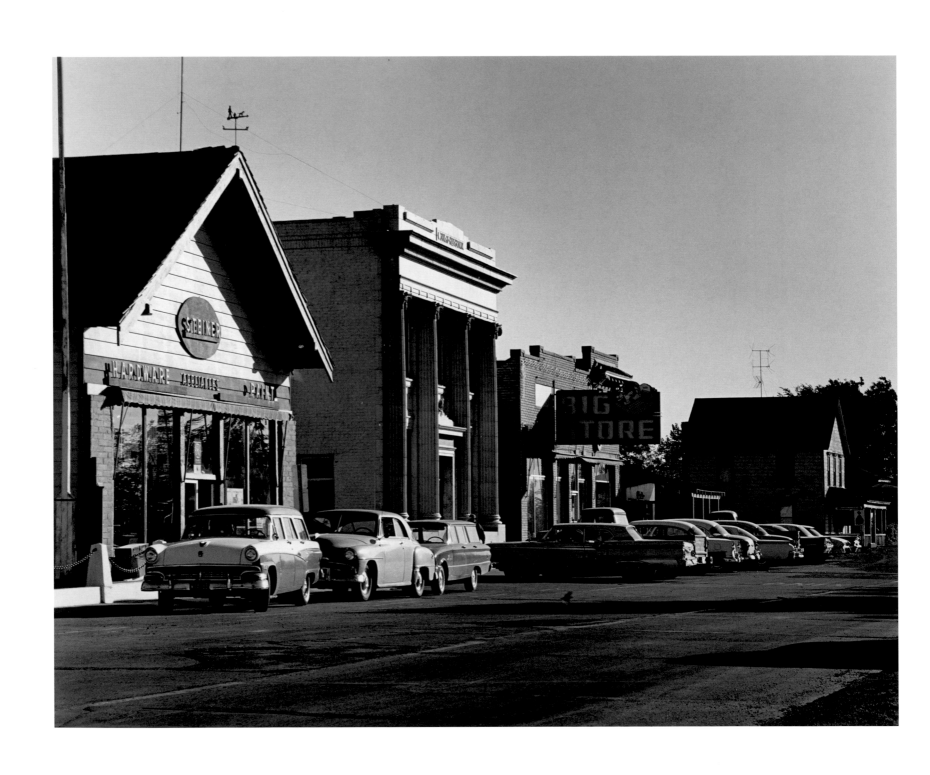

WALNUT GROVE: PORTRAIT OF A TOWN 1961

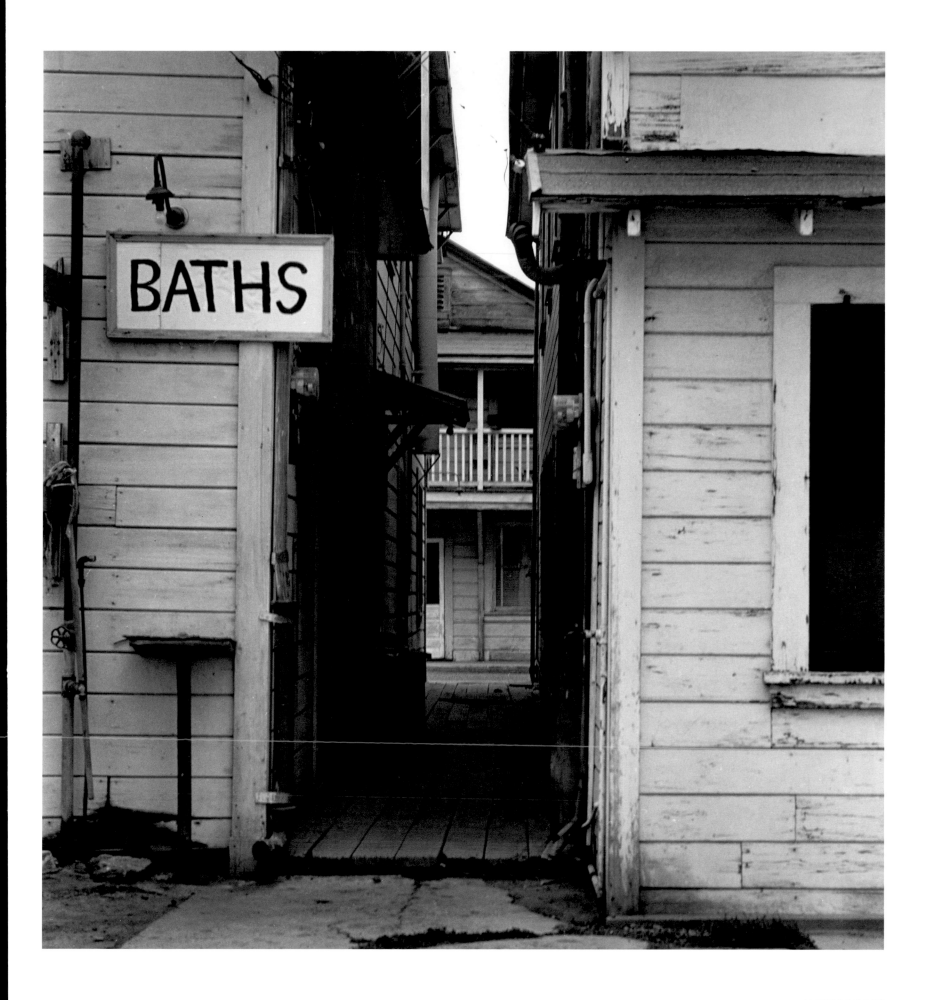

WALNUT GROVE: PORTRAIT OF A TOWN 1961

(OVERLEAF)
WALNUT GROVE: PORTRAIT OF A TOWN 1961

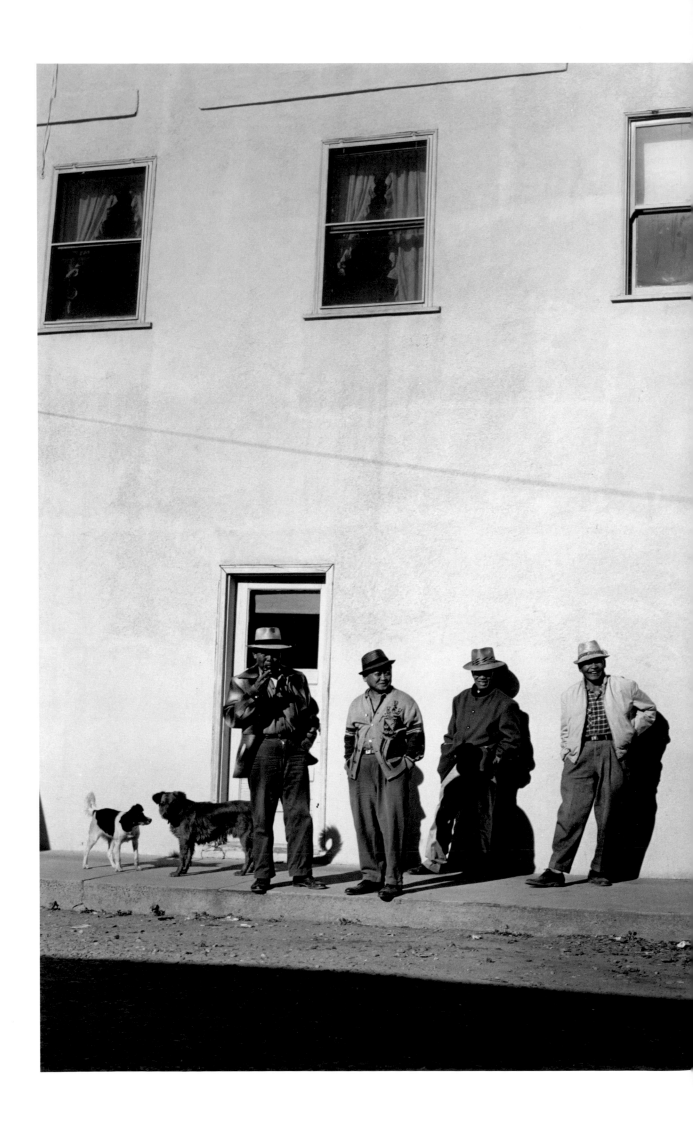

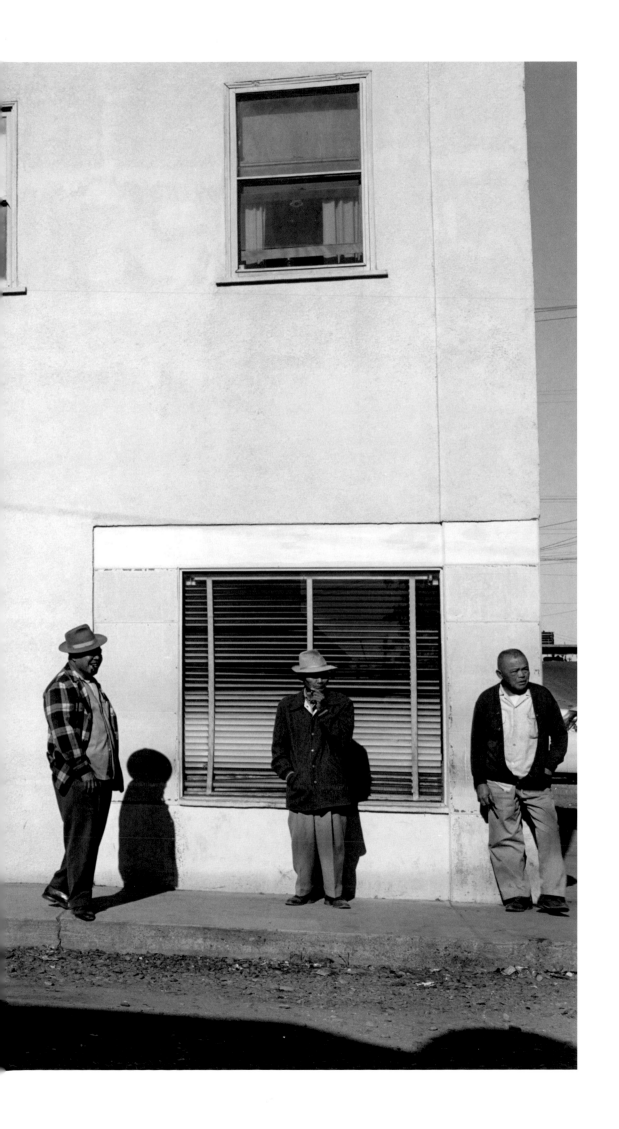

BLACK PANTHERS

Well then, believe it, my friend
That this silence will end
We'll just have to get guns
And be men…

A ballad of the Black Panther Party

In the 1960s, I worked on the Black Panther Party Project
with my wife, Ruth-Marion Baruch. Ruth-Marion and I were
involved with the Peace and Freedom Party, and there was a
coalition with the Panthers. Most people were unfamiliar with
who the Panthers were. They had this idea that the Panthers
were people to be feared. So we were trying to reach as many
people as possible. Ruth-Marion approached Kathleen Cleaver
and Eldridge Cleaver and Bobby Seale, and we were able to
photograph extensively within the Panthers. We gave them
stacks of photographs as they were produced, so that they
could use them in their paper.

The director of the de Young Museum agreed to produce
the show. But there were obstacles, threats of cancellation and
political maneuvering. But by the grace of God the show
opened, and perhaps one hundred thousand people came.

Pirkle Jones, 1990

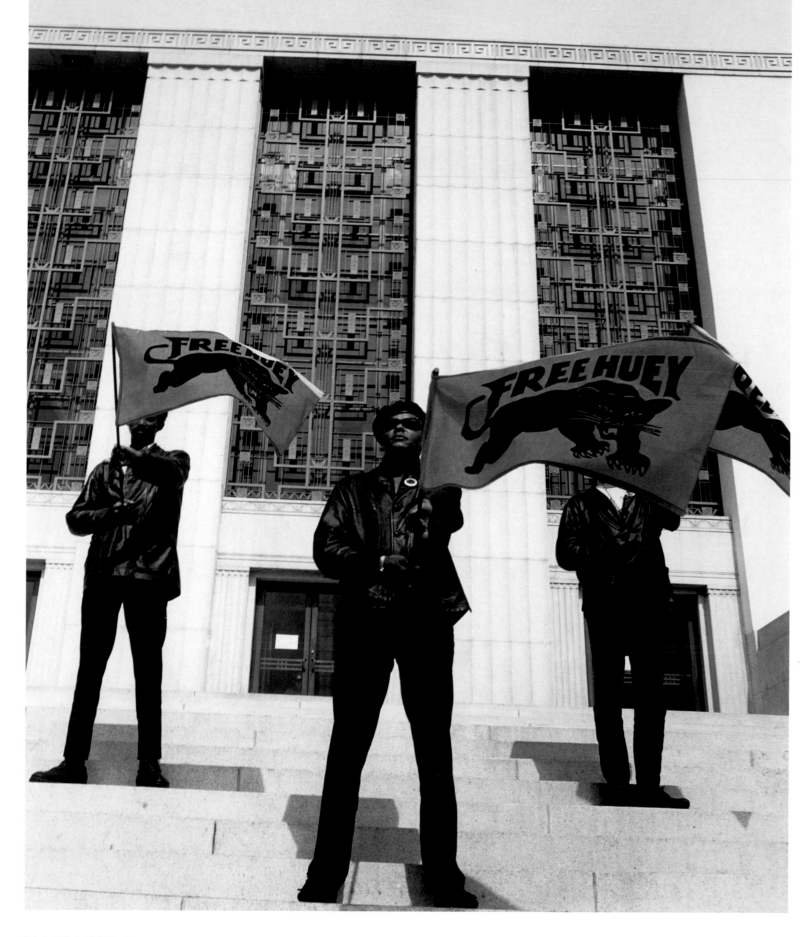

53 *BLACK PANTHER DEMONSTRATION, ALAMEDA COUNTY COURT HOUSE, OAKLAND 1968*

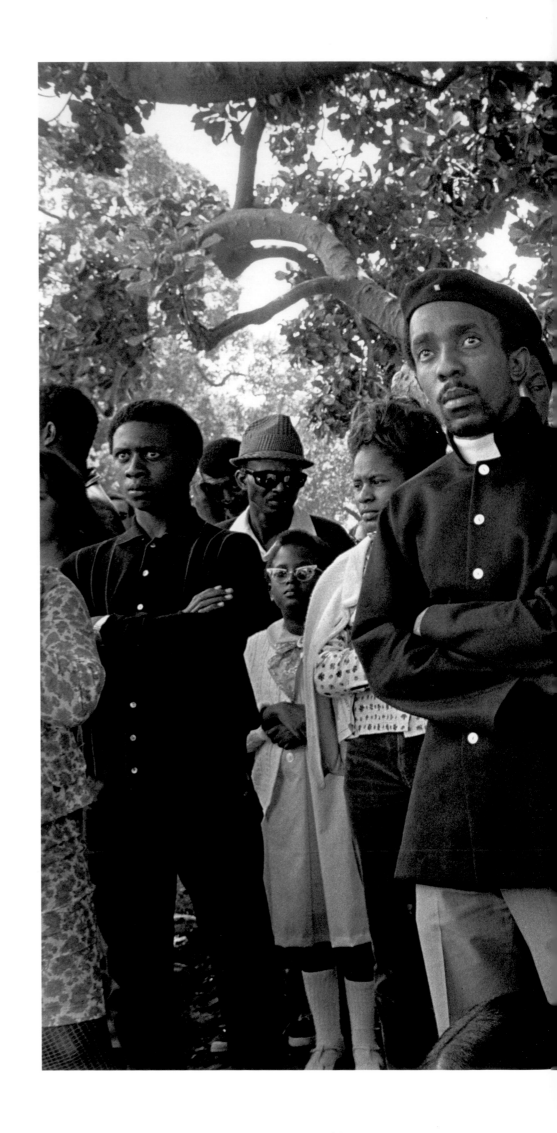

AUDIENCE,
FREE HUEY RALLY,
DE FREMERY PARK,
OAKLAND 1968

54

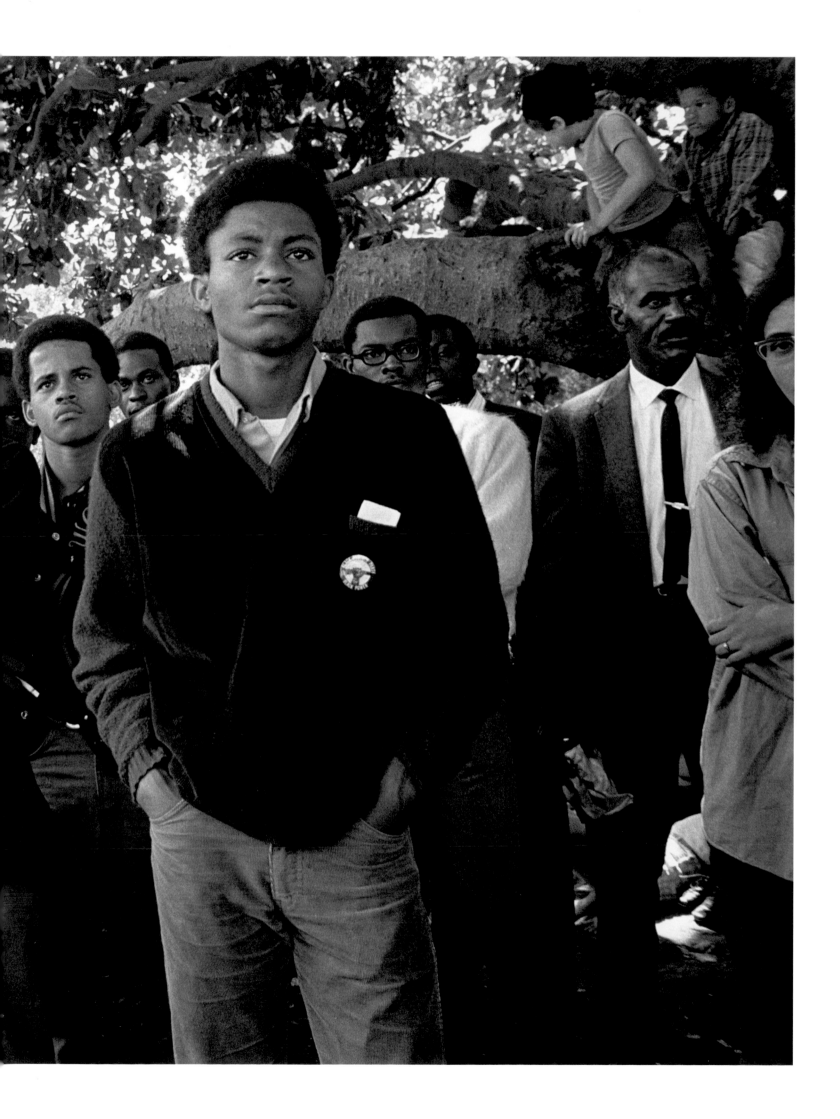

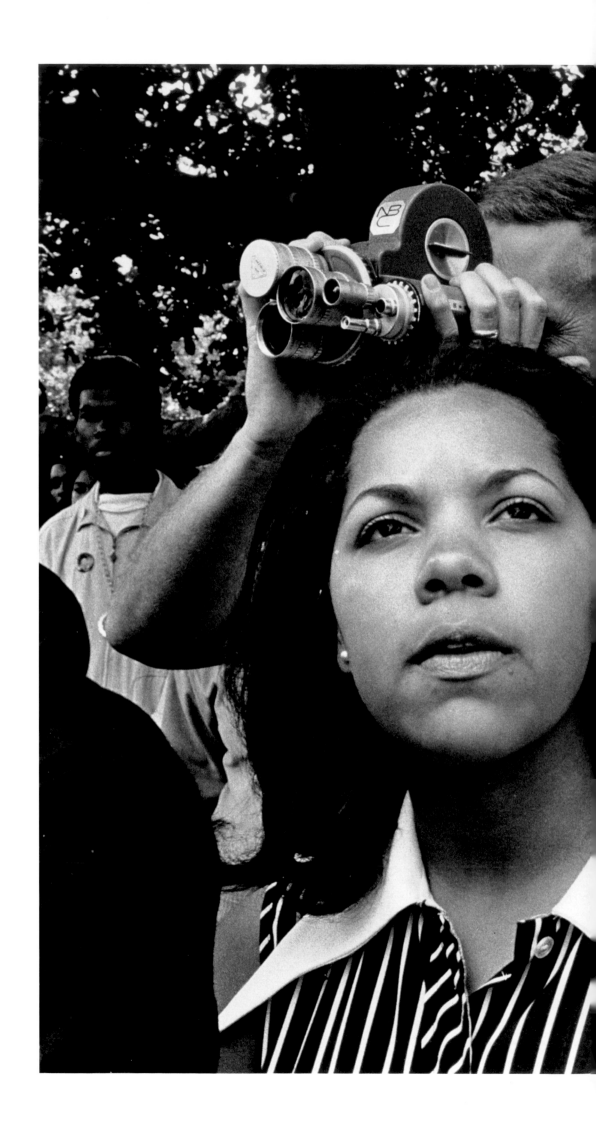

COUPLE LISTENING
AT FREE HUEY RALLY,
DE FREMERY PARK,
OAKLAND 1968

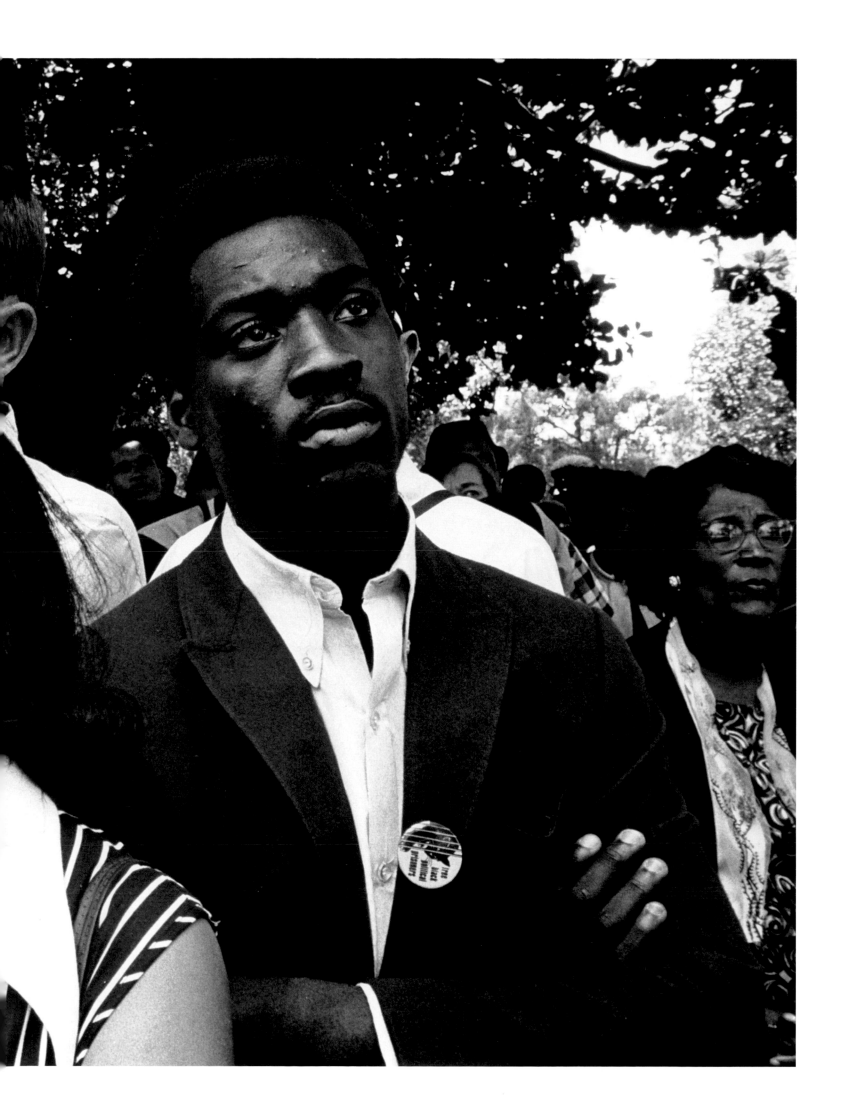

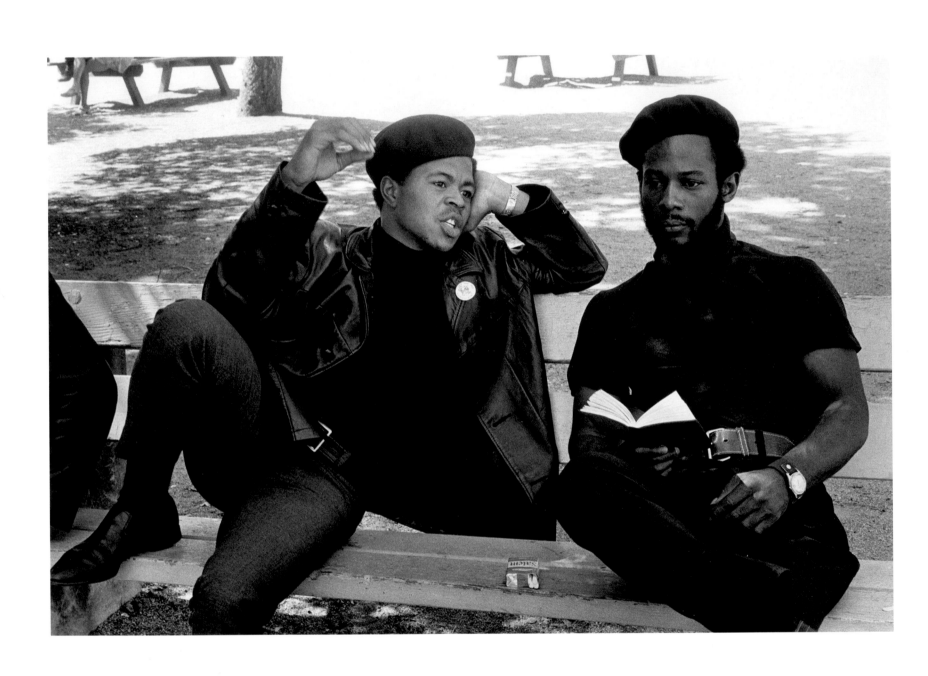

58 BLACK PANTHERS, BOBBY HUTTON MEMORIAL PARK, OAKLAND 1968

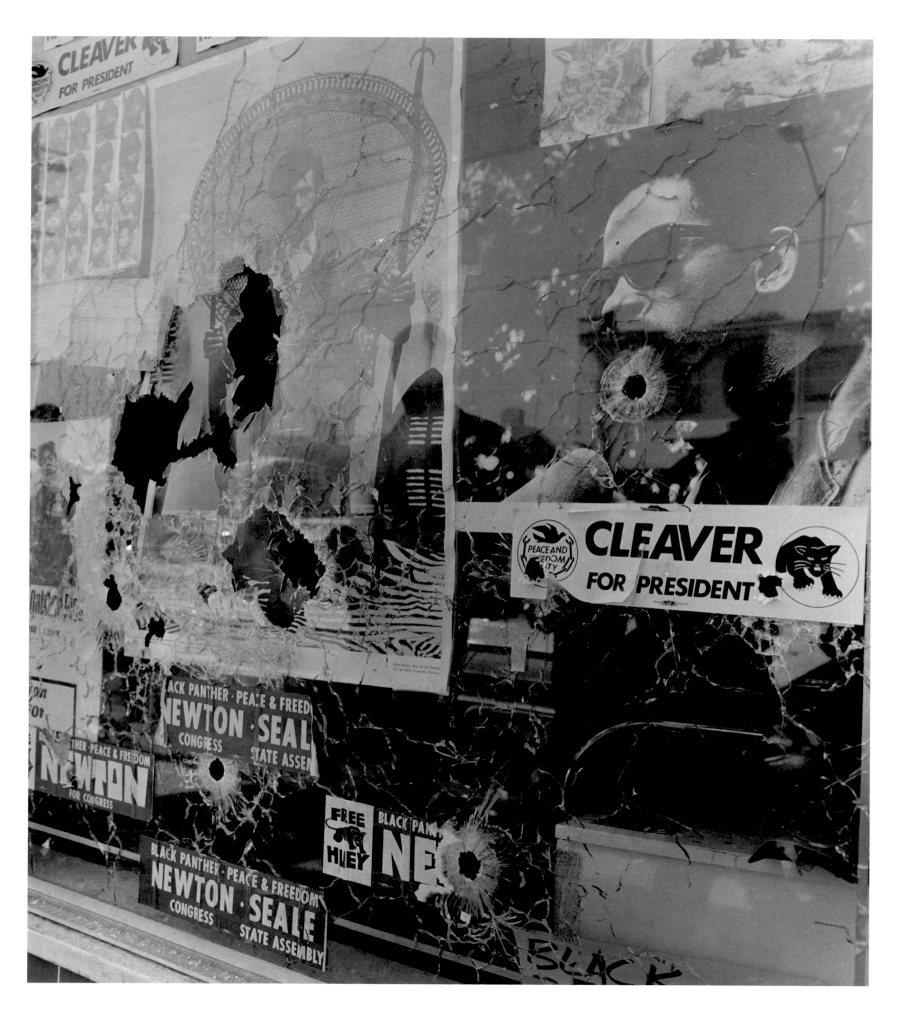

59 *PLATE GLASS WINDOW SHATTERED BY OAKLAND POLICEMEN, OAKLAND 1968*

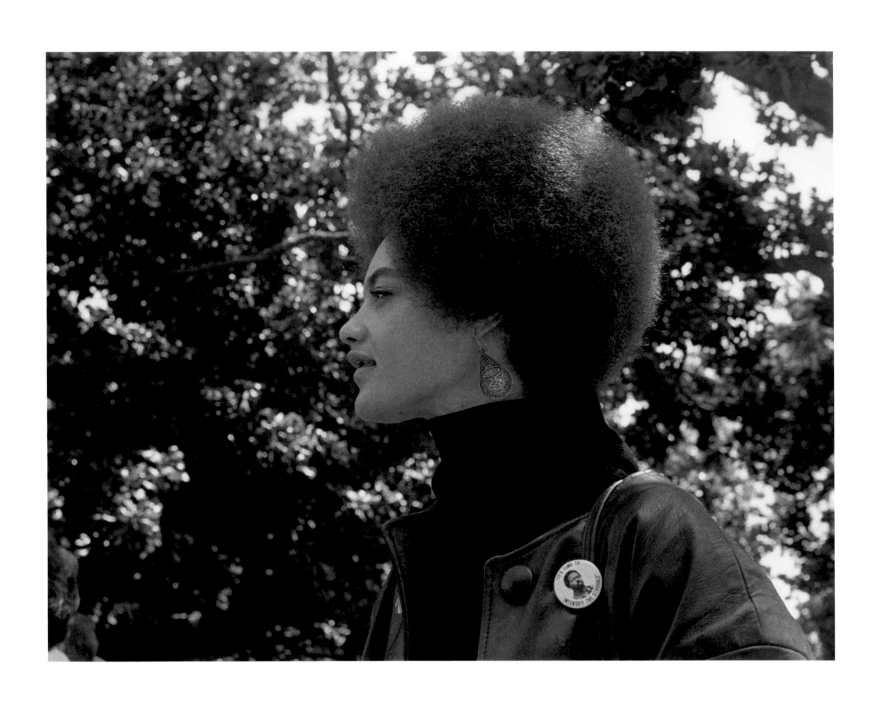

60 *KATHLEEN CLEAVER, COMMUNICATIONS SECRETARY, DE FREMERY PARK, OAKLAND 1968*

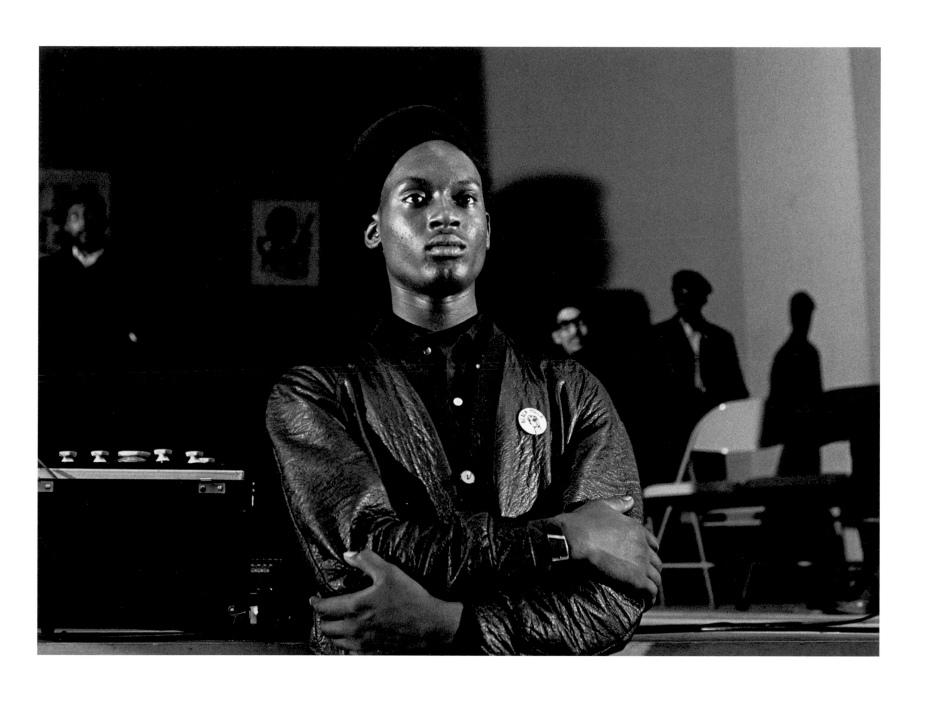

61 *BLACK PANTHER GUARD, MARIN CITY 1968*

GATE FIVE

The Gate Five community on the edge of Sausalito was a mecca in the late sixties; providing acceptance and tolerance for peoples' experimental life quests. Gate Five was the home and workshop of a number of people, who most important of all enjoyed life and worked with their hands and brains. Many creative people including artists, writers, craftsmen, and musicians lived there.

They lived on houseboats, boats, dry-docks, and some stayed for a time in cars, trucks, and buses. New houseboat architecture emerged daily; old boats were resurrected from the water and redesigned into highly imaginative centers of love. From an old barge, a fantastic sculpture "The Madonna" rose eighty feet above the water and dominated the seascape.

Pirkle Jones, 2001

San Francisco was where the social hemorrhaging was showing up. San Francisco was where the missing children were gathering and calling themselves "hippies."

Joan Didion, 1968

Each person [at Gate Five] has a different reason for being here, what everyone does have in common is the desire, drive, mania, to be allowed to pursue his or her own private dream or nightmare. Without judgment being passed by anyone.

Andree Connors, 1972

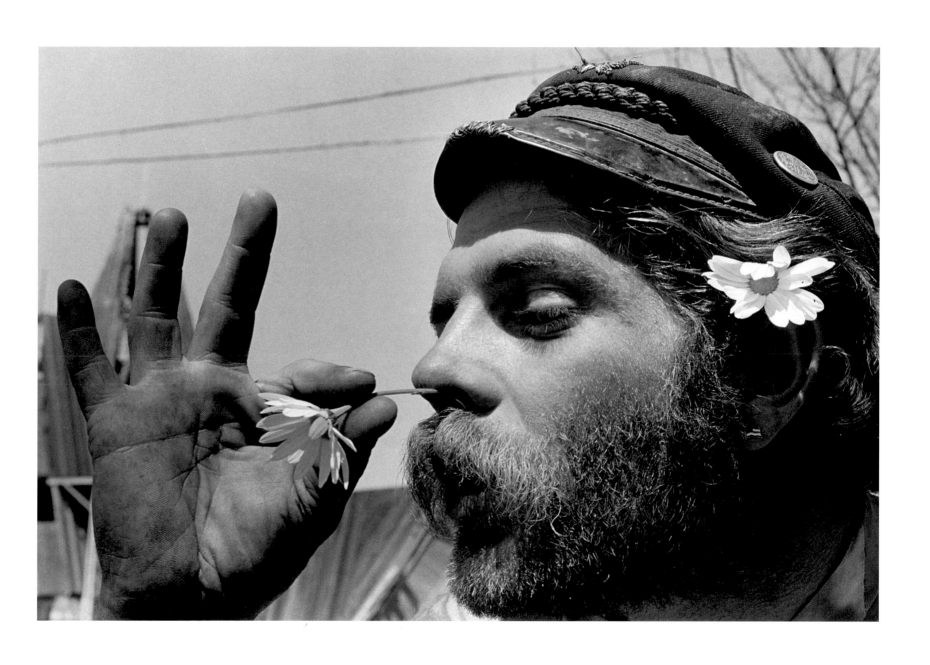

CAPTAIN GARBAGE, GATE FIVE, SAUSALITO 1970

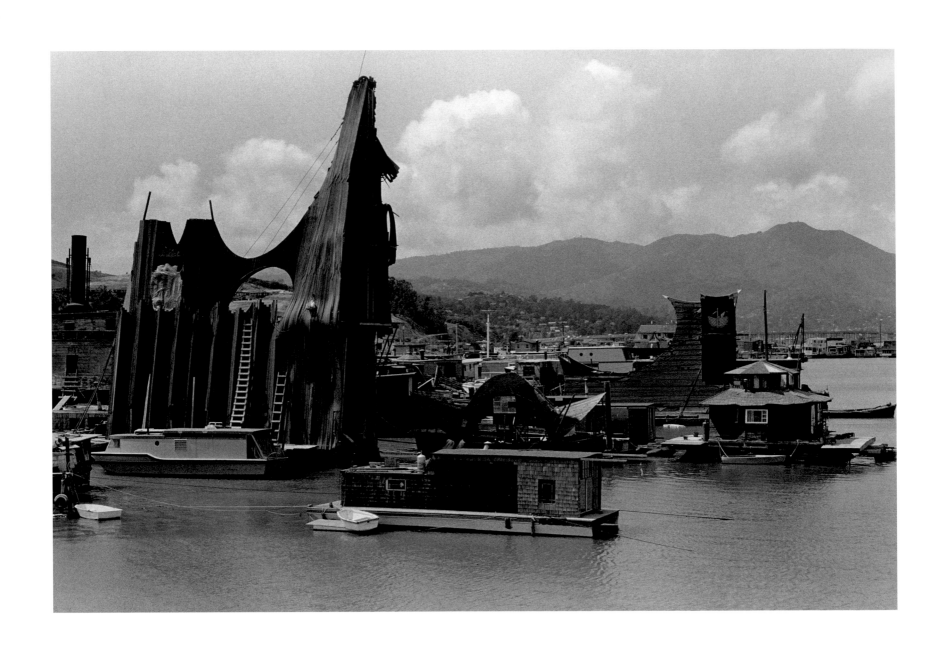

MADONNA AND MOUNT TAMALPAIS, GATE FIVE, SAUSALITO 1970

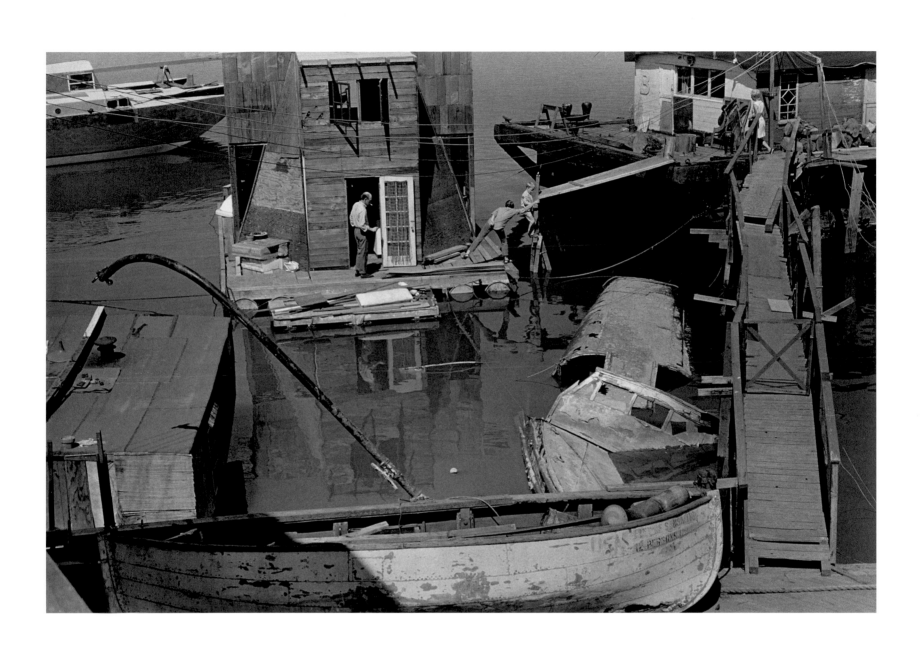

65 *GATE FIVE, SAUSALITO 1969*

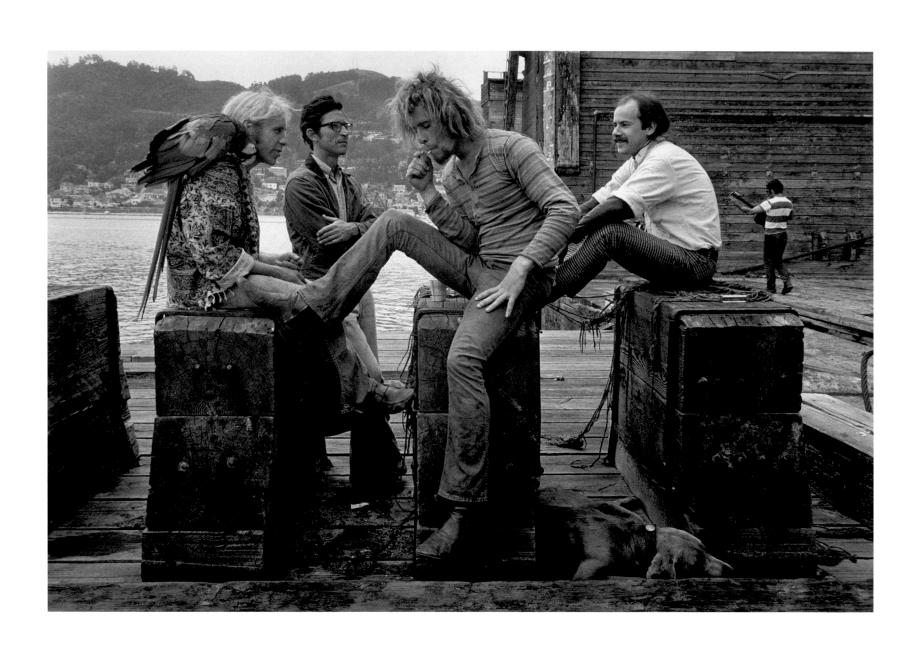

GATE FIVE, SAUSALITO 1970

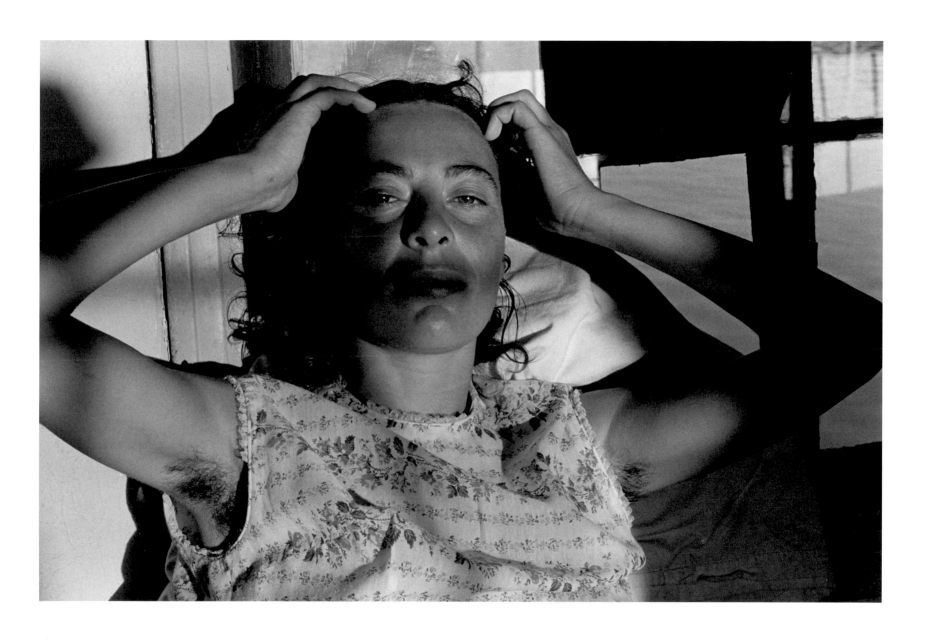

PORTRAIT, GATE FIVE, SAUSALITO 1970

(OVERLEAF)
JEAN VARDA AND TWO DANCERS,
GATE FIVE, SAUSALITO 1970

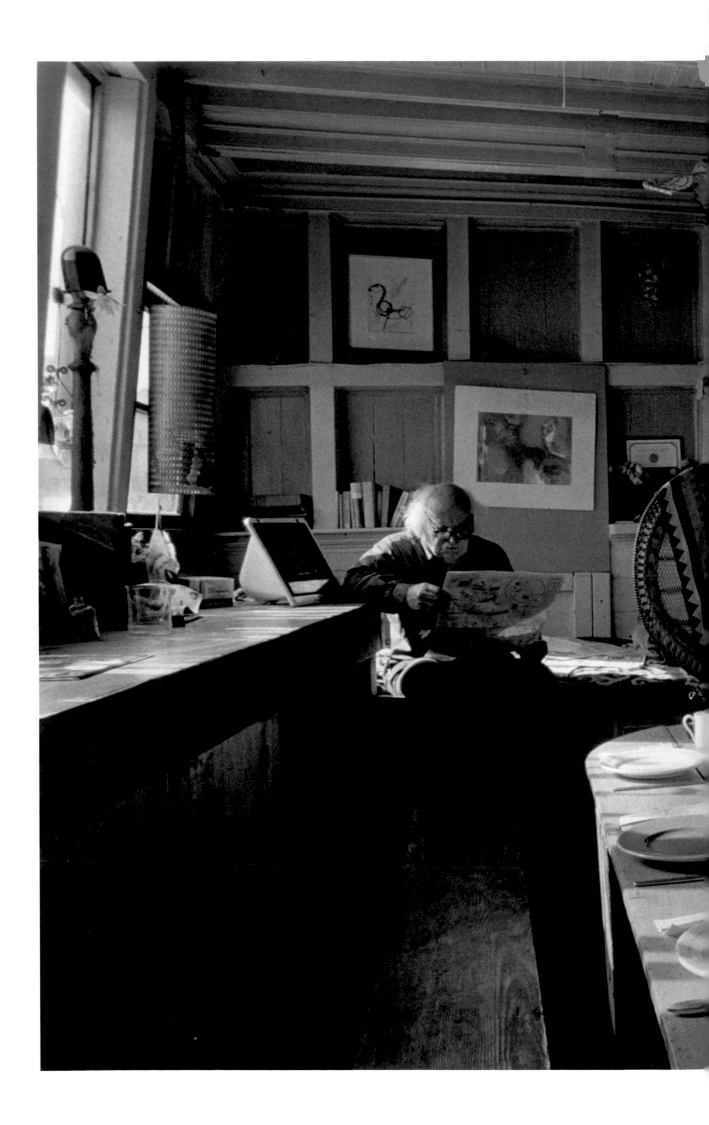

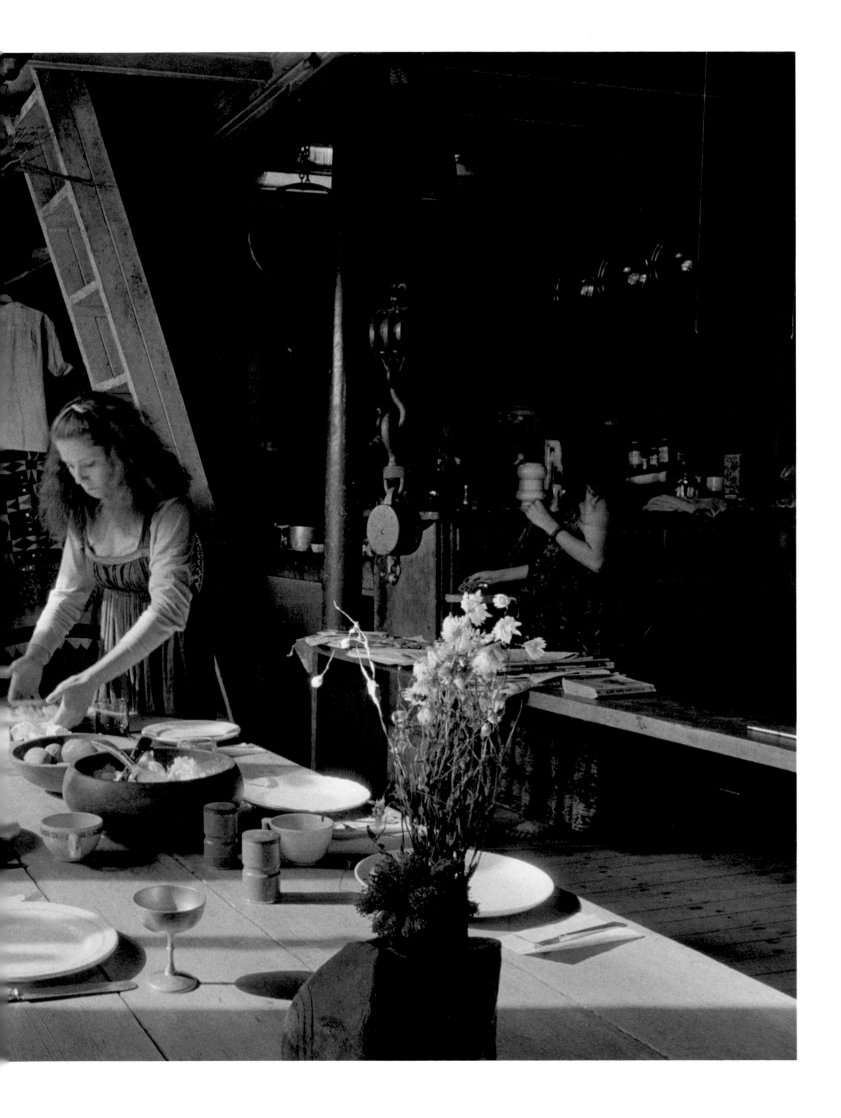

FLEA MARKET

Weekend visits to an extraordinary flea market in Marin City, California began in 1970. Some of the prized purchases were: first-edition books by Jacob A. Riis, the noted social reformer, photographer, and journalist; The Battle with the Slums, *published in 1902, and* Neighbors; Life Stories of the Other Half, *published in 1914;* The Photographic History of the Civil War in Ten Volumes, *published in 1911;* The Encyclopedia of Photography in Twenty Volumes, *published in 1962; vintage photographs by Ansel Adams, Arnold Genthe, and Johan Hagemayer. I photographed many surprising things in this flea market that is no longer there.*

Pirkle Jones, 2001

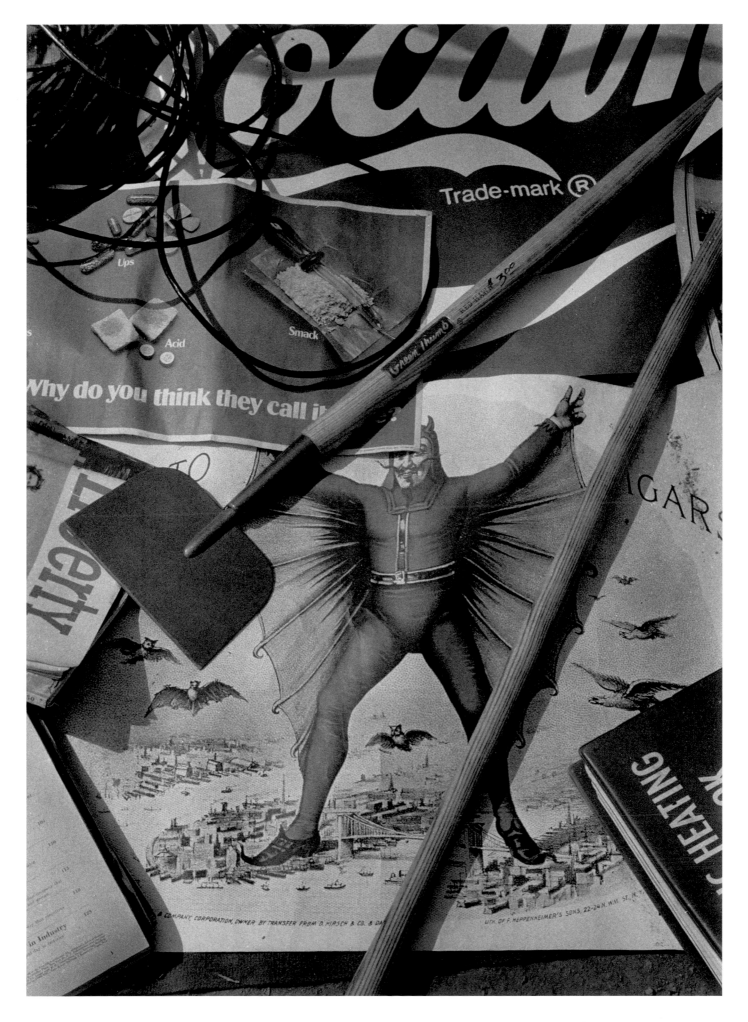

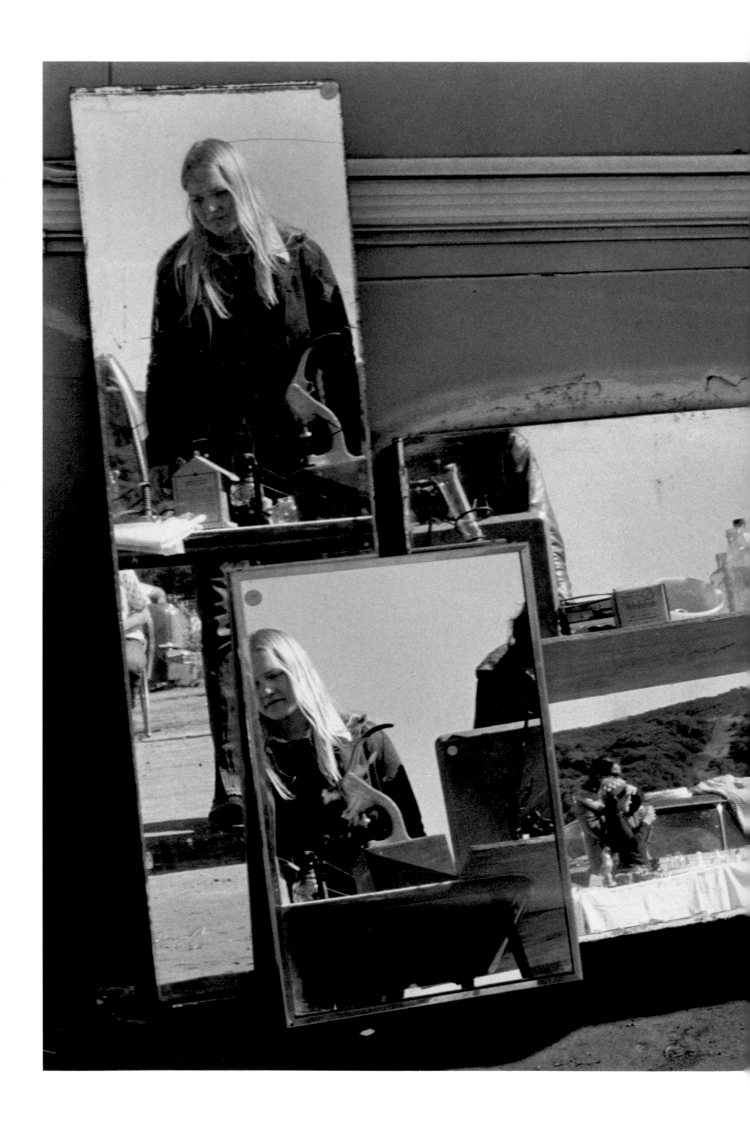

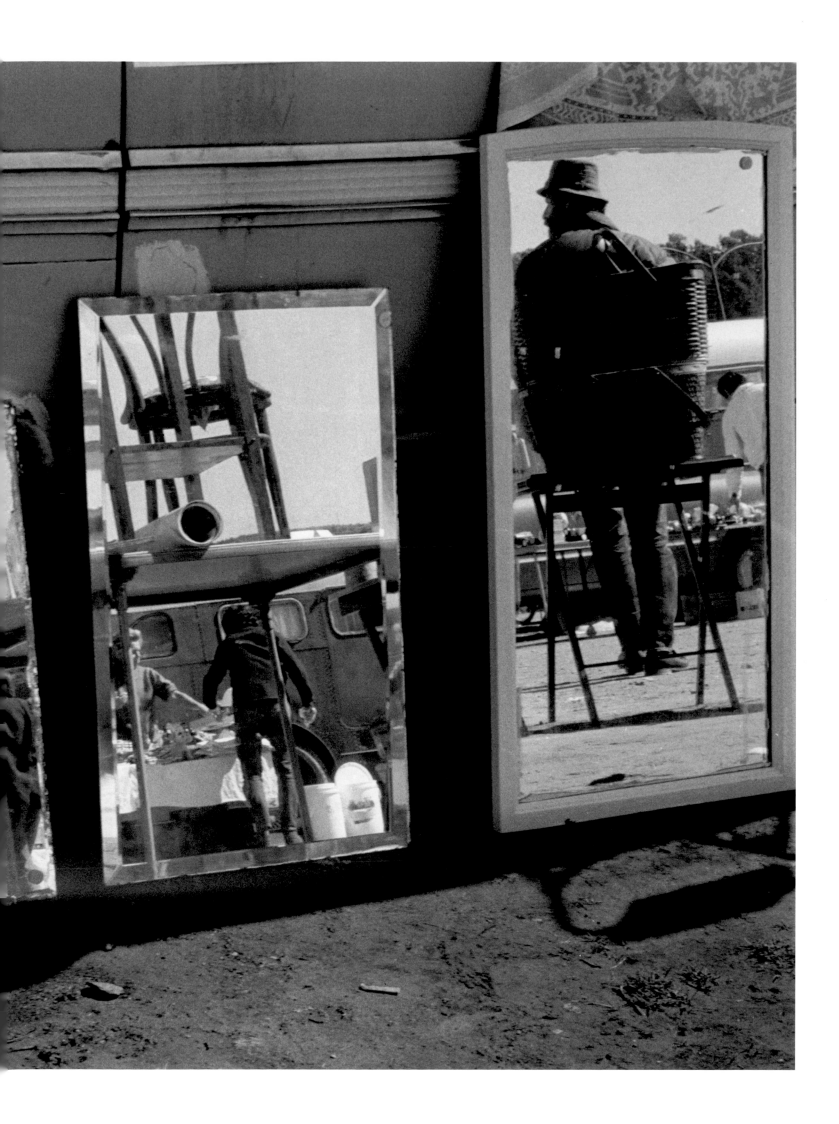

FLEA MARKET 1974

FLEA MARKET 1976

ROCKS AND MARSHES

In other, olden times there were only phantoms.
In the beginning, that is. If there ever was a beginning.

It was always a wild, rocky coast, desolate and
forbidding to the man of the pavements eloquent and
enchanting to the Taliessins. The homesteader never
failed to unearth fresh sorrows....

Though young, geologically speaking, the land has
a hoary look. From the ocean depths there issued
strange formations, contours unique and seductive.
As if the Titans of the deep had labored for aeons
to shape and mold the earth. Even millennia ago the
great land birds were startled by the abrupt aspect
of these risen shapes....

It is all thrown at you pell-mell: landscapes, seascapes,
forests, streams, birds of passage, weeds, pests,
rattlesnakes, gophers, earwigs... and that leech of the
plant world called the morning-glory. Even the rocks
are seductive and hypnotic.

Henry Miller, 1957

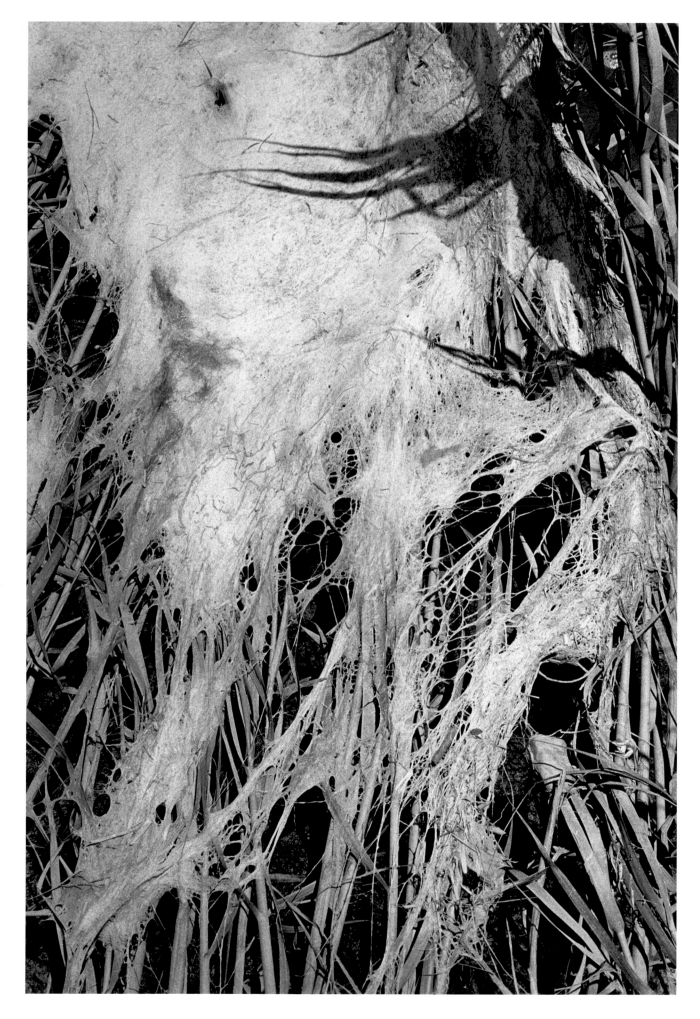

77 *SALT MARSH 2 1979*

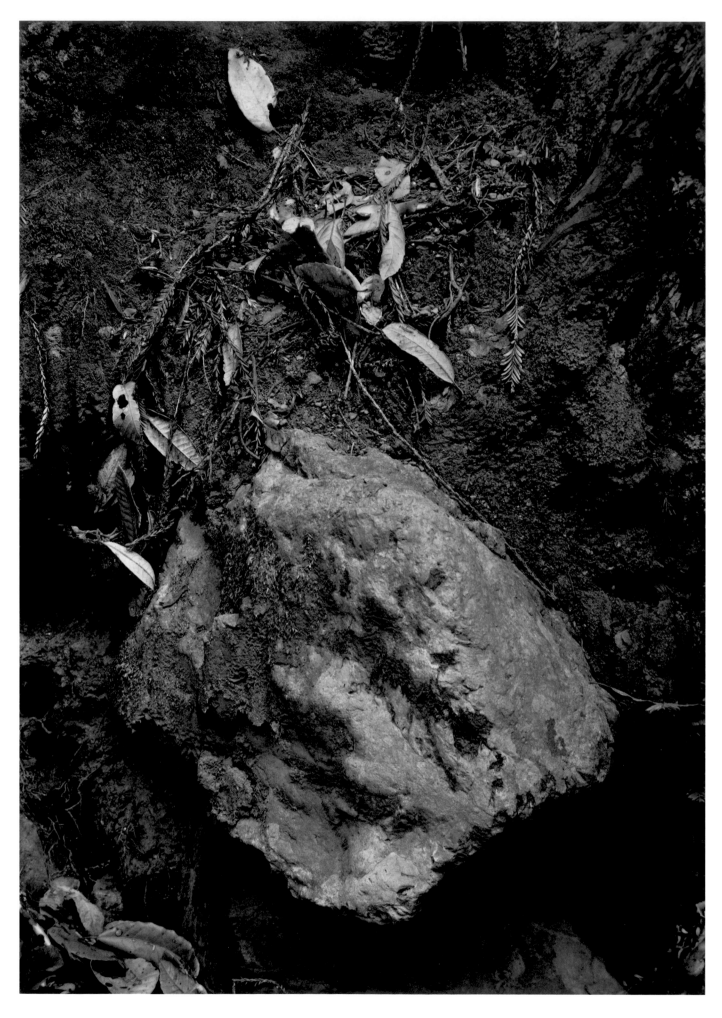

FERN CREEK 14 1991

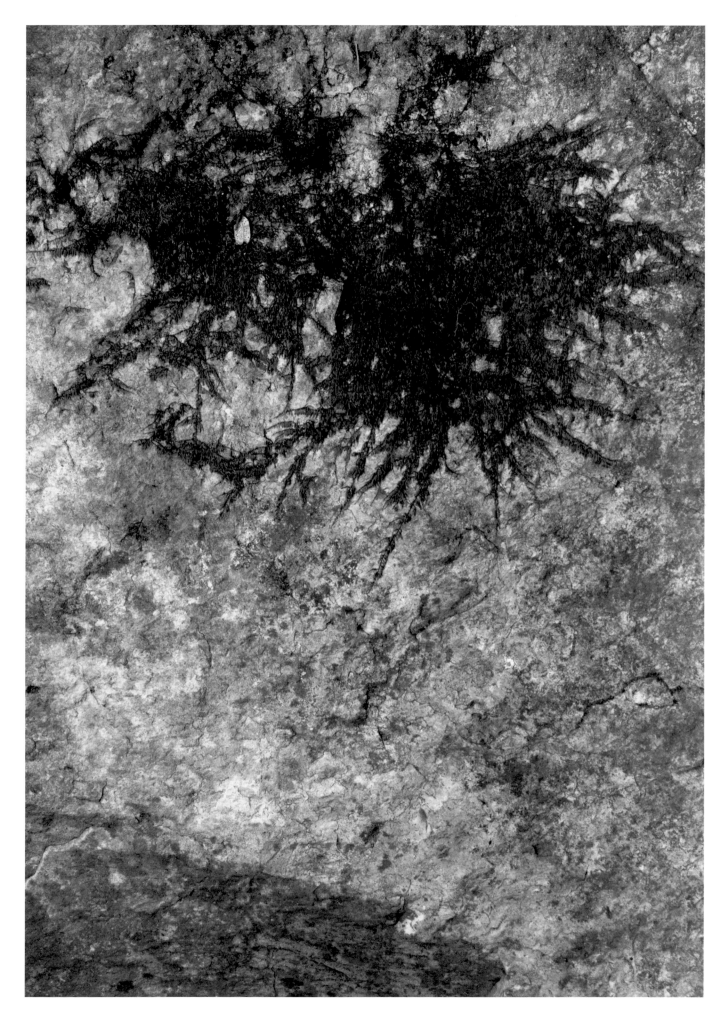

FERN CREEK 8 1991

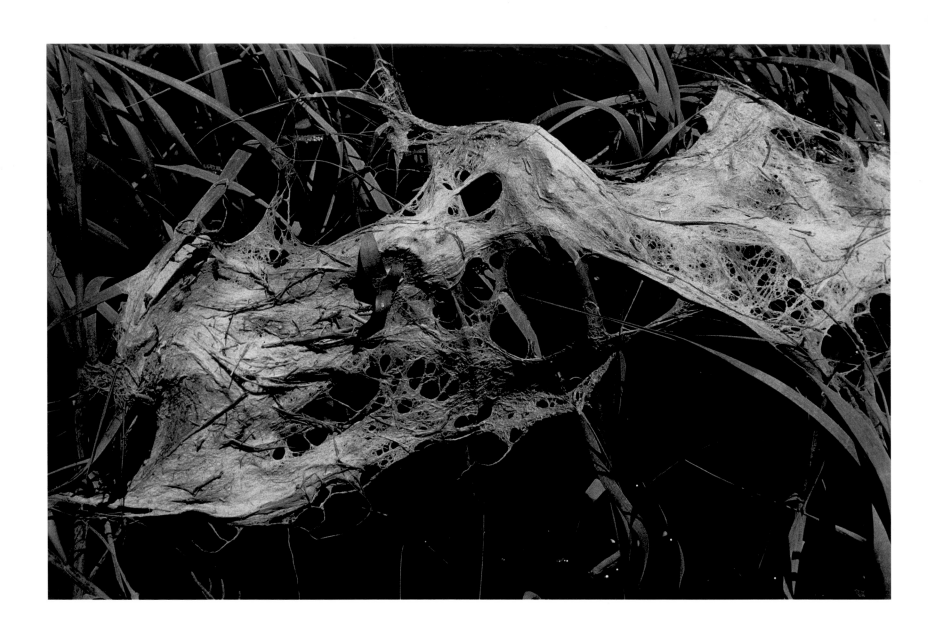

SALT MARSH 8 1979

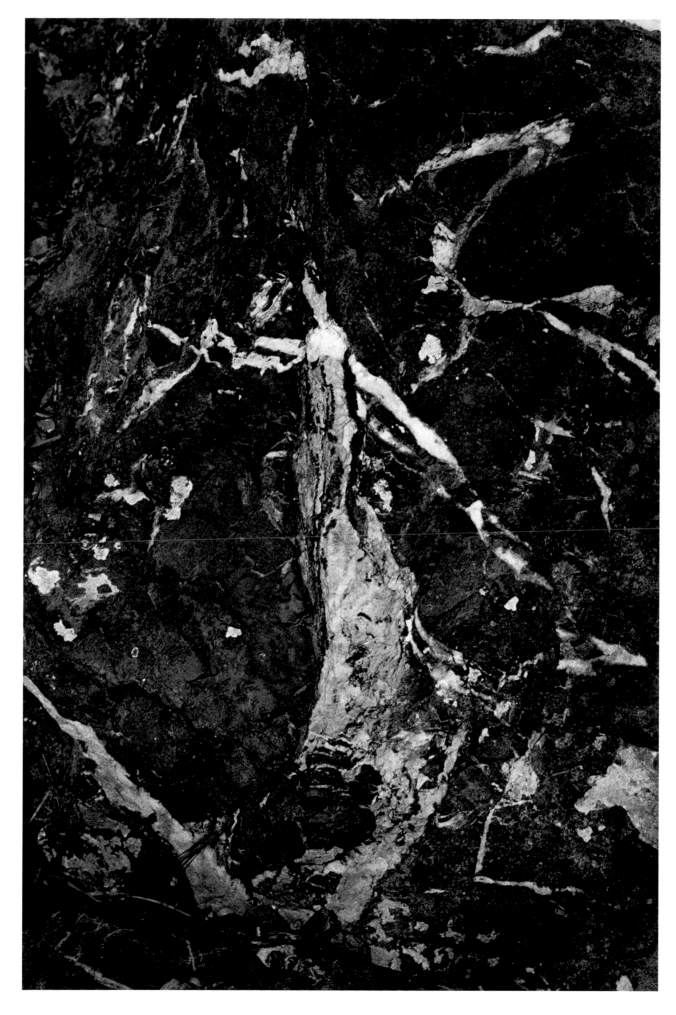

81 ROCK 4 1978

MOUNT TAMALPAIS

The Song Mt. Tamalpais Sings

This is the last place. There is nowhere else to go.

Human movements,
* but for a few,*
are Westerly.
Man follows the Sun.

This is the last place. There is nowhere else to go.

Or follows what he thinks to be the
movements of the Sun.
It is hard to feel it, as a rider,
on a spinning ball.

This is the last place. There is nowhere else to go.

Centuries and hordes of us,
from every quarter of the earth,
now piling up,
and each wave going back
to get some more…

…This is the last place.
There is nowhere else we need to go.

Lew Welch, 1973

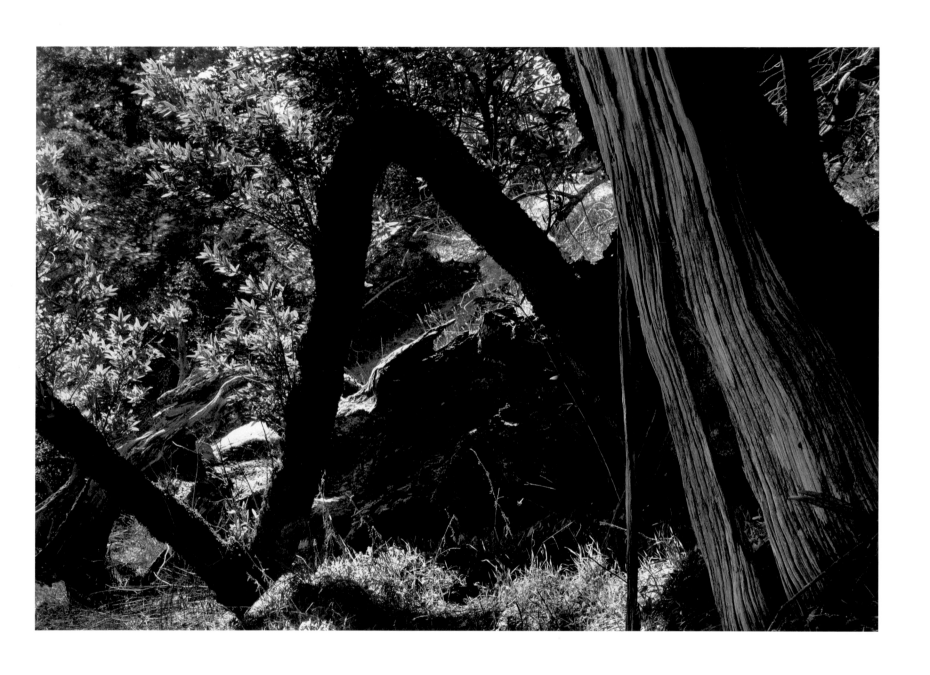

83 *MOUNT TAMALPAIS 50 1982*

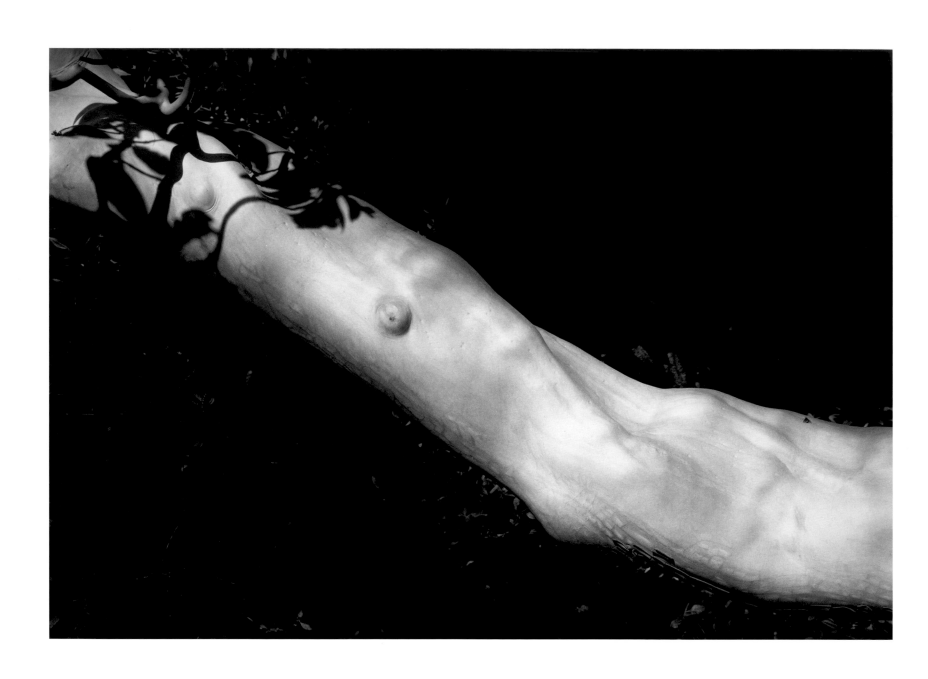

MOUNT TAMALPAIS 5 1981

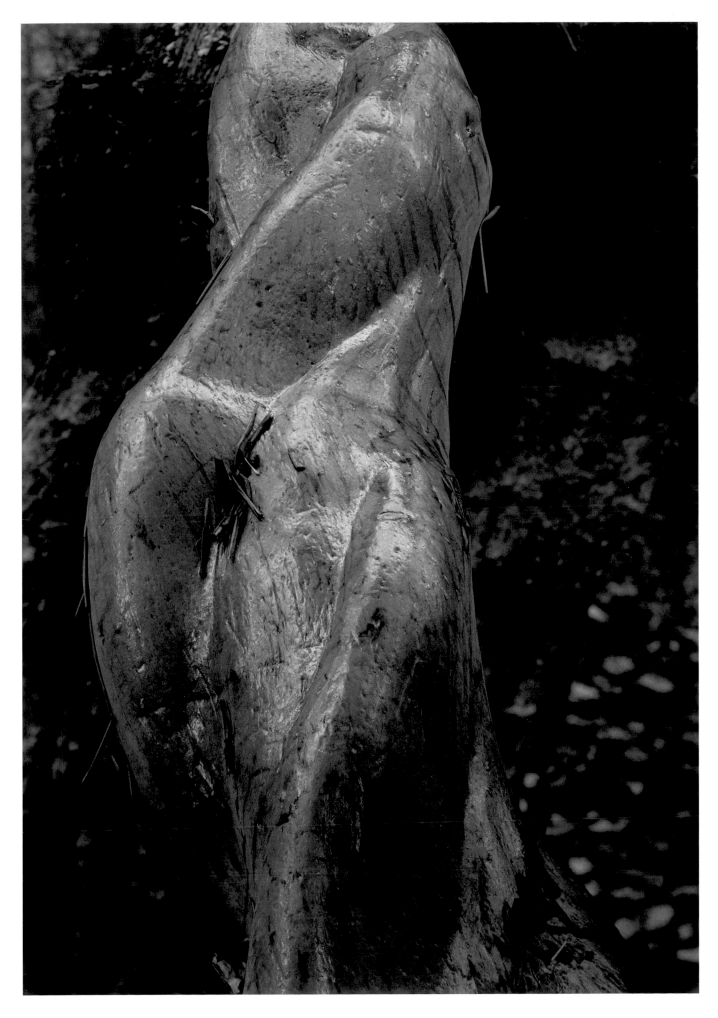

85 *MOUNT TAMALPAIS II 1980*

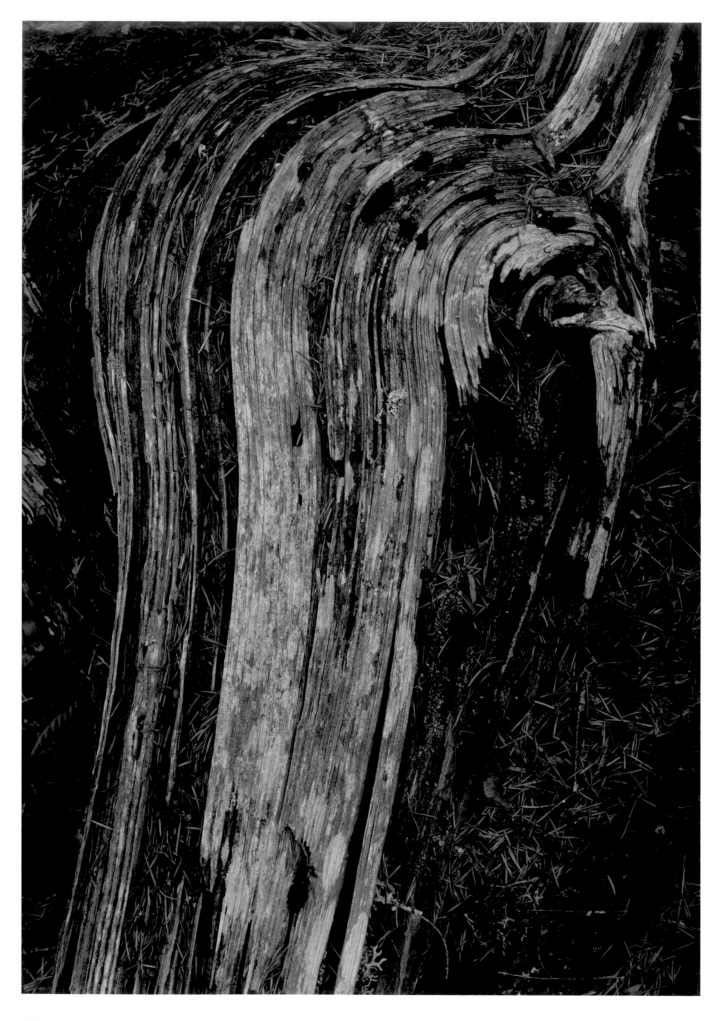

86 MOUNT TAMALPAIS 7 1980

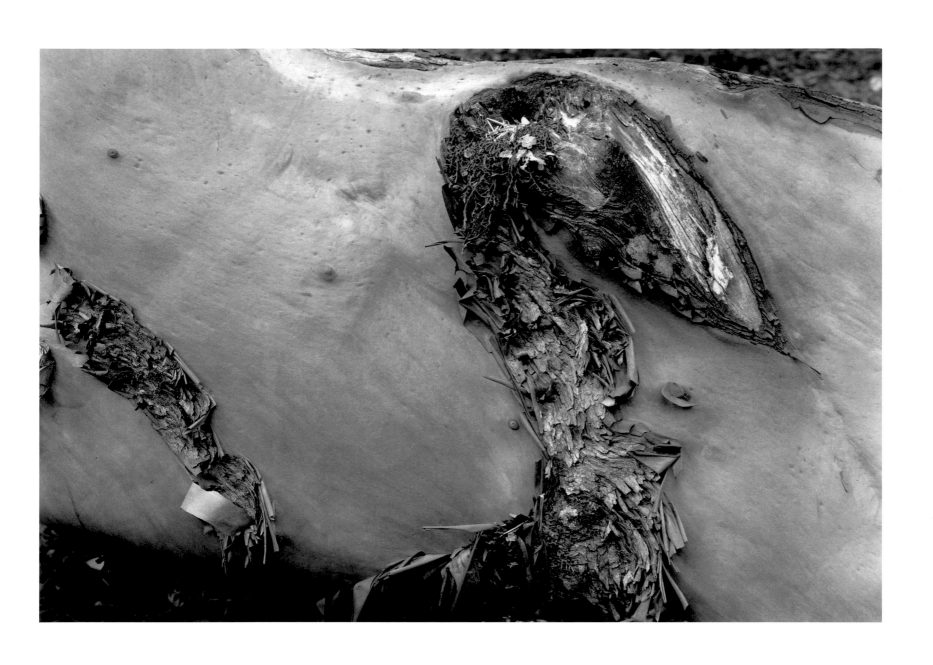

MOUNT TAMALPAIS 10 1980

LANDSCAPE

Landscape's most crucial condition is considered to be space, but its deepest theme is time. Landscape is identified with the past in Western tradition: humanity originated in—and lost—a garden, and natural landscape continues to represent a place in which change has not yet happened, the original condition of the earth, origin itself. There is a continuity of meaning.... Our landscape tradition comes out of the classical pastoral mode, which celebrates the purity of the rural in contrast to the corruption of the urban, of primitive culture, of simple lives, and does so in a mood of deep nostalgia and longing. For the ideal world of the pastoral is always in the past and has its parallels in Eden, the lost Golden Age, the landscape yet undiscovered, and the irrevocable world of childhood experience.

Rebecca Solnit, 2001

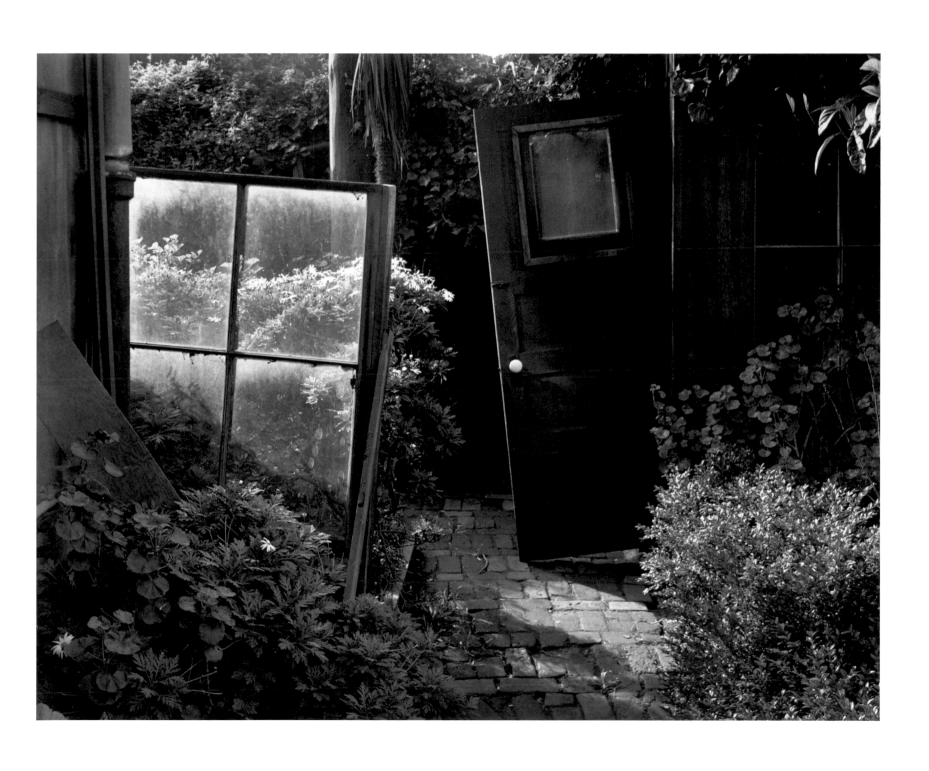

89 *GARDEN DETAIL, SAN FRANCISCO 1947*

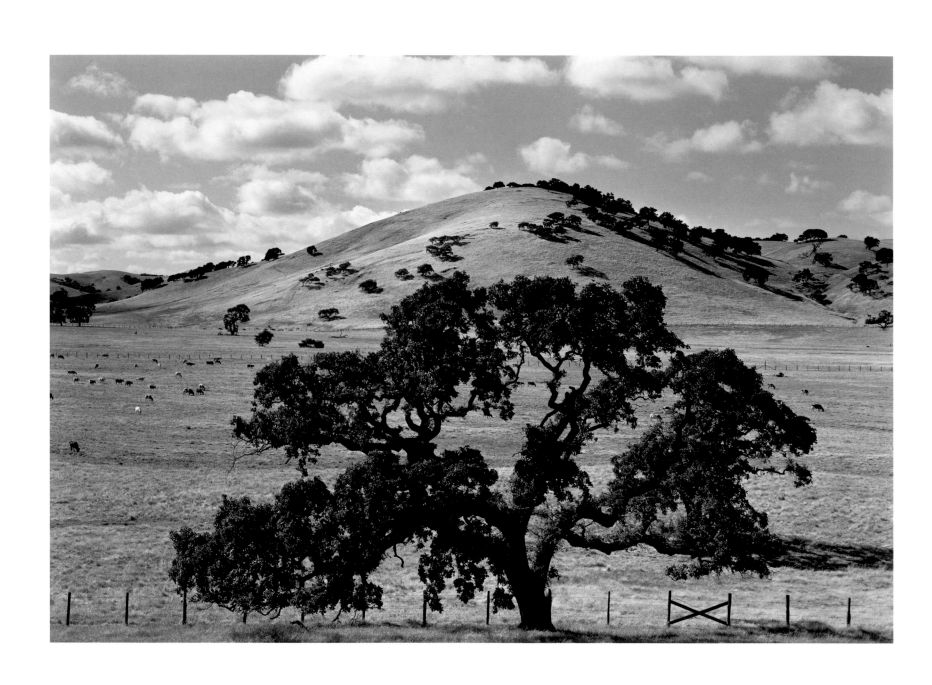

90 *OAK TREE, MARIN COUNTY 1952*

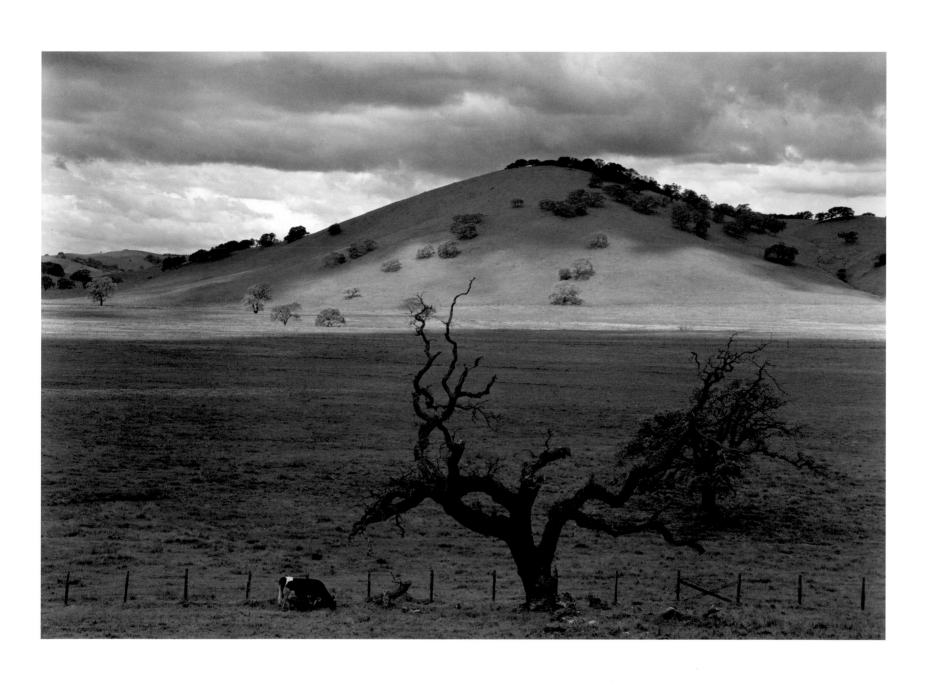

91 *OAK TREE, MARIN COUNTY 1978*

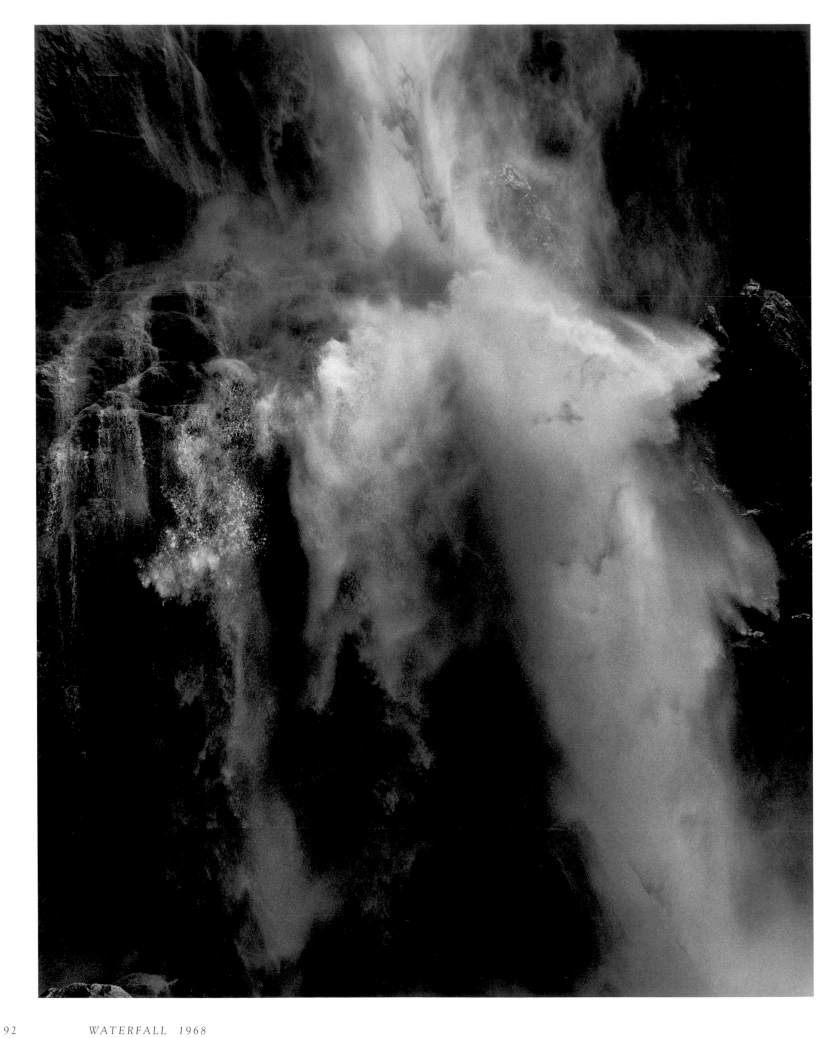

WATERFALL 1968

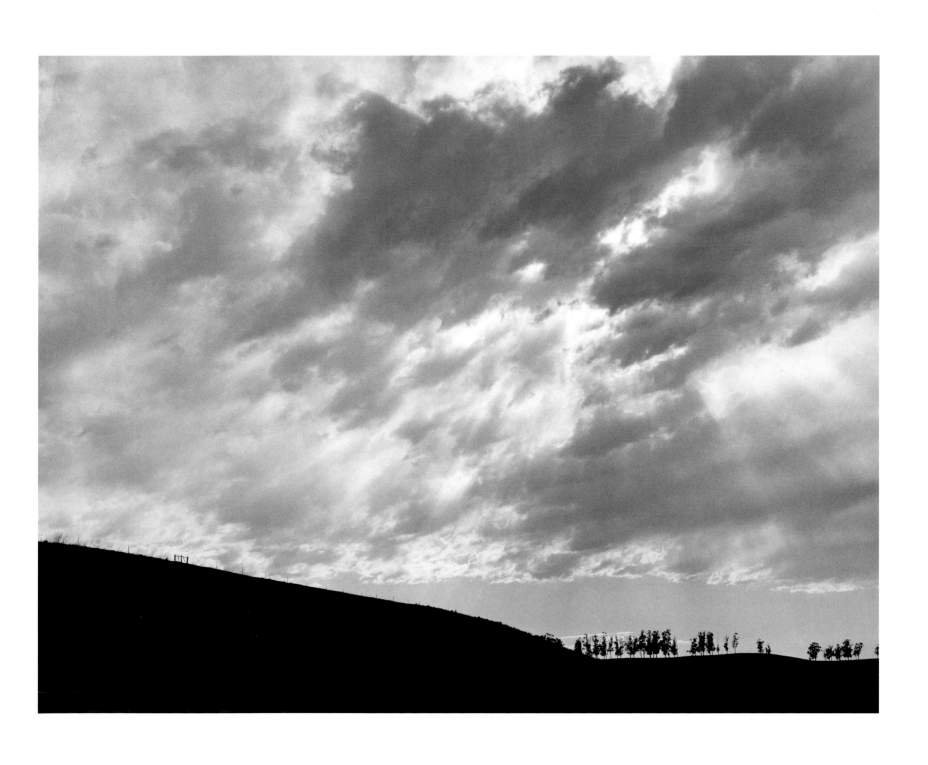

93 *LANDSCAPE, SOUTHERN CALIFORNIA 1970*

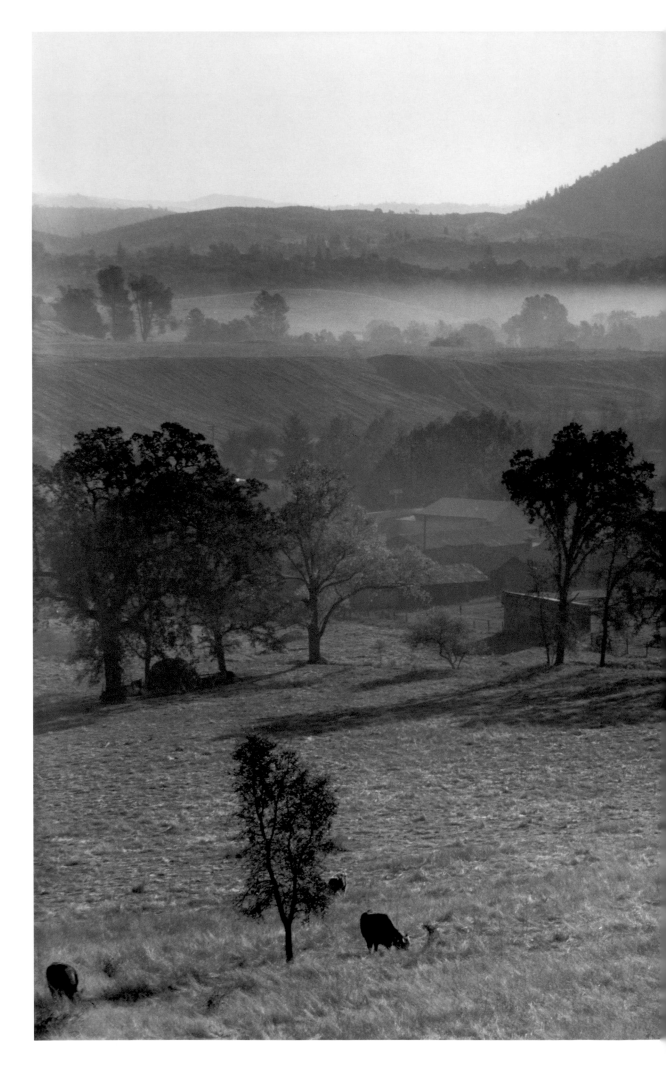

LANDSCAPE,
JACKSON,
94 CALIFORNIA 1948

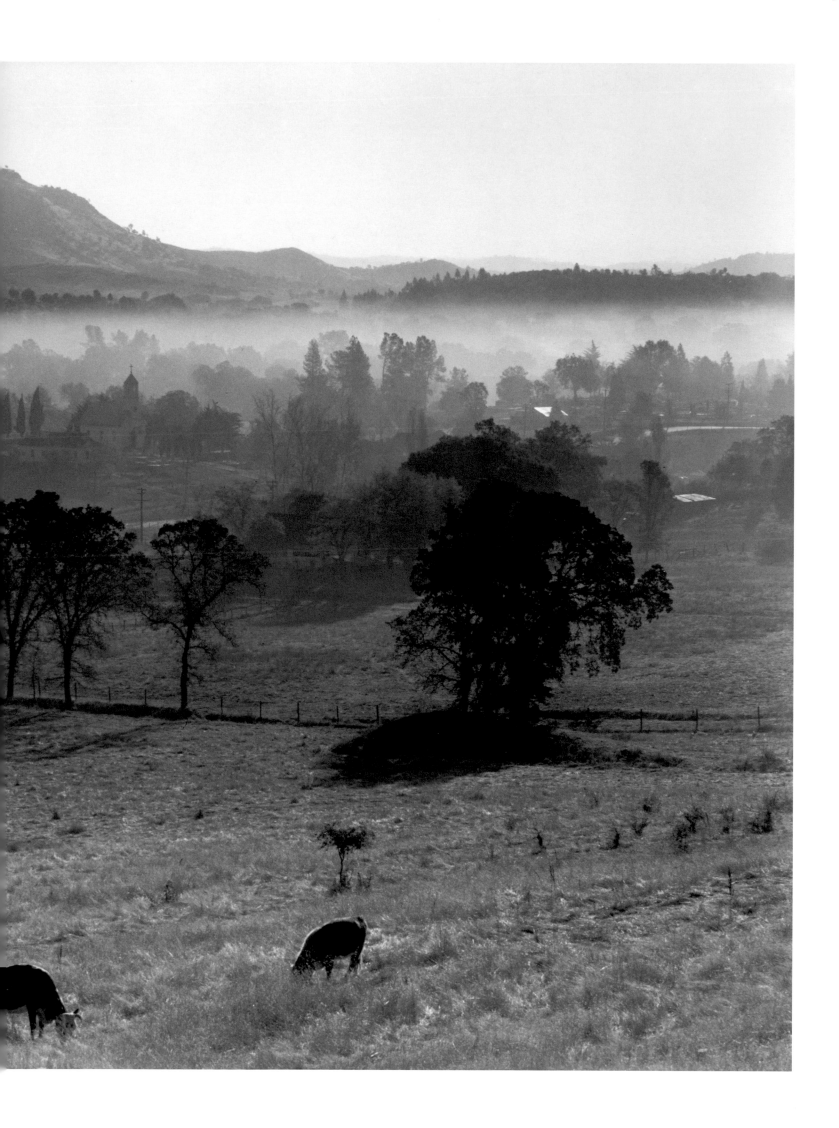

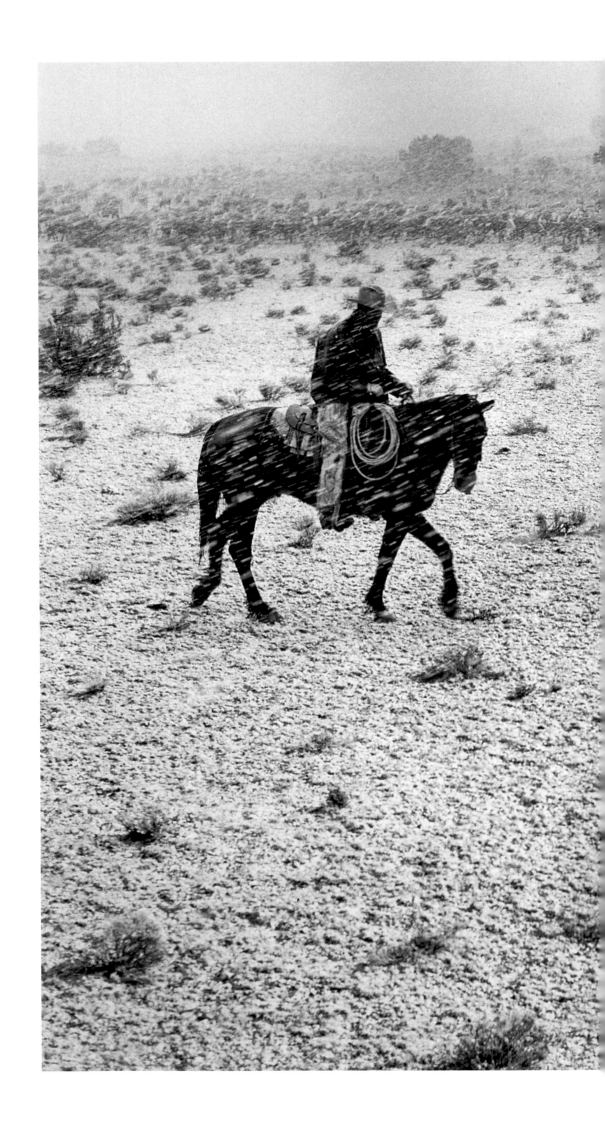

COWBOY, ARIZONA 1957

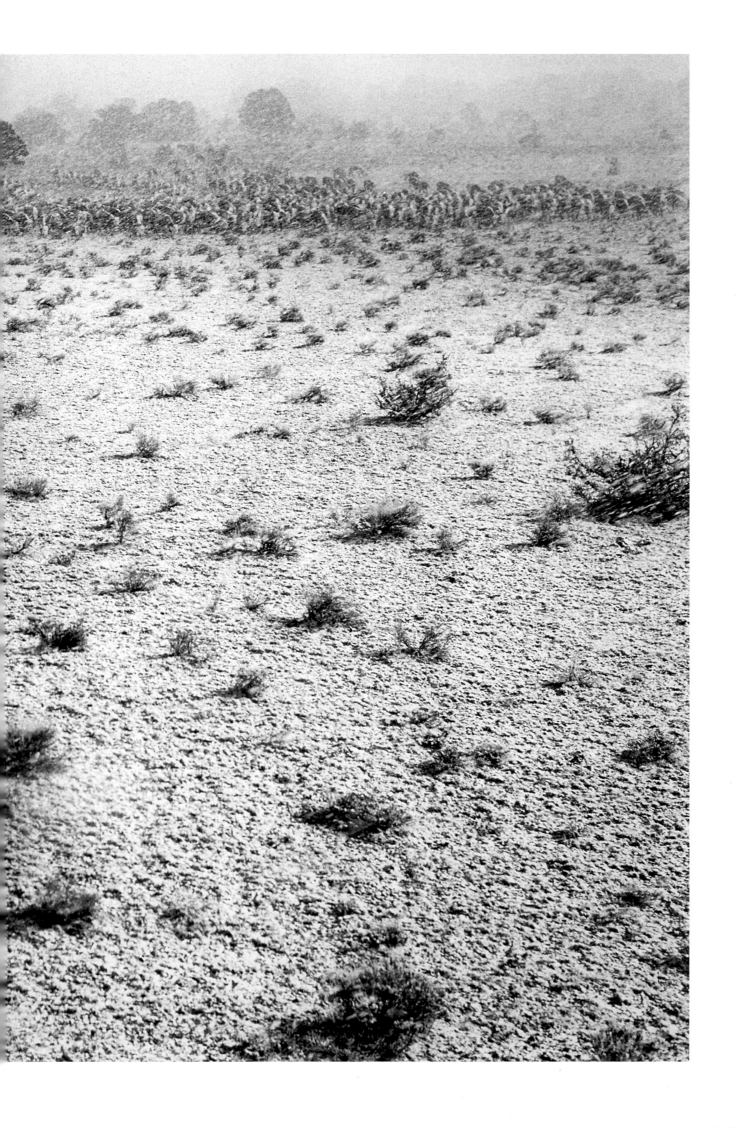

RECONCILING CALIFORNIA
THE REDISCOVERY OF PIRKLE JONES

I would rather make photographs
without thinking and suffer the consequences.
Pirkle Jones

To live and work as a photographer in California is to necessarily confront the visual legacy of the great California photographers such as Edward Weston, Ansel Adams, Imogen Cunningham, and Dorothea Lange. To live and work as a photographer in California and to have befriended and collaborated with these photographic luminaries is

to also necessarily seek out one's own pictorial strength, and to effectively emerge from the long shadows of their public and visual reputations. Such has been the predicament faced by Pirkle Jones.

To visit Pirkle's home in a wooded canyon in Mill Valley is to return to a California that recalls and still embodies the ethics and ideals born in the sixties, nurtured in the seventies, reviled in the eighties, and rediscovered in the nineties. The house is as much sculpture as it is architecture, an extension of the land around it that quickly evolves from forest floor to canyon. Intersecting wooden beams and panes of glass blur the boundaries between what is inside and what is out. Concrete floors terrace out toward the lichen-covered

boulders that punctuate the meandering pathway to the front door and give way to the angular jut of a rear redwood deck, hovering over a stream bed far below. The dramatic heave of the terrain allows the house and its inhabitant the luxury of existing half grounded on the pine and manzanita forest floor and half perched amid an oak canopy. Suspended between two worlds and intimately involved in each, the house yields more than a subtle clue to the character of the artist who built it.

Pirkle Jones has been taking photographs for more than sixty years. Yet, generally

speaking, it is rare for any two people to characterize his work or the influences on it in the same way. Some dismiss him as an acolyte of Weston and/or Adams: a consummate technician covering familiar ground. Some see his work as a reflection of the social conscience of Lange: didactic and socially driven. Some acknowledge the debt owed to both of these camps yet fail to look further. To understand the full range of Pirkle's images and the issues that have continually interested him, however, it is necessary to acknowledge a complex and idiosyncratic visual sensibility. And, while this sensibility may have been informed and abetted by those whose work is better known, Pirkle's

images have, nonetheless, a strength and conviction that is visually sophisticated, intellectually grounded, emotionally charged, and unique. Pirkle's experiences and the breadth of his work act as a visual journey through the cultural, political, and social history that informs the way we relate to the climate of California. But Pirkle's pictures also usher us into the realm of his personal musings on art and photography, and the manner in which they function, both inside and outside the art world.

Pirkle's professional career was fostered through the Pictorialist salon and regional camera-club system. He was mentored by Ansel Adams and Minor White (both with whom he later collaborated), involved with social and political causes (fueled by personal conviction and by his work with Dorothea Lange and with his wife Ruth-Marion Baruch), and bolstered by the fertile and dynamic social and art-making environment of the San Francisco Bay area. The photography of Pirkle Jones is

99 (TOP) ANSEL ADAMS AND EDWARD WESTON, WILDCAT CREEK, CARMEL 1952 (BOTTOM) MINOR WHITE AND PIRKLE JONES, 129 24TH AVENUE, SAN FRANCISCO, NEGATIVE BY F. W. QUANDT 1947

not to be taken lightly. The authority of his images lies not in their ability to conjure associations with the work of artists past, but in their ability to employ a familiar vocabulary in order to achieve an independent, cohesive, and emotionally vital body of work.

I am not concerned about style for style's sake.
Style is as natural as breathing.
If you are true to yourself, you'll be original.
Pirkle Jones

Pirkle first encountered San Francisco in 1942 on his way to the Pacific Theatre of Operations during World War II. His attraction to the city was cemented when he moved there to attend school following his tour of duty, and his ties to the region have remained unbroken ever since.

As was the case with many artists following the war, Pirkle took advantage of the newly defined G. I. Bill to further his education. Although he had been accepted by the well-established photography program at the Art Center in Los Angeles to study with Will Connell, Pirkle chose to shift his sights northward. In 1946, Ansel Adams, by then arguably the most renowned photographer in the country, pioneered a photography program at the California School of Fine Arts in San Francisco. Pirkle was among the first class to attend. His decision had a far-reaching impact. Not only did it bring him

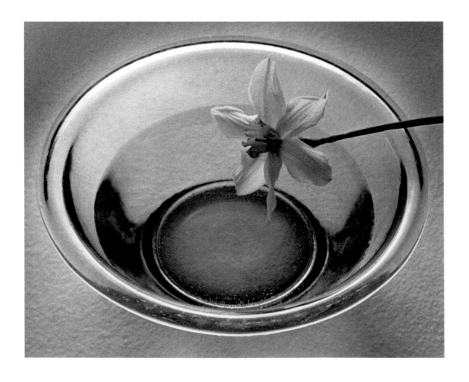

into the world of Adams, Weston, Lange, and White, it also established him within a community and an artistic tradition that would help define both his vision and his career.

The students in Adams's inaugural program brought with them a fairly established record of technical and artistic experience. They included, among others, Al Gay, Rose Mandel, Dwain Faubion, Frederick William Quandt, and Ruth-Marion Baruch. Pirkle was no exception: prior to his military service—during which he did no

photography—his images had been published and exhibited internationally in the Pictorialist organization's and camera club's salons and periodicals.

These early images, made while living and working in Lima, Ohio, are consistent with those of many artists of the time who sought to reconcile the traditional Pictorialist representations with the demands of a rising Modernist aesthetic. *Narcissus at the Pool,* one of Pirkle's most published and recognized images from the period, largely owes its success to the delicate negotiation of the tensions between the two schools of thought. Set within an undefined and flattened space, the photograph depicts the natural form of a flower counterbalanced by the abstraction of a water-filled, elegantly machined, industrial glass bowl. This interest in ambiguous spatial allusions and the dynamic of figure/ground relationships is further asserted in *The Champion* (page 121). In a sparse composition similar to that of *Narcissus,* a diver is liberated from the constraints of gravity and hovers, dissociated from time or space. Only the angular projection of the diving board, jutting from the right edge of the picture, lends a familiar or experiential context to the figure. In other early images, Pirkle eschews the figure altogether and foregrounds texture in a manner that recalls both the lighting techniques and the examination of design in commercial images by Edward Steichen or Gordon Coster. *Corn in the Crib* merges Pirkle's interest in patterning with a keen awareness of reciprocity: the cunning alternation of lights and darks, solids and voids, regularized rhythms and random textures. Arranged layers of the corn cobs' vegetal forms taunt the flowing grain of weathered wood slats, both punctuated by impenetrable black shadows; the image is solidly built, constructed from bottom to top. The result is a familiarized abstraction grounded in rural experience and nature, yet it achieves a purely modern photographic and pictorial statement.

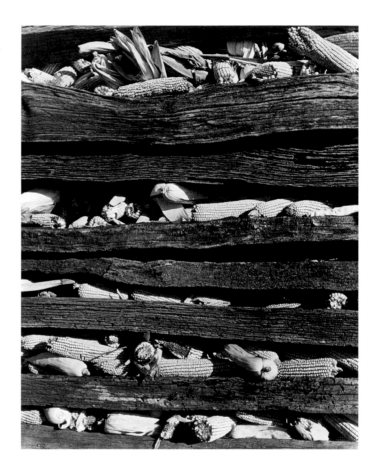

During the first year of his newly sprung photography program, Adams had already begun to feel the time constraints of teaching on his personal work. He had recently received a Guggenheim Fellowship, and was eager to pursue his own projects. On the

recommendations of Nancy and Beaumont Newhall, Adams recruited Minor White as the principal instructor and director of the program. In addition, Dorothea Lange drafted Homer Page, who began teaching 35mm and 2 1/4-inch format techniques to expand on

the view-camera exercises that had been offered by Adams, and then by White. Lange herself joined the staff to teach seminars, as did Imogen Cunningham, who taught courses, and there were frequent trips to Carmel to learn from Edward Weston. This augmentation of instructors, each with their own styles, influences, and strengths, proved to be liberating for Pirkle. The introduction of the smaller-format camera techniques, in particular, would effect his subsequent work for the duration of his career. Pirkle remembers the experience as "a rather rich group of people, spiritually rich, that I worked with."[1]

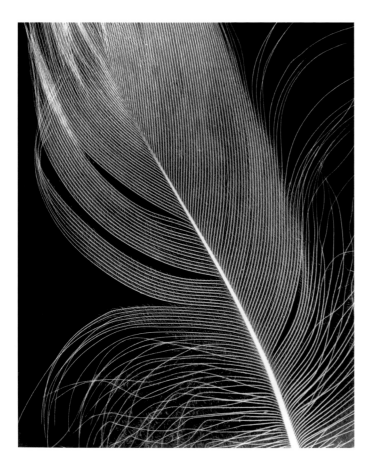

Although Adams was no longer a daily fixture at the school, he was never absent from the essence of the program and its nucleus of students and teachers. Pirkle worked as Adams's assistant from 1948 to 1953, processing film from Adams's Alaska trips, and assisting in the preparation of his "Portfolio I" in 1948 and "Portfolio II" in 1950. But far from simply enjoying an employee/employer relationship, Pirkle and Adams shared a bond that would remain constant throughout the span of their careers. In 1949, when Pirkle married fellow student Ruth-Marion Baruch, the wedding was held in Adams's Yosemite home. In 1952, Adams endorsed Pirkle's work in an article written for *U.S. Camera*, writing of the "strong personal expression and conviction underlying all of his work.... Pirkle works with precision and patience. These attributes reflect a quality proof personality and devotion to his art."[2] And in 1968, Adams encouraged Pirkle to issue his own "Portfolio Two,"[3] for which Adams also wrote a foreword:

(TOP) NANCY AND BEAUMONT NEWHALL, SAN FRANCISCO 1947 (BOTTOM) FEATHER STUDY 1939

I think that Pirkle Jones is an artist in the best sense of the term. His statement is sound and resonant of the external world as well as of the internal responses and evaluations of his personality. His photography is not flamboyant, does not depend upon the superficial excitements. His pictures will live with you, and with the world, as long as there are people to observe and appreciate.

Adams also conscripted Pirkle to teach at his Yosemite Photography Workshops: intense eight- to ten-day regimens that regularly attracted a diverse group of students with all grades of expertise. Ultimately, he was responsible for Pirkle's involvement in a commercial commission for Paul Masson Vineyards. The winery had wanted Adams to document the building of their new facilities in Saratoga, in 1958, which had been designed by architect John Bolles. Adams did not have the time, and so subcontracted the job to Pirkle, who, coincidentally, was then taking photographs for Bolles to document the construction of his Candlestick Park—a new baseball stadium for the San Francisco Giants. During the course of the Paul Masson project, however, the winery decided to expand upon its original intentions, and Adams became more directly involved. The two photographers decided to supplement Pirkle's existing architectural photographs with images of the workers involved in the making of wine, and of the wine-making process itself, and the final structure of the project took form. The result, which was not finalized until 1963, was an expanded essay, suitable for both exhibition and publication, titled "Story of a Winery." Upon its completion, Adams wrote a letter to the president of Paul Masson Vineyards, Otto E. Meyer, to voice his concerns about the commercial nature of the project. It read, in part:

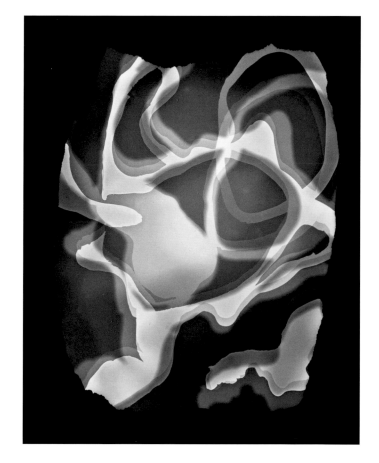

The Exhibit is in a class by itself; it is not a purely "creative art" show … but is a functional project in which photography was used (we hope imaginatively) to express an idea and reflect an industrial "situation." This is a very important use of

photography and I think it is successful. But it is an objective project—not a subjective one. It is questionable that it should be considered as something that it is not. It is a very healthy and honest use of the medium. But neither Pirkle nor I would assume it to be an example of free and experimental *personal* expression![4]

As a whole, the essay is, admittedly, a romanticized depiction of the laborers and the process of wine-making. The situations often seem staged, the workers stiff, and many of the rural situations lifted from a Currier-and-Ives conception of agriculture. The response from the public, however, was enthusiastic:

> Now this is blatantly commercial, of course—note that it is the story of 'a' winery—and one can assume that the collection was created by commission. Yet if one rejects a few of the more obvious advertisements, what remains is fine art and fine Adams and Jones.[5]

Yet, Pirkle's "pre-exhibition" contributions—those that document the construction of the facility and its architectural forms—stand alone, extending the approach he had begun to refine in prior commissions. As early as 1947, Pirkle worked with Minor White and Al Gay to document the architecture of Bernard Maybeck. By the time of the Paul

Masson essay, he had already photographed such high-profile architectural projects as the expansion of Stanford University (1949), and the construction of the Tidewater Associated Oil Refinery (1956–1957), Candlestick Park (1958), and IBM Headquarters in San Jose (1958–1959). With each assignment, Pirkle's propensity and facility for finding order amidst the chaos of modern building is expanded, his evocations of and attention to the human scale against such architectural enormity undertaken with greater authority.

In particular, Pirkle's rendering of the industrial components of the Tidewater Oil Refinery signal a sensibility akin to Piranesi as much as they recall that of Charles Sheeler or Edward Weston. His use of suspended figures that punctuate both the Tidewater and the Paul Masson essays could easily be compared to earlier work by artists

such as San Francisco's Peter Stackpole, were it not for Pirkle's already established, demonstrable concern for the ambiguities of figure/ground relationships (as seen in *The Champion*), and his use of daring, even baroque design elements against which the figures play.

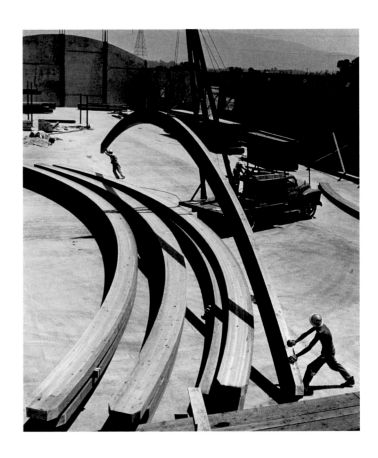

Beyond the strengths of Pirkle's and Adams's single images, "Story of a Winery" was intended as a collaboration, the product of two visions merged into a single affirming statement. The essay was accomplished, however, in a manner more disjointed than the word "collaboration" might imply. Whether or not it was affected by the inherent commercial nature of the project, what had begun as one idea became transformed and adapted into something far different, and the results, when compared to the artists' other joint ventures, do not always measure up.

It is important to document before change is made …
to make a record of what no longer exists.
Pirkle Jones

Much earlier, in 1953, Adams had worked with Dorothea Lange on an essay and potential exhibition about the Mormons in Utah for *Life* magazine.[6] Neither artist was particularly pleased with the process or its outcome, and for a time the experience soured Lange and Adams's relationship, quelling any promise of future collaborations. Because of it, Adams declined to participate in another project when Lange proposed it in 1956. It was therefore Pirkle to whom she approached with the offer.[7]

Lange had already sold the story, again to *Life* magazine: a photographic documentation of the final year in Napa County's Berryessa Valley, which was slated to be flooded upon the completion of the Monticello Dam. For Pirkle this was an unparalleled opportunity to work on an even par with a photographer whose work ethic and powerful images—solidified under the auspices of the "alphabet agencies" of the New Deal—were legendary. He remembered it as "one of the most meaningful photographic experiences of my professional life."[8]

LABORERS MOVING CURVED BEAM, PAUL MASSON WINERY, SARATOGA 1958

Lange and Pirkle began work on the project with no preconception of what the form or the outcome of the story would be. They simply began to frequent Berryessa Valley and take pictures, responding to each situation as it presented itself. Though they would usually go to the valley together, they worked fairly independent of one another. At times, they would cross paths at a common location and yet produce vastly different impressions of a similar theme. Pirkle remembered, "Dorothea always had a purpose for her photographs." Lange's images, while contributing to the nature of the story, are not limited by the story

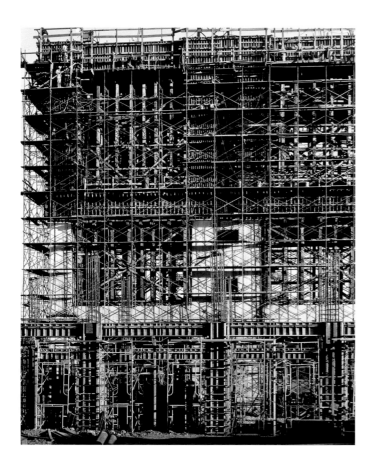

itself. Pirkle worked with less regard to the final outcome of the essay, and responded strongly to the people, places, and emotions that he encountered as he became more and more familiar with the rhythm and soul of the valley and its inhabitants. Years later, he wrote of the experience:

"My response to the people and the events that unfolded as I photographed in the valley were influenced both by my background of living on a farm when I was a youngster and the sense of urgency that Dorothea and I felt as we worked to record the events of this last year in the valley…. We knew that we were seeing and recording for the last time—the orchards in bloom, the beautiful home with its mature leafy walnut trees, the McKenzie Store, the harvests of pears, grapes, and grain…."[9] Over the course of the year, Lange and Pirkle came to know and confide in each other. The respect that each held for the other's images and sensibility is obvious in the final project, and the consistent quality of the images and the cohesive manner in which they contribute to the story line often make it difficult to ascribe authorship.

Explaining the evolution from magazine feature to exhibition, Pirkle remembers: "On the 'Death of a Valley' project, Dorothea had received a thousand-dollar retainer for us to photograph on. We split that fee and the work was submitted to *Life* magazine with the understanding that if they used the story they would pay page rate. As you know, the story was not used and the right to it was returned to Dorothea and me."[10] Lange and Pirkle assembled the images into an exhibition (with an accompanying *Aperture*

publication) in 1960. The images met with both popular and critical success. The *San Francisco Examiner* wrote: "The photographs are superb in pictorial quality and likewise reaffirm, in a most dramatic way, the fact that photography is the art for the telling of a human story today."[11] Three years later, the images were still being hailed as "a record by Dorothea Lange and Pirkle Jones of the abandonment and inundation of California farmland doomed by the West's insatiable need for water, a story told in a series of moving poignant images…."[12]

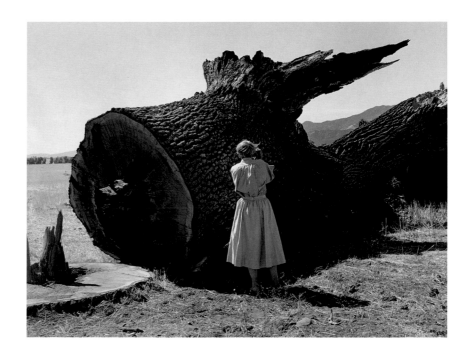

Pirkle later noted: "I think Maynard Dixon [California painter and Lange's first husband] had an enormous influence on her ideas of beauty and aesthetics. When referring to her work, however, she always tried to push any discussion of it in relation to beauty away."[13] This is not to imply that Lange did not have strong feelings about both beauty and art. In a handwritten (but not dated) note to Pirkle, Lange wrote:

> I have not used the words Art or Beauty. I have not spoken of Composition.
> To me Composition is the *strangest* way of saying what one wants to say.
> To me Beauty appears when one feels deeply. And Art is a by-product
> of an act of total attention.

By this or any definition, "Death of a Valley" is an essay of art, composition, and beauty. Its pacing is relentless, the tonal shifts that punctuate long stretches of narrative images immaculately timed, and the overarching mood sensitively orchestrated.

Pirkle's contributions to "Death of a Valley" encompass a vastly different sensibility than is evident in his images of Paul Masson Vineyards. It is unclear whether this is due to the divergent nature of the two collaborations, or the affinity he held for the rural way of life Berryessa Valley offered. What *is* clear is that Pirkle's depictions of the valley carry an empathetic mood and tone born of his Midwest background. Even those rare images

that, in retrospect, verge on the cloyingly prosaic (such as *The Grape Picker*, page 33) impart a directness and an honest respect for their subjects that is absent from "Story of a Winery." Mostly, his photographs attest to the free manner in which he extended his own aesthetic investigations as he explored the metaphor within the parameters of the project. *Larry Gardner with Dog, #5, Death of a Valley* (page 34) affords Pirkle the technical challenge of capturing his image in the searing white light of the valley while drawing an allusion to a dark primal being (the dog) carelessly stalking the simple life (the boy on his bike). More ominous, however, are the gaping black rectangles piercing the plane in *Open Graves (from above), Death of a Valley*, 1956, which formally recall Pirkle's prewar use of negative space even as they symbolically function as both invitation to and rejection of the vanishing way of life in the valley.

In "Death of a Valley," Lange and Pirkle achieved a balanced working and critical methodology that insured that both photographers as well as the final outcome of the project were served. Their collaboration blended two strong perspectives—often similar, though just as often divergent—with a fair and at times brutally honest negotiation for the benefit of the tone and narrative they constructed together. Pirkle would go on to take this attunement for collaboration to its most elegant conclusion in the work he produced in tandem with his wife—writer, poet, and photographer Ruth-Marion Baruch.

A photograph is not real.
The moment we make a picture we become political.
Pirkle Jones

Born in Berlin in 1922, Ruth-Marion immigrated to the United States with her family in 1927. She attended the University of Missouri, where she earned Bachelor degrees in journalism, literary criticism, and creative writing. It was during this period that she became interested in photography. She decided to pursue it, and went on to receive her Master of Fine Arts degree from Ohio University in 1946. Her graduate thesis—a critical examination of the work of Edward Weston—precipitated a stay in Carmel, where she moved into a small cabin near Weston's home while doing research. It was therefore only a matter of a northward realignment when Ruth-Marion returned to California to attend Adams's new photography school where she met Pirkle. Like Pirkle, she quickly joined the extended family that encompassed the students and instructors of the school, as well as a coterie of writers and poets to whom she naturally gravitated.[14]

Insofar as every marriage is a collaboration of a sort, Pirkle and Ruth-Marion were collaborators from the very beginning. Naturally, each brought their own unique sensibility to whatever they were doing, but they also chose to undertake projects together when the right situation arose. Their first such project was a still-unpublished children's book: *Felinimus and Twig*. The story of a cat and a bird, the book evolved from a series of writings done by Ruth-Marion for which Pirkle contributed images. The process can be characterized as an evolving call-and-response, each playing off of the other's contribution. Pirkle's images served both to illustrate and to draw out the resonance of Ruth-Marion's writings, which would themselves be extended in answer to the challenge of his images. In this way each partner maintained a creative individuality while contributing to the nature of the story. The importance of distinct artistic identities was something that both artists were very much aware of, especially when they began working together as photographers. They were mindful of being "lumped … as a team."[15] Not wanting to allow the public a perception of one having been taught by or less than the other, they consistently reinforced that each had gravitated to photography separately and had come together as equals.

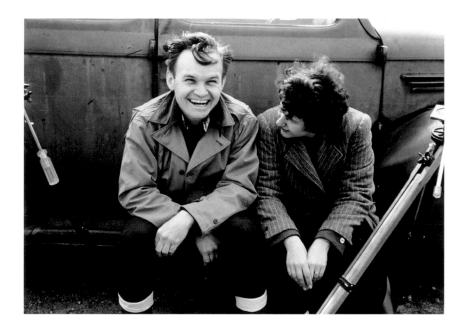

In 1961, while returning home from a trip to the Sierras, Ruth-Marion and Pirkle stopped to investigate a small town on California's Sacramento River, thirty miles south of the state capital. They were affected by the views afforded by driving along the levees, and found themselves drawn to the diversity of the people and the feel of the place. This was the beginning of their second collaborative project: "Walnut Grove: Portrait of a Town."

The images that comprise the "Walnut Grove" essay are evenly weighted for impact and sympathy. The essay is a masterful blend of formal ingenuity and humanistic restraint. The artists produced two equally tenacious and perceptive sets of photographs that are seamlessly woven together into a visual record that is as much about frame of mind as it is about subject. Isolating Pirkle's contribution to the essay, however, reveals a consistency of interest evident in his previous work: figure/ground relationships, formal ordering, and his

PIRKLE JONES AND RUTH-MARION BARUCH, POINT LOBOS, BY F. W. QUANDT 1948

use of contrasting tonal and textural elements. Additionally, his images of Walnut Grove imply and carry with them an increased metaphoric maturity that lends an indisputable authority to the mood of the story.

Pirkle's ability to layer implication within an exploration of formal concerns is most obvious in the images in which architectural studies hint at ominous threats; isolated figures wander empty streets; and alienated pedestrians precariously navigate a narrowing

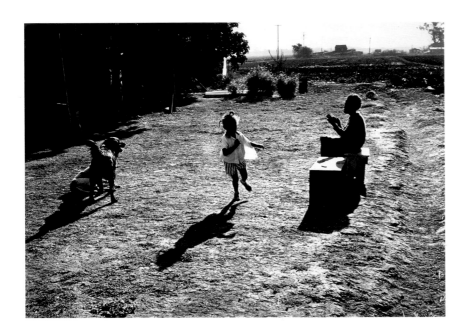

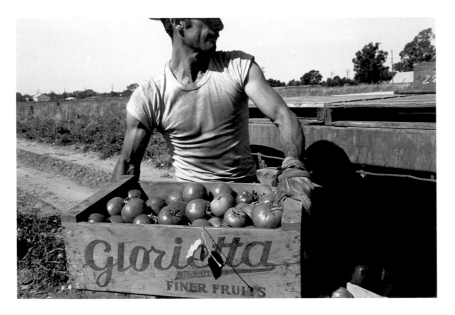

sidewalk (pages 46–51). Even during playtime, the raking shadows of late afternoon float down the dirt street and seem to shift the character of the playing child away from an expansive celebration of life toward a more somber paean to life already lived. As if in rebuttal to his own "Death of a Valley" image of a smiling grape picker, Pirkle proffers *Man Lifting Tomato Box,* 1961. The former image celebrates the bounty of the valley—a bounty that was to be artificially cut short—through the depiction of a worker, buttressed by verdant rows of vines, consciously offering the fruit of his labor to the viewer. The Walnut Grove worker's image plumbs a far different psychology. The land, previously fertile and rising in support of the grape picker, here gets relegated to a small sun-seared area— alienated from the laborer who twists from it, snatching his harvest away from the viewer onto a waiting truck. His cropped anonymity, vascular arms, and straining musculature do not so much celebrate as protect by threat the way of life of which he is a part.

The "Walnut Grove" essay marked an extended process of discovery for Pirkle through which a momentum, energy, and organic point of view began to emerge. The

(TOP) WALNUT GROVE 1961
(BOTTOM) MAN LIFTING TOMATO BOX, WALNUT GROVE: PORTRAIT OF A TOWN 1961

project was not self-consciously constructed around a preordained thesis; in this way it was similar to what Pirkle had undertaken when he worked with Dorothea Lange on "Death of a Valley." In fact, Pirkle and Ruth-Marion had sought Lange's advice during the course of photographing Walnut Grove. As they were contemplating the final form the essay would take, Pirkle recalled something Lange had told him: "Take a stand; at a certain point you must take a stand."[16] While this may have been the gist of her counsel, Lange also sent them the following penned thought:

Dear Ruth and Pirkle: This applies to your study of [Walnut Grove]? I am *very* interested in what you will bring out of this series, and would like to follow it, Love *D.*

Determinism. We no longer describe for the sake of describing, from a caprice and a pleasure of rhetoricians. We consider that man cannot be separated from his surroundings, that he is completed by his clothes, his house, his city and his country; and hence we shall not note a single phenomenon of his brain and heart without looking for the causes or the consequence in his surroundings. I should define description: "An account of environment which determines and completes man." In a novel, in a study of humanity, I blame all description which is not according to that definition.

Emile Zola in *The Experimental Novel*[17]

Once Pirkle and Ruth-Marion had begun work on the essay, the San Francisco Museum of Art committed to an exhibition. The accompanying text for the exhibition demonstrates both that they heeded Lange's counsel and took the Zola excerpt to heart: "An American town comes to a period of vacancy; it is a forgotten place; it must face a transition because its central reason for being has disappeared. This is the portrait of such a town."

Each in their own way, "Death of a Valley" and "Walnut Grove" stake political- and social-reform positions that question authority and admonish the abdication of personal responsibility. "Death of a Valley" uses images as memorials to ask, "What have you done?" while the "Walnut Grove" images function as witnesses, imploring, "What are you willing to do?" But it was not until the last collaborative essay that Pirkle and Ruth-Marion undertook that the political aspects of Pirkle's oeuvre reached their most overt, and ultimately their most confrontational, stand.

The "Black Panther" essay grew out of the couple's activist work with the Peace and

Freedom Party—part of an umbrella organization that included the Panthers—though the idea, contacts, and initial work on the series were Ruth-Marion's. The Black Panthers organized in October of 1966 and quickly became one of the most radical factions of the civil rights movement. The first point of their platform and program pointedly articulated the aim of the group: "We want freedom. We want power to determine the destiny of the black community." The call for black power reverberated in every part of the country; it did not go unnoticed by Ruth-Marion, who gained access to the organization through an introduction to Eldridge Cleaver's wife, Kathleen, a Panthers leader who invited her to one of their meetings in Oakland. Pirkle accompanied Ruth-Marion to the meeting, and the project was launched.

The "Black Panther" essay is a multilayered response to the most polarizing and explosive racial, political, and social phenomenon of the time, providing empathetic as well as humanistic overtones, and articulating the photographers' position as outsiders. They wrote:

"We photographed the Black Panthers intensively from July into October 1968 during the peak of an historic period, working within the Bay Area where the Black Panther National Headquarters is located. We couldn't possibly photograph all the aspects of this virile, rapid-growing and deep-rooted movement; but we can show you: This is what we saw, this is what we felt, these are the people."[18] The resulting images contain all of the elements that fed Pirkle and Ruth-Marion's earlier collaboration: capitalizing on a theme's

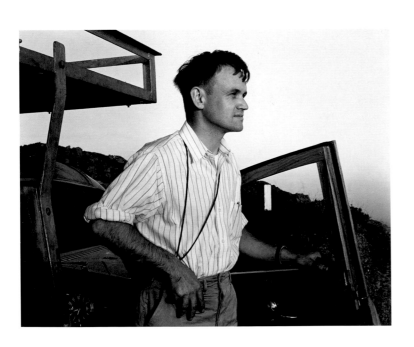

visual authority while maintaining each artist's singularity. The moral imperative of Ruth-Marion's humanist aesthetic remains consistent throughout the essay. It is bolstered by Pirkle's more psychologically charged portraits and situations, which provide the larger context for the story (pages 53, 56–57). Pirkle seems to have been concerned with the sweep of images that convey a more complete sense of an occasion or an event, whereas Ruth-Marion seems to search out moments and individual personality studies. Moreover, Pirkle's images work as counterpoints that save the project from becoming overly sympathetic and didactic, and therefore break the essay's heroic overtones and blatant appeals to the heart by occasional jarring moments—the bullet-riddled window of National Panther Headquarters (page 59), the charred exterior of a Panther stronghold in Oakland,

the depiction of an inflammatory headline, "Pigs Want War," repeated within a stack of bundled newspapers.

Each insight complements and depicts a common cause in which they both deeply believed, but the collaboration itself stands out in that it employed a far different working method. Instead of photographing and allowing the essay to evolve organically, they began the project with a clear idea of what they wanted to portray, and to what end. This self-admitted purpose was, they said, to "create a better understanding of the Black Panthers."[19] The essay was not merely a by-product of the merging of Pirkle and Ruth-Marion's perspectives, but of the Panthers' as well. While the "Walnut Grove" essay repeatedly utilizes emotional appeals and signals, the "Black Panther" essay, though undeniably sympathetic, displays a sense of restraint. Pirkle and Ruth-Marion acknowledged the inherently opposing political reaction that their essay engendered, but one gets the sense that great pains were taken to neutralize these emotions, bracketing them within universal themes of family, commitment, and hope for the future.

Pirkle recalled the obstacles that they had to overcome during the project:

A lot of people tried to talk us out of it. They said that it would be dangerous being around those people. At the start, there were problems. A lot of [the Panthers] didn't know what we were doing. But we didn't push it. We didn't go sticking our cameras in anyone's face.[20]

But they did not end there:

The director of the de Young Museum agreed to produce the show. But there were … threats of cancellation, political maneuvering. But … the show opened and perhaps 100,000 people came. The exhibition was then made into a book, published by Beacon Press, a non-profit press. It was sold for $2.95 in paperback, so more people could buy it.[21]

The exhibition met with generally favorable reviews, though many of the photographers' longtime supporters felt alienated by the subject matter, and not all of the responses were positive. A letter that Ansel Adams wrote to Pirkle reveals much of this disappointed sentiment, decrying the propensity of "really well-meaning people [to get] submerged with cleverly-designed propaganda in art/social/political (and other) fields."[22]

Freedom is something that you don't realize you have until you've lost it.
When you try to define it you get lost in a lot of words.
Pirkle Jones

In 1969, while leading a photography workshop with Ruth-Marion, Pirkle noticed the color and excitement that revolved around a section of the Sausalito waterfront known as Gate 5. Much as with Walnut Grove, Pirkle felt drawn to the harbor basin and its community of largely improvised houseboats and ersatz sailors because of its character and the wealth of visual interest. Beginning work on this new subject was "routine" for Pirkle in the sense that it echoed the processes he had followed with other endeavors: He approached Gate 5 "with an open mind."[23] He also, however, approached it alone; Ruth-Marion never understood the enthusiasm and interest that Pirkle had for the band of artists, writers, and free spirits for whom the marina was home. Pirkle's solitary, almost daily return to the area over the next two-and-a-half years resulted in an extended series of images in both color and black and white.[24] The result is telling: It marks a subtle shift in sensibility for Pirkle in that prior to his involvement with Gate 5, his work had always been undertaken from the vantage of an "outsider"—no matter the depth of his commitment to a project, he maintained a respectful, and critical, distance. This changed at Gate 5.

For Pirkle, Gate 5 was a foreign place open to exploration, a submersion into the exotic. Working at Gate 5 provided an opportunity to participate in the impromptu sequences of shifting tableaux that passed for daily life, an ever-changing performance piece. His intimate association with the people, the place, and its seductive openness established a new methodology that was intrinsically different: Pirkle was approaching the project as an insider. The energy that this new psychological and philosophical position generated was reinvigorating. He remembers the project as "a shot in the arm," and that he "never wanted to cut it off."[25]

Speaking within the context of the experience, Pirkle also noted, "it is not enough to do one photo of something … you want more and more. But one must be very brutal and cut it off, as with a knife." It is interesting that the terms with which he described the essay are similar to those one might use when referring to an addiction. Pirkle felt drawn to the "outlaw" nature of the place, and became infatuated with the life, the people, and the social, sexual, spiritual, recreational, and creative experiments that were constantly evolving.[26] While his earlier contributions to projects are perhaps more elegant in their restraint, noble in their point of view, or critically driven in their intent,

the images that came out of Gate 5 convey a sense of unbridled joy, a tender wildness, and a new exuberance through which to photograph.

While Pirkle's acceptance among the "pioneers" who lent Gate 5 its character and from whom its iconoclastic reputation was earned[27] recalls the collaboration between artist and subject that began in the "Panther" essay, Gate 5 was not an experience born from a political or social commitment. Putting aside Dorothea Lange's earlier advice that a photographer must "take a stand," Pirkle worked outside the constraints of social metaphor and allegory, and relied instead on humanity and humor. The portraits that dominate his "Gate 5" essay are imbued with a sensitivity and intimacy that preclude judgment or criticism. They access a presentness, a sense of experiencing and celebrating the moment without regard to issues, statements, or agendas.

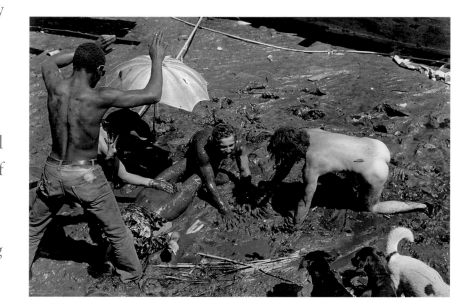

Pirkle's studies of Gate 5 do not shy away from portraying the full range of existence on the waterfront. Every aspect of life is equally weighted in the sweep of the project: the spiritual and the sensual, the private and the communal, the playful and the lethal. His discerning rendering of Captain Garbage—before and after his "mud wedding" to the lovely and alluring Thunderpussy—chronicles the swaggering self-assurance of a cocky iconoclast (page 63) in contrast to the juvenile glee of an earth-encrusted satyr enjoying the ceremony. Even the manner in which the overdressed county officials are pictorially forced to "walk the plank" as they survey and inspect the community is less an indictment than a humorously affirming comparison to the live-aboard community (page 115). But perhaps most important, the story of Gate 5 is less the study of a lifestyle in the aggregate than it is an accumulation of personal moments and

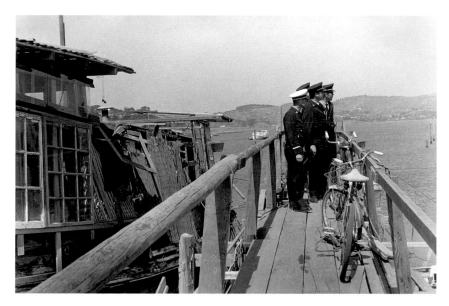

(TOP) MUD WEDDING, GATE 5, SAUSALITO 1970 (BOTTOM) INSPECTORS FROM THE MARIN COUNTY FIRE DEPARTMENT, GATE 5, SAUSALITO 1970

epiphanies which, when strung together, reveal as much about the photographer as his subjects.

Constantly asserted within these character studies is the urgency of Pirkle's interest, and his ability to order illustrated elements and thereby infuse them with personal meaning. He selects and constructs intimate still lifes as if building altars at which to reaffirm his own reliance on the photographic image. In the essay, Pirkle's innate sense of composition and instincts toward organic beauty are brought to bear on algae-draped tangles of ropes and power lines, the sensual overlay of medallions, chains, and shells across the breadth of a naked male chest, and a random collection of personal artifacts unabashedly laid bare. Each is a vital assertion undertaken with a bolstered sophistication.

Yet, in centering less on the external and more acutely reflecting his own emotional state, Pirkle's photographs from Gate 5 exist mostly not as subjective interpretations, but as reflections of a spiritual, emotional, and psychological sense of self. It is this shift in approach that allowed Pirkle to readdress nature—a subject he had never abandoned, but one that he could now comprehend in a manner far different than he had done in the past. Ultimately, Pirkle's obsession with Gate 5 provided him with a new sensibility from which to explore his environment and the California landscape.

I see photography from many directions.
For me this art is an expression of my inner self,
and I've never narrowed my work down to
just the highly creative, interpretive category.
Pirkle Jones

Pirkle's connection to nature and his environs has been a consistent thread over the course of his career. His relationship to them, however, deepened and broadened through his maturing interests in and evolving interpretations of photography. Beginning with even his earliest salon images, a connection to nature is obvious, if only in its use as subject. Pirkle's affiliations with Ansel Adams, Edward Weston, and Minor White further enriched his appreciation of the visual potential of the landscapes of San Francisco and Northern California: These were his laboratories and his refuges. His experience of San Francisco and its inhabitants, as well as the natural wonders of the California landscape, became sources of his "art" photography. His images of these subjects were often included in museum and gallery exhibitions and publications, and at length they formed the leit-motif of "Portfolio Two" (pages 15, 22–23, 33, 89, 94–95, 96–97).

The portfolio, a selection of twelve of Pirkle's most recognizable images from his artistic career to that point, met with enthusiastic reviews: "Jones has an eye of his own for familiar San Francisco vistas.... And his landscape of Jackson, California—in all its pictorial diversity, imagination, and unity—is a masterwork worthy of Ansel Adams ..."[28] The comparison with Adams, however, was not always made with positive appraisal. Photography historian and critic A. D. Coleman praised the distinction of Pirkle's aesthetic but astutely states the dilemma:

Despite the obvious influences on his work—Ansel Adams and Edward Weston predominantly—Jones is becoming his own man; nevertheless, I can't help wishing that he (and countless other West Coast photographers) could look at a California Beach and find something more than those pictures Weston either overlooked or decided not to take. Individualism consists of more than filling in the gaps in someone else's aesthetic.... Jones appears to be fighting his way out of the paper bag of Weston-Adamsism, but strong traces can still be detected.... Jones is in the process of developing his own synthesis of these two styles; at its best, the result is fascinating.... Jones is much more than just another acolyte.[29]

Pirkle's picture-making approach that informs "Portfolio Two" was forever altered by his experiences and discoveries at Gate 5. However, it was a subsequent series of images taken while haunting the small weekly bazaar in Marin City that made possible the ultimate shift that was to occur in his imagery.

While the flea market images work as a palate cleanser of sorts following the ideological intensity and the glare of the political and social spotlight ignited by the "Black Panther" essay, many of them return to the purely visceral and retinal concerns of Pirkle's earlier preoccupations. His use of repetitive visual elements can be traced as far back as his Pictorialist salon days (page 75). His isolation of evocative scenery and the random placement of objects in the vendors' stalls and booths holds a more immediate resonance to both the "Panther" and "Gate 5" series (page 71). New to the mix, however, are images that overtly explore the ambiguous nature of the picture plane and the expressive qualities of surfaces, textures, and tones as pure abstractions (pages 72–73). This time, Pirkle photographed from the fringes, recorded the margins, and glamorized the disenfranchised. The crucial difference lies in that of his subjects: Instead of depicting them as primary carriers of meaning, they were only of interest to Pirkle insofar as they act as vehicles of

expression for an internal emotional state. This sensibility, which had begun to be evident in the "Gate 5" imagery, strengthens in the flea market images and would dictate Pirkle's approach to photography from here on.

Pirkle cites an exhibition from 1946 of Paul Strand's work at the San Francisco Museum of Modern Art as an influence on his nature photographs, and ranks Strand and

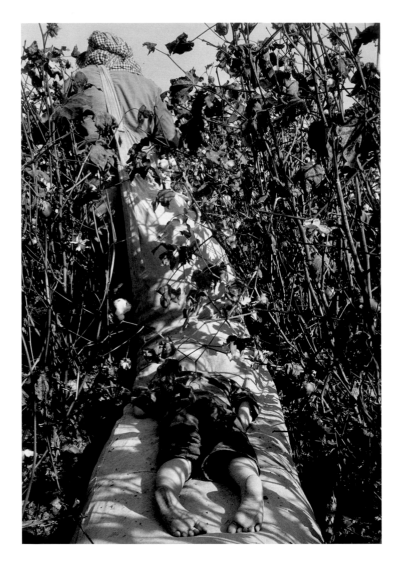

Edward Weston as the two preeminent American landscape photographers. He has reflected that it is "easy to be seduced by nature"[30] but very difficult to make photographs that spring from a truly personal vision. After his flea market sojourns, Pirkle began to reevaluate his ability to photograph nature as he started to see things that he felt were original, his own. He explains: "When you go into an area everything is attractive … you don't want to edit on the spot."[31] The challenge for Pirkle was to see if he could make something out of the chaos—something never before seen.

Beginning in 1978, Pirkle aggressively rose to the task. The resulting "Rock" series was quickly followed by the "Salt Marsh" series, and then by the much longer and localized "Mount Tamalpais" series. Each seems to build upon its predecessor; Pirkle notes, "After all these years I [had] finally found some things in nature in which I could find some satisfaction.… Images that I feel are my own."[32]

The "Rock" series was about "finding the image; seeing and organizing.… No sooner would I finish one than I would turn and there would be something else for me."[33] The series is a lesson in abstract composition, and an uneasy balance of tonal and textural weights constantly shifting from top to bottom and side to side (pages 78–79). The "Salt Marsh" images are equally abstract—dissolving contextual references and contrasting attenuated and calligraphic vegetal elements with intense light and deep shadow—though they are innately more expressive (pages 77, 80–81).

While both the "Rock" and "Salt Marsh" essays were accomplished with a 35mm camera, Pirkle began his visual exploration of Mount Tamalpais with a view camera. The more cumbersome process resulted in images that reflect a discernible shift in aesthetic concerns. From a purely technical perspective, greater time and effort were necessary for each image, and the images are, in turn, more studied and reflective.

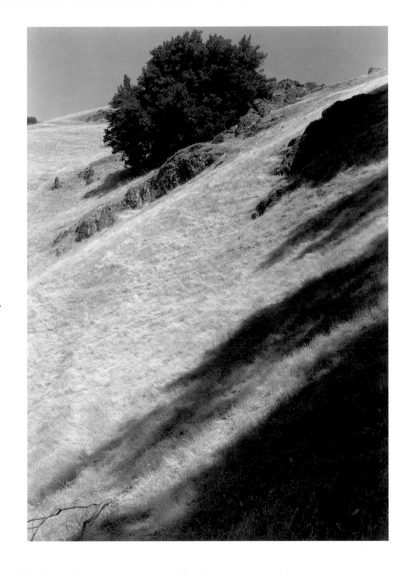

What is perhaps of most lasting significance is the fact that Pirkle's approach to Mount Tamalpais in particular and to his later studies of nature in general was one of introspection. Whether concentrating on the smallest of textural details, isolating anthropomorphic stretches of tree limbs, or extending his vision to include broad expanses of rolling hillside, the images exude a tension between abstraction and verisimilitude, an external correspondence coupled with an unspoken personal inference. In a manner that recalls Alfred Stieglitz's "Equivalents," Pirkle sought to achieve in these images an expression of his subconscious and spirit, and his photographs, in turn, elicit from nature an approximation of the inner man. The photographic interpretation of the world "out there," therefore, is only valid in as much as it is an accurate expression of an internal awareness and the product of a delicate collaboration between nature and the artist.

Timing is everything when working collaboratively.
Pirkle Jones

Pirkle Jones has produced an astounding body of work over the course of his career. His images are part of the finest private and institutional photography collections in the country. His friends and colleagues number among the most renowned figures in

photography. And yet, whether in spite of these affiliations or because of them, he has battled anonymity in the broad sweep of photographic history.

To trace the evolution of Pirkle's photographs and the sensibility that shaped them is to encounter a visual strength and pictorial conviction born of rigorous self-evaluation. His keen sense of reflection has always allowed him to learn from his experiences and from those around him. Pirkle Jones is the rare artist who has both the ability and the facility to be open to collaboration. If one were to dissect the influence of Pirkle's collaborators and subjects, it might be said that Ansel Adams was the key to the visual; Dorothea Lange to the political; Ruth-Marion Baruch to the intellectual; the inhabitants of Gate 5 to the interpersonal; and nature to the spiritual. By his own admission, Pirkle sees himself aligned with Adams in his celebration of technical mastery, and with Weston in seeking order in chaos and the erotic in the erratic. He rejects the segregation of one type of image-making from another, however, in his pursuit of photography that succeeds in merging technical expertise with content, and captures an emotional and expressive authority.

Throughout his career, Pirkle's images have met with success and recognition through an array of mediums—commercial, documentary, and "art" photography. This, perhaps, is the key to the general misperception of Pirkle's work. His is not an oeuvre that is easily classified. All the more reason to understand and celebrate it.

—Tim B. Wride, co-curator,
Pirkle Jones: Sixty Years in Photography

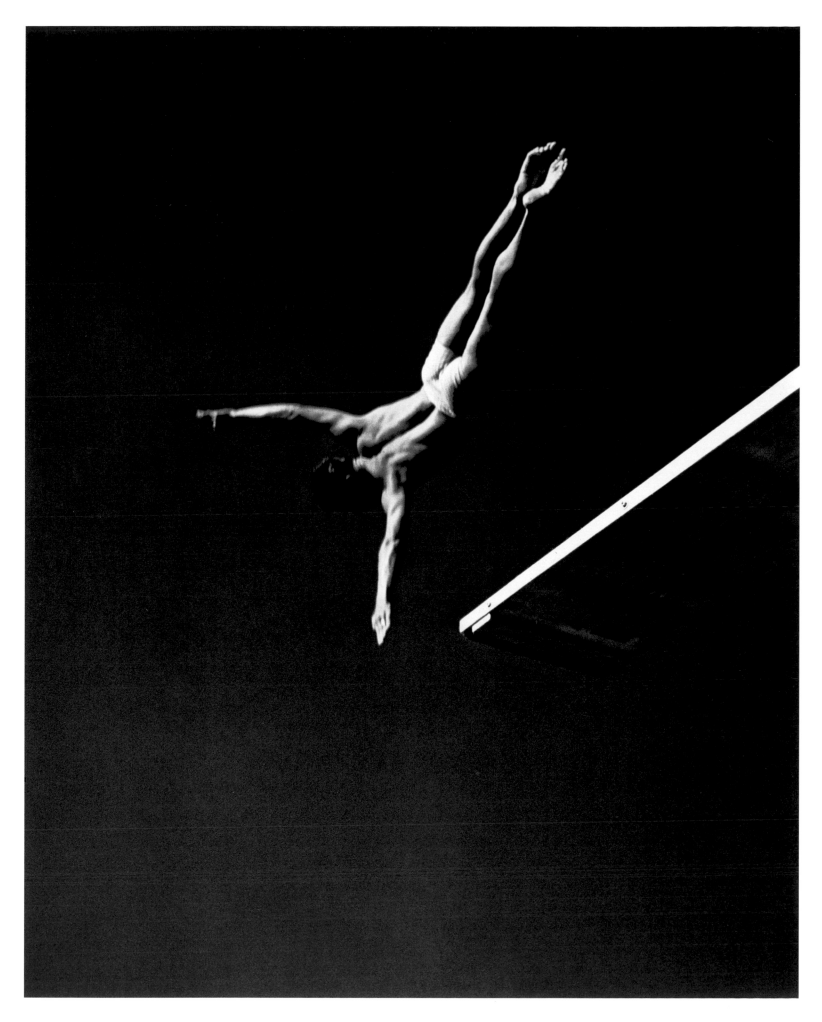

121 *THE CHAMPION, LIMA, OHIO 1939*

ACKNOWLEDGMENTS

The author would like to thank Aperture, and especially Phyllis Thompson Reid for her insight, patience, and persistence; Karen Sinsheimer, Curator of Photography at the Santa Barbara Museum of Art, whose confidence led to my involvement in the project; Dale Stulz for insights into Pirkle's work; Richard delle Fave and Eric Holmgren for their friendship and hospitality; and Kate Palmer for her unflagging optimism and invaluable contributions.

Jennifer McFarland is singularly amazing: her organization, humor, dedication, and expansive spirit have made this project both a joy and a privilege. And finally, there are no words to express the gratitude, respect, and admiration that I hold for Pirkle Jones. He is a friend and an inspiration.

For Matt.

—Tim B. Wride

NOTES

1 McKenzie, Bob. "Demise of Berryessa Valley recorded in photography." *Napa Register* (July 24, 1994), 4C.

2 Adams, Ansel. "Pirkle Jones: Photographer." *U.S. Camera* (October, 1952), 42.

3 "Portfolio Two" is so named because Pirkle had completed an earlier "portfolio"—consisting of two works, *Breaking Wave* and *View of San Francisco*—that was commissioned by the Bank of America to be presented to each delegate of the U.N. on the 10th anniversary of its founding.

4 Carbon copy of a typewritten letter from Ansel Adams to Otto E. Meyer at Paul Masson Vineyards, February 28, 1963.

5 Kay, Kent. "Photographers Tell Story of a Winery." *San Francisco Chronicle* (June 9, 1966).

6 Though he and Adams never spoke of the chain of events that led to his collaboration with Lange, Pirkle believes it was Adams who suggested to Lange that he would be the correct partner in the Berryessa project.

7 Jones, Pirkle and Ruth Garner Begell, editor. *Berryessa Valley: The Last Year*. Exhibition Catalog (Vacaville, California: Vacaville Museum, A Center for Solano County History, 1994), 54.

8 Ibid.

9 Ibid.

10 Letter from Pirkle Jones to Lange's biographer, Milton Meltzer, dated July 10, 1976.

11 Frankenstein, Alfred. "Acquisitions at the de Young." *San Francisco Chronicle* (November 6, 1960), 23.

12 Breckenridge, James. "Photography Art Exhibit Provides Meaningful Message." *Chicago's American Sunday* (January 27, 1963).

13 Conversation with Pirkle Jones, January 23, 2001 by Tim B. Wride.

14 Ruth-Marion was affiliated with the San Francisco Poetry Center where she ultimately met Allen Ginsberg and other members of the Beat Generation.

15 Parr, Jorie. "Husband, wife photogs not always 'a team thing.'" *Mill Valley Record* (January 21, 1981).

16 At the time of writing, this handwritten note from Lange to Ruth-Marion and Pirkle is part of Jones's personal archive. This and other correspondence and personal papers are due to be transferred to Special Collections of the Research Library at the University of California, Santa Cruz.

17 Ibid.

18 "Rights Photo Exhibit." *The Argonaut* (December 11, 1968), 14. Taken from Baruch, Ruth-Marion and Jones, Pirkle, Introduction for the Exhibition of *A Photographic Essay on the Black Panthers*.

19 Letter from Pirkle Jones to Minor White, March 10, 1969.

20 Caldwell, Earl. "A Photographic Exhibit in San Francisco Tells Story of the Black Panthers." *The New York Times* (December 16, 1968).

21 "Pirkle Jones's Photography: Art and Social Commentary." *Unity* (May 18, 1990), cover, 9. The book to which Pirkle refers is *The Vanguard: A Photographic Essay on the Black Panthers*, published by Boston's Beacon Press in 1970.

22 Typewritten letter from Ansel Adams to Pirkle Jones dated January 3, 1969; part of the Pirkle Jones Archives. On the whole, Adams did not approve of Pirkle's more political work. In a subsequent letter, dated March 15, 1971, he discusses Pirkle's participation in the Twenty-Fifth Anniversary Yosemite Workshop, complaining, "There has been more than a little criticism of your political concerns and emphasis from some Workshop members. Not that you do not have a complete right to such opinions. . . . The problem is that [the] Workshop . . . [is] not happy with political or "social" overtones. I keep away from such involvements at the professional level. I certainly do not approve of the Black Panthers, for example, but I cannot suggest that you must agree with me! Only this, we should keep such discussions out of the Workshop picture."

23 Conversation with Pirkle Jones, January 23, 2001.

24 The "Gate 5" series began as a project to be done completely in color but was quickly switched to a black-and-white essay. While Pirkle acknowledges the color work as part of the series, when talking about the project, it is to the black and white that he refers.

25 Ibid.

26 From an unpublished interview by Etel Adnan with one of the artists who lived at Gate 5 during this time. He quotes Pirkle as saying: "Had I lived [there], moved in to stay, I would have probably laid the camera down."

27 In a 1993 video interview with Larry Moyer, Pirkle characterizes the lifestyle as being one of "openness among people," and the influx to the area like "another Gold Rush. . . . They were not looking for money, but for a new lifestyle. [Visitors, tourists, and journalists] were converging on Gate 5 from all over the world."

28 Fried, Alexander. "Sensitive Lens and Brush." *San Francisco Examiner* (May 11, 1968), 10.

29 Coleman, A. D. "Latent Image: Pirkle Jones." *The Village Voice* (February 27, 1969), 15.

30 Conversation with Pirkle Jones, October 13, 2000 by Tim B. Wride.

31 Conversation with Pirkle Jones, October 14, 2000 by Tim B. Wride.

32 Ibid.

33 Conversation with Pirkle Jones, February 12, 2001 by Tim B. Wride.

PIRKLE JONES
ANNOTATED CHRONOLOGY

1914

Born January 2, 1914 to Charles and Willie Jones in Shreveport, Louisiana. His father, of Dutch ancestry, was a cabinetmaker. His mother, a French Huguenot, supported his interest in the arts. Named for the doctor who delivered him, Dr. Pirkle. His family moved to Indiana and then to Ohio where Jones attended Lima High School in Lima, Ohio, and graduated in 1931.

1930s

Developed an interest in art by attending numerous art museums in Dayton, Detroit, Toledo, and the Philips Museum in Washington, D.C. In addition to seeing a very influential van Gogh show in Cleveland, Jones also remembers seeing a number of Alfred Stieglitz photographs paired with one Georgia O'Keeffe painting in Cleveland. He studied drawing and became interested in photography. In 1931, he bought a Beau Brownie 2A and in 1936 a friend offered him a Rolliflex, and he taught himself photography.

Operated a shoe-trimming press at the Lima Sole and Heel Company in Ohio from 1933–1941.

From 1936 to 1940, actively participated in pictorial photography salons organized by the Camera Pictorialists of Los Angeles, The American Museum of Natural History, New York; the National Gallery of Canada, The Camera Pictorialists of Bombay, and the Minneapolis Institute of the Arts, and international salons in Australia, Belgium, Canada, England, France, Greece, Hungary, Scotland, South Africa, Spain, and Wales.

1941–1946

Served the United States Army in the Signal Corps, 37th Infantry Division; stationed in the South Pacific as a Warrant Officer and worked as a cryptographer. Received a Bronze Star for his service. Though he had been accepted in the Signal Corps because of his experience as an amateur photographer, he did no photography while in service.

Returned from the South Pacific through the Port of Los Angeles and was eligible for continued education because of the G.I. Bill of Rights. After a brief time back in Lima, Jones applied and was accepted into the first class that was offered in photography at the California School of Fine Arts in San Francisco (now the San Francisco Art Institute) in order to study with Ansel Adams, who had started the department.

Met the poet and photographer Ruth-Marion Baruch, who was also at the school to study with Adams.

1947

Photographed the architecture of Bernard Maybeck with Minor White and Al Gay. The assignment came to them through an acquaintance and was never published. The three men lived in Ansel Adams's father's house while affiliated with the California School of Fine Arts.

1948

Photographed the sculpture of Annette Rosenshine from 1948 through 1960.

1949

Ruth-Marion Baruch and Pirkle Jones married.

Professional assistant to Ansel Adams in San Francisco from 1949 to 1953.

Began freelance photography work in San Francisco, including corporate assignments, illustration, and architectural photography to support his own personal work.

1952

Taught at the Ansel Adams Workshop in San Francisco.

At the request of Bill Quandt, Jones returned to teach at the California School of Fine Arts when Minor White left for Rochester; Instructor in Photography until 1958.

Adams's article about Pirkle appears in the *U.S. Camera*

Annual, outlining Jones's biography and praising the quality of his photographic work.

1955

Formed the Bay Area Photographers with Ruth Bernhard, Imogen Cunningham, Paul Hassel, Wayne Miller, and Gini and Jerry Stoll, among others. The organization was formed to offer encouragement and support for the photographers and to exhibit new work. In the fall, the group put on "San Francisco Weekend." This exhibition was shown at the San Francisco Art Festival and included 107 images of the city taken by twenty-eight photographers over a single weekend. This was exhibited internationally by the U.S. Information Agency through 1957.

Felinimus and Twig, written by Baruch and illustrated with photographs by Jones, was the couple's first collaborative effort. This children's book remains unpublished.

Assisted Dorothea Lange with her project, "Public Defender."

1956

Joined Dorothea Lange in a *Life* magazine commission to do a photographic study of Berryessa Valley in California. The area was chosen by the U.S. Bureau of Reclamation as a necessary dam site, and it was flooded to create Lake Berryessa in 1957. Lange and Jones documented the valley, the town of Monticello, and the people who lived there in the last year of the valley's existence. *Life* never published the story. The collaboration was transformed into an exhibition that was first shown at the San Francisco Museum of Art in 1960.

Commissioned by the Royal Blue Print Company to photograph the construction of Tidewater Refinery. Tidewater was a new oil refinery in the East Bay, built by Bechtel Construction.

1957

Participated in the Symposium on West Coast Photography held at San Francisco State College with Ira Latour, Pirkle Jones, Imogen Cunningham, Ansel Adams, Ruth-Marion Baruch, and Wayne Miller.

1958

Jones left his position as Instructor of Photography at the California School of Fine Arts to allow him more time to pursue his personal work.

Began photographing the construction of the Paul Masson Winery in Saratoga, CA for the architect John Bolles. In 1959, this project became "The Story of a Winery" in collaboration with Ansel Adams.

1960

Aperture published "Death of a Valley," twenty-five photographs that Lange and Jones selected from over three thousand images taken during their 1956 Berryessa Valley project. Their photographic essay was exhibited at the San Francisco Museum of Modern Art.

1961

Edward Steichen presented Jones with the Photographic Excellence Award, from the National Urban League, New York.

Collaborated with Ruth-Marion Baruch on the photographic essay "Walnut Grove: Portrait of a Town."

1963

Completed "The Story of a Winery" with Ansel Adams which began as an exhibition at the Smithsonian Institution in Washington, D.C., and toured the U.S. An accompanying catalog was written by Elsa Gidlow, and a related publication, *Gift of the Grape,* was published in 1959 with photographs by Adams and Jones.

1965

Moved with Ruth-Marion to Mill Valley in Marin County.

1966

Instructor at the Ansel Adams Workshops in Yosemite National Park, CA, through 1970.

1967

Taught two-week workshop, Images and Words / The Making of a Photographic Book, with Ansel Adams, Beaumont Newhall, Nancy Newhall, and Adrian Wilson through U.C. Santa Cruz Extension. The workshop continued annually through 1970.

1968

Published *Portfolio Two: Twelve Photographs.* Individual

exhibition of the same portfolio at the California Redwood Gallery in San Francisco. The portfolio had an introduction by Ansel Adams and included images primarily of nature and people in San Francisco, Saratoga, Berryessa Valley, and Arizona.

Collaborated with Ruth-Marion Baruch on "A Photographic Essay on the Black Panthers." Their work culminated in an exhibition of over 120 prints that originated at the de Young Museum in San Francisco. The exhibit was nearly canceled due to unfavorable press, but was popular enough to extend two weeks. It traveled to the Studio Museum in Harlem, NY; Dartmouth College in Hanover, NH; and U.C. Santa Cruz.

1969
Began "Gate Five," a study of a large houseboat community on the edge of San Francisco Bay in Sausalito, CA; continued into 1971.

Began teaching photography workshops with Ruth-Marion Baruch and Al Weber; continued through 1974.

1970
Returned to teaching at the San Francisco Art Institute, a position he would keep until 1997.

1974
Taught workshop on the Zone System and darkroom technique, Ansel Adams Studio, Yosemite National Park, with Richard Garrod.

Began "Flea Market" series; continued until 1978.

1975
Participated in a nation-wide photographic study—financed by The Seagram Company as a bicentennial project—of approximately one thousand American county courthouses by twenty-four photographers. Other contributors included William Clift, Charles Traub, Tod Papageorge, Ellen Land-Weber, Frank Gohlke, Lewis Baltz, Nick Nixon, Stephen Shore, William Eggleston, and others. The final presentation toured nationally and internationally under the auspices of the American Federation of Arts through 1981.

1977
Awarded a Fellowship Grant in Photography by The National Endowment for the Arts.

1978–1979
Produced the "Rock Series" and the "Salt Marsh Series," both collections of work from nature. The salt marsh was at Richardson Bay in Marin County.

1980
Produced "The Tanbark Oak Series" and "The Madrono Series," which subsequently became "Mount Tamalpais Series."

Taught the Friends of Photography Members Workshop in Carmel, CA with Ruth-Marion Baruch.

With his colleague at the San Francisco Art Institute, Grayson Mathews, and assisted by James Alinder, Director of the Friends of Photography, put together the mail-order catalog *Photography for Collectors* to bridge the gap between independent photographers and collectors, as well as those photographers who opposed exclusive gallery representation. The first edition included twenty-eight western photographers.

1983
Presented with an Award of Honor at the San Francisco Arts Festival by the San Francisco Arts Commission and the Citizen of the Day Award from KABL radio in San Francisco.

1984
Taught a Master Class at U.C. Santa Cruz Extension Photography Workshops, (reprised in 1988).

1997
Established the Pirkle Jones and Ruth-Marion Baruch Endowment in support of their Photography Archives Endowment at Special Collections, University Library, U.C. Santa Cruz.

Pirkle's wife Ruth-Marion Baruch dies in October.

2001
Jones currently lives and works in Mill Valley.

Compiled by Kate Palmer

PIRKLE JONES
EXHIBITIONS

SOLO EXHIBITIONS

1947 Lima Public Library, Lima, OH

1952 Ansel Adams Studio, San Francisco

1955 George Eastman House, Rochester, NY; Minor White, curator

1956 *Building an Oil Refinery*, San Francisco Academy of Sciences; construction of the Tidewater Oil refinery, color prints

1960 *California Roadside Council Exhibition*, Sacramento and Washington, D.C. in 1967

1965 American Federation of Arts, Carmel, CA

1967 Bay Window Gallery, Mendocino, CA

 Carmel Photography Center, Sunset Cultural Center, Friends of Photography, Carmel, CA

1968 *Portfolio Two* and a series of the photographer's reflections on his architectural environment, California Redwood Gallery, San Francisco

1969 *Photographs by Pirkle Jones*, Underground Gallery, New York

1970 *Gate 5, Sausalito*, Focus Gallery, San Francisco, color prints

 Gate 5, Sausalito, Eikon Gallery, Pacific Grove, CA, color prints

1971 *Pirkle Jones Portfolio*, San Francisco Museum of Modern Art, San Francisco

 Photography by Pirkle Jones, Tintype Photography Center Gallery, Tiburon, CA

1972 *Photography by Pirkle Jones*, The Studio Gallery above the Gibson House, Bolinas, CA

1973 The Photography Place, Berwyn, PA

 The Shado Gallery, Oregon City, OR

1977 *Photographs of Ansel Adams, Dorothea Lange, Charles Sheeler, and Edward Weston*, San Francisco Art Institute Library

 Works of Annette Rosenshine, San Francisco Art Institute Library

1982 *Pirkle Jones*, The Art Institute of Chicago; lecture and slide presentation

 Meet the Artist, Community Center for the Arts, Michigan City, IN; lecture and slide presentation

1983 *Historical Photographs*, San Francisco Art Institute Library

1984 *Vintage Years Through 1980*, Vision Gallery, San Francisco

1985 *Gate 5*, San Francisco Art Institute, slide presentation

1994 *Berryessa Valley: The Last Year*, Vacaville Museum, Vacaville, CA, and Napa Valley Museum, Napa, CA; Ruth Garner Begell, curator

2001 *Retrospective*, Santa Barbara Museum of Art, Santa Barbara, CA; Tim B. Wride and Karen Sinsheimer, co-curators, scheduled for December 8, 2001 to March 10, 2002

PHOTOGRAPHIC ESSAY EXHIBITIONS

1960 Dorothea Lange and Pirkle Jones, *Death of a Valley*, San Francisco Museum of Modern Art, Oakland Museum, CA; The Art Institute of Chicago and Napa Public Library, CA

1963 Ansel Adams and Pirkle Jones, *The Story of a Winery*, Paul Masson, Smithsonian Institution, Washington, D.C.; traveled throughout the U.S. from 1963 to 1966; de Young Museum of Art, San Francisco

1964 Ruth-Marion Baruch and Pirkle Jones, *Walnut Grove: Portrait of a Town*, San Francisco Museum of Modern Art

1968 Ruth-Marion Baruch and Pirkle Jones, *A Photographic Essay on the Black Panthers*, de Young Museum of Art, San Francisco; Studio Museum in Harlem, NY; Hopkins Center, Dartmouth College, Hanover, NH, and U.C. Santa Cruz

GROUP EXHIBITIONS

1952 *Man and Nature in Marin*, Ross Art and Garden Center, Ross, CA and California Academy of Sciences, San Francisco; Ray Strong, curator

1954 *Perceptions*, San Francisco Museum of Modern Art; organized by John Humphrey

1955 *Pictorial Image*, George Eastman House, Rochester, NY; Minor White, director

 San Francisco Weekend, San Francisco Art Festival Prize Exhibition and international venues through the U.S. Information Agency

 Subjective Fotografie Exhibition, Saarland Museum, Saarbrücken, West Germany and other venues through 1956; Dr. Otto Steinert, curator

1956 *These Are Our People*, United Steel Workers of America, Pittsburgh, PA, traveled throughout the United States; Roy Stryker, curator

 This Is the American Earth, California Academy of Sciences, San Francisco; exhibition purchased by the United States Information Agency and internationally circulated; Ansel Adams and Nancy Newhall, curators

1957 *I Hear America Singing*, United States Information Agency, Kongresshalle Exhibition, Berlin, West Germany and Tokyo, Japan in 1959; Ansel Adams, Nancy Newhall, curators

1958 *Images of Love*, Limelight Gallery, New York; Helen Gee, curator

1959 *Photographers' Choice*, Indiana University, Bloomington, IN; Henry Holmes Smith, curator

1960 *Photography at Mid-Century*, George Eastman House, Rochester, NY; Walker Art Gallery, Minneapolis, MN; de Young Museum of Art, San Francisco; Wadsworth Athenaeum, Hartford, CT; Addison Art Gallery, Andover, MA, and Boston Museum of Fine Arts

1961 *Photography in the Fine Arts: Collection III*, New York, 1958; exhibited in forty-five venues throughout the U.S. and Canada

 Photographs and Etchings: The World of Copper and Silver, Metropolitan Museum of Art, New York

1962 *The Centennial of Agriculture Photography Exhibit*, United States Department of Agriculture, Washington, D.C.

 Photography USA, DeCordova Museum, Lincoln, MA; Frederick P. Walkey, director

 The World Around Us, San Francisco Museum of Modern Art, San Francisco

1963 *Photography in the Fine Arts, Collection IV*, New York; exhibited at forty-five national venues

1967 *Photography for the Art in the Embassies Program*, Focus Gallery, San Francisco; co-sponsored by the Oakland Museum of Art and Focus Gallery; traveled internationally

 Photography in the Twentieth Century, National Gallery of Canada, Ottawa; from the George Eastman House Permanent Collection, toured Canada and the U.S. 1967–1973

1968 *Photographs from the Permanent Collection*, Museum of Modern Art, NY

 Selections from *A Photographic Essay on the Black Panthers*, Massachusetts Institute of Technology, Department of Architecture, Cambridge; twenty-seven photographs with Ruth-Marion Baruch

1969 *Recent Acquisitions, Contemporary Photographers*, The Art Institute of Chicago

1971 *Recent Acquisitions, Permanent Collection*, San Francisco Museum of Modern Art

1972 *Faculty Exhibition Winter 1972*, San Francisco Art Institute, San Francisco

 Octave of Prayer, Massachusetts Institute of Technology, Boston; Minor White, director

1973 *Through One's Eyes: A Photographic Exhibition*, Muckenthaler Cultural Center, Fullerton, CA; Dr. Donald Huntsman, curator

1974 *The San Francisco Art Institute: Photography 1974*, Shado Gallery, Oregon City, OR

1975 *Group Show*, Peter Loo Gallery, Manchester, England

 Hanson Fuller Gallery Pays Tribute to the San Francisco Art Institute, Hanson Fuller Gallery, San Francisco

 The Land: Twentieth-Century Landscape Photographs, Victoria and Albert Museum, London; exhibition traveled to National Gallery of Modern Art, Edinburgh; Ulster Museum, Belfast and National Museum of Wales, Cardiff; selected by Bill Brandt

 Marin County Spectrum: The Camera Work of Marin County Photographers, Lamkin Camerawork Gallery, Fairfax, CA; Ruth-Marion Baruch, Judy Dater, Jack Fulton, Pirkle Jones, and Jack Welpott

 One Hundred Images by Faculty, Alumni, and Students from the San Francisco Art Institute, The Photo Exchange Gallery, New Orleans, LA

 Portraits of Artists, Palo Alto Cultural Center, Palo Alto, CA

 San Francisco Art Institute Faculty Show, San Francisco, and Richard DeMarco Gallery, Edinburgh

1976 *Camerawork Gallery Benefit*, Camerawork Gallery, San Francisco

 Court House, Seagram House, New York; selections from the bicentennial photograph project commissioned by Joseph E. Seagram & Sons, Inc., under the auspices of the National Trust for Historic Preservation and the American Federation of Arts; Richard Pare, curator. The exhibition also traveled to the Museum of Modern Art, New York; The Art Institute of Chicago, IL; American Institute of Architects, Washington, D.C.; San Francisco Art Institute, and The Camden Arts Centre, London

 Golden Gate Park, Focus Gallery, San Francisco

 Palo Alto Cultural Center Invitational, Palo Alto, CA

 SFAI Faculty and Students, Friends of Photography, Carmel, CA, and Banff School of Fine Arts, Banff, Canada

1977 *Photographs from the Collection of Herb Quick*, Inland Empire Gallery, Riverside, CA

1978 *Erotic Art Show*, Hale/Van Hass Gallery, Sausalito, CA

 New Acquisitions, University of New Mexico Art Museum, Albuquerque, NM

 Photographs from the Permanent Collection, San Francisco Museum of Modern Art; John Humphrey, curator

 Prints from the Photography Place Collection, Photography Place, Philadelphia

 The Sacramento River Delta: Five Photographic Views, H.C.D. Community Arts Gallery, Sacramento, CA

1979 *Exhibition & Sales Message from West Coast Series III*, Photo Gallery International, Tokyo, Japan

 Photographs from the Theo Jung Collection, Recent Acquisitions, San Francisco Museum of Modern Art

1980 *1980 Members Exhibition,* Friends of Photography, Carmel, CA

Bay Area Photographers 1954–1979, Focus Gallery, San Francisco; a retrospective exhibition of ninety vintage photographs in celebration of the twenty-fifth anniversary of Bay Area Photographers

Curator's Choice: Selections from the Permanent Collection by John Humphrey, San Francisco Museum of Modern Art

New Landscapes Part I, Friends of Photography, Carmel, CA

Rock Series and Salt Marsh Series, San Francisco Art Institute

San Francisco Museum of Modern Art Rental Gallery, TransAmerica Center, The Downtown Gallery, San Francisco

San Francisco Museum of Modern Art Rental Gallery, Building "A" Fort Mason, San Francisco

1981 *Alumni Exhibitions SFAI, January 1981,* Focus Gallery, San Francisco, celebrating the 110th birthday of the San Francisco Art Institute

California Riparian Systems Conference Art Exhibit, Davis Art Center, University of California Davis; Pirkle Jones and Robert Else, jurors

1981 Master Photographers: A Sentimental Celebration, Focus Gallery, San Francisco

Photography: A San Francisco Tradition, January 1981, Alumni Exhibition, Chevron Gallery, San Francisco; celebrating the 110th birthday of the San Francisco Art Institute

San Francisco Art Institute: 1981 at the Richmond Art Center, Richmond, CA; Madrono Series

San Francisco Art Institute: Alumni Exhibition, Diego Rivera Gallery, San Francisco Art Institute

Works by Faculty, Emanuel Walter, Atholl McBean, and Diego Rivera Galleries, San Francisco Art Institute

1982 *Facets of the Collection: Urban America,* San Francisco Museum of Modern Art

Fifteen Outstanding Photographers, Carmel Photoart Gallery, Carmel, CA

1983 *Awards of Honor: A Documentary Exhibition,* presented by the San Francisco Arts Commission, SFMO Gallery, Bank of America World Headquarters, San Francisco

Five Visionists, Kaiser Center Art Gallery, Oakland, CA

From the "California Sharp School," San Francisco Museum of Modern Art

The Last Memorial Day, Berryessa Valley, 1956, Stillights Gallery, San Francisco Art Institute

Works by Faculty, Emanuel Walter and Atholl McBean Galleries, San Francisco Art Institute

1984 *Artists Call Against U.S. Intervention in Central America,* Stephen Wirtz Gallery, San Francisco

Artists' Valentines, Emanuel Walter and Atholl McBean Galleries, San Francisco Art Institute

Photography in California 1945–1980, San Francisco Museum of Modern Art; Akron Art Museum, Akron, OH; The Corcoran Art Gallery, Washington, D.C.; Los Angeles Municipal Art Gallery, Barnsdall Park, Los Angeles; Herbert F. Johnson Museum of Art, Cornell University, Ithaca, NY; The High Museum of Art, Atlanta, GA; Museum Folkwang, Essen, West Germany; Musee National d'Art Moderne, Centre Georges Pompidou, Paris, and the Museum of Photographic Arts, San Diego, CA; Louise Katzman, curator

Point Lobos: Place As Icon, Friends of Photography, Carmel, CA

Subjective Fotografie, from the Otto Steinert collection, San Francisco Museum of Modern

Art; Sarah Campbell Blaffer Gallery, Houston, TX; Museum Folkwang, Essen, Germany; Vasterbottens Museum, Umeå, Sweden; Kulturhest, Stockholm; Saarland Museum, Saarbrücken, Germany, and Palais des Beaux-Arts, Brussels; organized by Museum Folkwang, Essen in collaboration with the San Francisco Museum of Modern Art

The Turbulent Sixties in the Bay Area: Photography of Dissent, Focus Gallery, San Francisco

1985 *The Photo Metro,* San Francisco Art Institute, San Francisco, CA; benefit auction and exhibition

Second Annual Artists' Valentines, San Francisco Art Institute

1986 *The Monterey Photographic Traditions: The Weston Years,* Monterey Peninsula Museum of Art, CA; Fresno Art Center, Fresno, CA; Triton Museum of Art, Santa Clara, CA; the Sierra Nevada Museum of Art, Reno, NV and nine international venues sponsored by the United States Information Agency; Rick Deragon, curator

With the Land: A Photographic Survey, University Art Gallery Sonoma State University, Rohnert Park, CA

1987 *Black and White in ZYZZYVA,* Concourse Gallery, Bank of America World Headquarters, San Francisco

Faculty Selection, 1987, Emanuel Walter and Atholl McBean Galleries, San Francisco Art Institute; "Flea Market" series, 1973 and 1974

Northlight Gallery Permanent Collection Recent Acquisitions, School of Art, Arizona State University, Tempe

1988 *Master Photographs from "Photography in the Fine Arts Exhibitions, 1959–1967,"* International Center of Photography, New York; Miles Barth, curator

Legacy: Northern California's Photographic Heritage, Friends of Photography, San Francisco

Picturing California: A Century of Genius, Oakland Museum, CA; Therese Heyman, curator

Ten Years, 1979–1989: Photographers from the World, Photo Gallery International/SATA Corporation, Tokyo

1990 *Legacy: 15 Protégés of Ansel Adams,* Arkansas Art Center, Little Rock

1991 *Patterns of Influence: Teacher/Student Relationships in American Photography since 1945,* Center for Creative Photography, University of Arizona, Tucson

1992 *Food & Wine: A Feast in Photographs,* Alinder Gallery, Gualala, CA

This Is the American Earth: A Silver Celebration—In Celebration of the Twenty-Fifth Anniversary of The Friends of Photography, Ansel Adams Center, San Francisco and venues throughout the U.S. and Japan in 1993

Watkins to Weston: 101 Years of California Photography 1849–1950, Santa Barbara Museum of Art, CA; Crocker Art Museum, Sacramento, CA, and the Laguna Art Museum, Laguna Beach, CA; Karen Sinsheimer, consulting curator

1993 *1993–94 Faculty Exhibition at the San Francisco Art Institute,* Walter/McBean Gallery, San Francisco Art Institute

Revolution Into the 2nd Century at the San Francisco Art Institute, One Market Plaza, San Francisco; a survey exhibition of over a century of alumni and faculty

Selections from "A Photographic Essay on the Black Panthers," San Francisco Art Institute; fifteen photographs with Ruth-Marion Baruch

Tenth Annual Art Auction, San Francisco Art Institute

1994 *Friends and Contemporaries: Documentary Photography in Northern California, Lange in Context,* San Francisco Museum of Modern Art

1995 *Luz y Tiempo,* Centro Cultural Art Contemporaneo, A.C. Modern Art Cultural Center, Mexico City; Manuel Alvarez Bravo, curator

1996 *San Francisco Art Institute: Fifty Years of Photography,* TransAmerica Pyramid Gallery, San Francisco

1997 *The Edge of Shadow,* photographs from the Merrily and Tony Page collection, Monterey Museum of Art, CA

 Summer of Love: Revolution & Evolution, Ansel Adams Center for Photography, San Francisco

1999 *An American Century of Photography: From Dry-Plate to Digital,* The Hallmark Photographic Collection, Hallmark Cards Inc., Kansas City, MO; Phillips Collection, Washington, D.C.; Seattle Art Museum; Nelson-Atkins Museum, Kansas City, MO; Joslyn Art Museum, Omaha, NE; Columbus Museum of Art, GA, and the Denver Art Museum, CO

2000 *Made in California: Art, Image, and Identity, 1900–2000,* Los Angeles County Museum of Art; Tim B. Wride, co-curator

2001 *Capturing Light Masterpieces of California Photography, 1850–2000,* Oakland Museum of California; Drew Heath Pearson, curator

BIBLIOGRAPHY

A Courthouse Conservation Handbook (Washington, D.C.: National Trust for Historic Preservation, 1976), 6, 42.

Adams, Ansel, and Pirkle Jones. "The Story of a Winery," by Elsa Gridlow. In *U.S. Camera,* International Pictures Annual, edited by Tom C. Maloney, 40–51. New York: Random House, 1963.

———. "The Story of a Winery," by Elsa Gridlow (Saratoga, CA: Paul Masson Vineyard, 1963), 10, 14, back cover.

Adams, Ansel, and Nancy Newhall. *This is the American Earth.* (San Francisco: Sierra Club, 1960), 72.

———. *This is the American Earth.* 2nd ed. (San Francisco: Sierra Club, 1991), 72.

Adams, Ansel. "Architectural Photography." *In The Encyclopedia of Photography: Volume Two,* 236–238. New York: Greystone Press, 1962.

———. "Pirkle Jones: Photographer." *U.S. Camera Magazine* (October 1952): 40–42.

———. *Artificial Light Photography: Basic Photo 5* (New York: Morgan & Morgan, Inc., 1956), 4, 76, 113.

Adnan, Etel. *Journey to Mount Tamalpais* (Sausalito, California: The Post-Apollo Press, 1985), 51–52.

Alinder, Mary Street. *Ansel Adams: A Biography* (New York: Henry Holt and Company, Inc., 1996), 246, 271, 441, reproduction.

American Institute of Architects Journal AIA, Washington, D.C. (1978): 32.

American Photography (August 1939): 568.

American Photography (July 1940): 509.

American Photography (August 1940): 552.

American Photography (September 1940): 667.

An American Century of Photography: Hallmark Photographic Collection (Kansas City: Hallmark Cards, Inc., 1999), plate 278.

Anderson, Walter Truett. *The Upstart Spring: Esalen and the American Awakening* (Reading, Massachusetts: Addison Wesley Publishing, 1984), 145.

"Architecture of Violeta Autumn." *Progressive Architecture* (May 1964).

Auer, Michéle, and Michel Auer. *Photographers Encyclopedia International.* Switzerland: Editions Camera Obscura, 1985.

Baldinger, Wallace S. *The Visual Arts* (New York: Rinehart, Holt and Winston, Inc., 1960), 162, 183, 250.

Balzer, Robert. *This Uncommon Heritage: The Paul Masson Story* (Los Angeles: Ward Ritchie Press, 1970), 46, 72–73.

Barron, Stephanie, Sheri Bernstein, and Ilene Susan Fort. *Made in California: Art, Image, and Identity, 1900–2000* (Berkeley: Los Angeles County Museum of Art/University of California Press, 2000), 15, 221, 301.

Barth, Miles, curator. *Master Photographs from 'Photography in the Fine Arts' Exhibitions, 1959–1967* (New York: International Center of Photography, 1988), 169.

Baruch, Ruth-Marion, and Pirkle Jones. *Progressive Architecture* (March 1969): 130–132.

———. *The Vanguard: A Photographic Essay on the Black Panthers.* Boston: Beacon Press, 1970.

Bravo, Manual Alvarez, curator. *Luz y Tiempo Vol. II* (Mexico City: Centro Cultural Art Contemporaneo A. C./ Fundacion Cultural Televisa, 1995), 146.

Camera Craft Magazine (March 1941): 121.

Contact #2: The Journal of New Writing (San Francisco: Angel Island Press, 1959), 35, 43.

Coppel, Alfred. *The Architect's World: John S. Bolles.* San Francisco: The Cerwin Organization, 1963.

Dater, Judy. *Imogen Cunningham: A Portrait* (Boston: New York Graphic Society, 1979), 67–69.

Deragon, Rick, curator. *The Monterey Photographic Traditions: The Weston Years* (Monterey, California:

Monterey Peninsula Museum of Art, 1986), 45, 49.

Dreyfuss, Jane. "Gallery Snooping." *Modern Photography* (June 1969): 26, 28.

Fels, Thomas Weston, Therese Heyman, and David Travis. *Watkins to Weston: 101 Years of California Photography* (Niwot, CO: Santa Barbara Museum of Art/Roberts Rinehart Publishers, 1992), 147.

Ginger, Ann Fagan, editor. *Minimizing Racism in Jury Trials* (Berkeley: The National Lawyers Guild, 1969), back cover.

Goldberg, Vicki. "A Clean, Well-Lighted Courthouse." *American Photographer* (November 1978): 16–17.

Hall, Norman, and Basil Burton Poles, editors. *Photography Yearbook* (London: Photography Magazine, 1956), 128.

———. "La Littérateur de l'Objectif." *Informations & Documents 139,* Paris (March 15, 1961): 19–25.

Helen Gee and the Limelight: A Pioneering Photography Gallery of the Fifties. New York: Carlton Gallery, 1977.

Heyman, Therese, editor. *Picturing California: A Century of Genius* (San Francisco: Chronicle Books/Oakland Museum, 1989), 69.

Hilliard, David, and Lewis Cole. *This Side of Glory: The Autobiography of David Hilliard and the Story of the Black Panther Party.* Boston: Little, Brown and Company, 1993.

Holmes, Robert. "Photography for Collectors." *British Journal of Photography,* London (June 6, 1980): 542, 543.

———. "Pirkle Jones." *British Journal of Photography,* London (October 17, 1980): 1040, 1041.

Johnson, Drew Heath, editor. *Capturing Light: Masterpieces of California Photography 1850–2000* (New York: W.W. Norton & Co., 2001), 221, 336.

Jones, Pirkle, and Ruth Garner Begell, editor. *Berryessa Valley: The Last Year.* Vacaville, California: Vacaville Museum, 1994.

———. "House and Home Photography." In *The Encyclopedia of Photography,* Volume 10, 1770–1777. New York: Greystone Press, 1962.

———. "Pirkle Jones: Plant Patterns, Nature Photography, XXII." *Pacific Discovery* XX, no. 1 (January/February, 1967): 16, 17.

———. *Portfolio I*, with text by Charles P. Johnson. San Francisco: Bank of America, 1955. (Portfolio commemorating the tenth anniversary of the signing of the U.N. Charter, presented to each delegate on June 20, 1955.)

———. *Portfolio II*, with a foreword by Ansel Adams. San Francisco: privately printed, 1968. (A portfolio of twelve photographs produced in a limited edition of 110.)

Kahn, Herbert, curator. *Photographs from the Collection of the LaSalle National Bank* (Chicago: LaSalle National Bank, 1995), 68, 69.

Katzman, Louise, curator. *Photography in California 1945–1980* (New York: Hudson Hills Press/San Francisco Museum of Modern Art, 1984), 11, 17, 25, 27, 32–33, 54, 185, 191.

Kutnick, Esther. "Pirkle Jones: Photographer." *Exploratorium Quarterly* 13, no. 3 (Fall, 1989): 20–24.

Lange, Dorothea, and Pirkle Jones. "Death of a Valley." *Aperture* 8, no. 3 (1960): cover, 127–165.

Latour, Ira. "Symposium on West Coast Photography: Does It Really Exist?" *Photography Magazine*, London (June 1957): 26–45.

Littel, Joy, editor. *America, Twentieth-Century Exposition: Man and the Social Machine* (Evanston, IL: McDougal, Littel, 1973), 172.

Lyons, Nathan. *Photography in the Twentieth Century* (Rochester: Horizon Press/The George Eastman House, 1964), 54.

Maloney, Tom C., editor. *U.S. Camera* (New York: U.S. Camera Publishing Co., 1956), 88–89.

———. *U.S. Camera* (New York: U.S. Camera Publishing Co., 1957), 68–69.

McDowell, Jack, editor. *San Francisco* (Menlo Park, California: Lane Magazine & Book Company, 1969), 129.

Meltzer, Milton. *Dorothea Lange* (New York: Farrar, Straus & Giroux, 1978), 273, 299, 301–303, 307, 308, 340.

Messer, Richard. "Viewed: 'The Court House Project' at The Camden Arts Centre." *The British Journal of Photography*, London (July 27, 1979): 721–723.

Mezey, Phil. "Masters of the Darkroom: 'In Tandem,' an Interview with Ruth-Marion Baruch and Pirkle Jones." *Darkroom Photography* 1, no. 7 (1979): 22–26.

Miller, Richard Connelly. *Bohemia: The Protoculture Then and Now* (Chicago: Nelson-Hall, 1977), 267, 274.

Modern Photography and Beyond: Photographs in the Collection of The National Museum of Modern Art (Kyoto, Japan: The National Museum of Modern Art, 1987), plates 418–429.

Nash, Stephen. *Facing Eden: One Hundred Years of Landscape Art in the Bay Area* (Berkeley: University of California Press, 1995), 173.

Newhall, Nancy. "Pirkle Jones Portfolio." *Aperture* 4, no. 2 (1956): 49–57.

Ohrn, Karen B. *Dorothea Lange and the Documentary Tradition* (Baton Rouge: Louisiana State University Press, 1980), 173, 178, 180, 194.

Pare, Richard, editor. *Court House: A Photographic Document* (New York: Horizon Press, 1978), plates 63, 133, 180, 235–237, 305–306, 334, 347.

"Photography Annual." In *Popular Photography* (New York: Ziff-Davis Publishing, 1960), 198.

Photography at Mid-Century (Rochester: The George Eastman House, 1959), 46.

Photography for Collectors, Volume 1 (California: The West, 1980), 64–67.

"Photography in the Fine Arts." *News Front* (November 1963): 25–29.

"Pictures That Talk…" In *U.S. Camera*, edited by Tom C. Maloney (New York: U.S. Camera Publishing Co., 1959), 216–217.

"The Picture Universe." In *U.S. Camera Annual*, edited by Tom C. Maloney (New York: Random House, 1961), 223.

Porter, Alan, editor. "Narrative Nature." *Camera*, no. 7, Munich (1981): 12–18.

Renaissance: San Francisco Underground Art Celebration 1945–1968. Second edition (Intersection Center for Religion and the Arts, 1975), 35.

San Francisco Bay Area Photography 1976 (San Francisco: The Society for the Encouragement of Contemporary Art/San Francisco Museum of Modern Art, 1976), 27, 41, 45, 47.

"Short Run Color." *Image* 6, no. 49 (March 1957): 60–64.

Sierra Club Bulletin (December 1964): 49.

Stryker, Roy, curator. *These Are Our People* (Pittsburgh, PA: United Steel Workers of America, 1956), 28, 33, 42–44, 47, 53.

Subjektive Fotografie: Images of the 50s, curated by Ute Eskilden (Essen, Germany: Fotografische Sammlung im Museum Folkwang, 1984), 124. (A catalog published for an international exhibition, organized by the Museum Folkwang, Essen, in collaboration with the San Francisco Museum of Modern Art.)

"The American Annual of Photography." In *Who's Who in Pictorial Photography,* Volume 53 (1939), 273.

The American West: The Magazine of Western History VI, no. 1 (January 1969): cover.

"The Last Word: West Coast Writers and Artists." ZYZZYVA 2, no. 4, San Francisco (Winter 1986–1987): 49.

Travis, David. *Edward Weston: The Last Years in Carmel* (Chicago: The Art Institute of Chicago, 2001): 136.

U.S. Camera (New York: U.S. Camera Publishing Co., 1953), 233, 264.

U.S. Camera (New York: U.S. Camera Publishing Co., 1940), 27.

University of New Mexico Art Museum, Bulletin Catalog, no. 11 (1978): 31.

Von Werlhof, Jay C. "Granite Galleries: Paintings of the Tule-Kaweah Indians." *Pacific Discovery* (July/August 1958): cover, 16–21.

Walsh, George, Colin Naylor, and Michael Field, editors. *Contemporary Photographers* (New York: St. Martin's Press, 1983), 382–384.

Warren, Dody. "Exclusive preview…Perceptions of an SFMOMA exhibition." *U.S. Camera Magazine* (August 1954): 54–57.

———. "Perceptions: A Photographic Showing from San Francisco." *Aperture* 2, no. 4 (1954): 11–33.

Watts, Alan. *In My Own Way: An Autobiography 1915–1965* (New York: Pantheon Books, 1972), 178.

———. *The Essential Alan Watts* (Berkeley: Celestial Arts, 1977), cover.

Webb, William. *Henry & Friends: The California Years 1946–1977* (Santa Barbara: Capra Press, 1991), 72–73.

White, Minor. "Octave of Prayer." *Aperture* 17, no. 1 (1972): 56.

———. "Towards Camera." *Photography,* London (October 1955): 26–31.

———. "Views of Shows.…" *Modern Photography* (April 1955): 18, 20.

Wolbarst, John, editor. *Polaroid Portfolio #1* (New York: American Photographic Book Publishing Company, Inc., 1959), 15, 39.

A MAJOR EXHIBITION, *PIRKLE JONES: SIXTY YEARS IN PHOTOGRAPHY*, WILL BE PRESENTED AT THE SANTA BARBARA MUSEUM OF ART FROM DECEMBER 8TH 2001–MARCH 31, 2002 AND WILL BE AVAILABLE FROM APERTURE TO TOUR THEREAFTER.

Library of Congress Catalog Card Number: 2001090659
Hardcover ISBN: 0-89381-949-2
Design by Peter Bradford/Joshua Passe
Duotone separtions by Martin Senn
Printed and bound by
Sing Cheong Printing Co., Ltd., Hong Kong

The Staff at Aperture for *Pirkle Jones: California Photographs:*
Michael E. Hoffman, *Executive Director*
Phyllis Thompson Reid, *Editor*
Stevan A. Baron, *V.P., Production*
Lisa A. Farmer, *Production Director*
Michael Famighetti, *Assistant Editor*
Eileen Connor and Céire Clark, *Editorial Assistants*

Aperture Foundation publishes a periodical, books, and portfolios of fine photography and presents world-class exhibitions to communicate with serious photographers and creative people everywhere. A complete catalog is available upon request.

Aperture Foundation, including Book Center and Burden Gallery: 20 East 23rd Street, New York, New York 10010. Phone: (212) 505-5555, ext. 300. Fax: (212) 979-7759. E-mail: info@aperture.org

Aperture Customer Service: 20 East 23rd Street, New York, New York 10010. Phone: (212) 598-4205. Fax: (212) 598-4015. Toll-free: (800) 929-2323. E-mail: customerservice@aperture.org

Aperture Millerton Book Center: Route 22 North, Millerton, New York 12546. Phone: (518) 789-9003.

Visit Aperture's website: www.aperture.org

Aperture Foundation books are distributed internationally through:

CANADA: General/Irwin Publishing Co., Ltd., 325 Humber College Blvd., Etobicoke, Ontario, M9W 7C3. Fax: (416) 213-1917.
UNITED KINGDOM, SCANDINAVIA, AND CONTINENTAL EUROPE: Aperture c/o Robert Hale, Ltd., Clerkenwell House, 45-47 Clerkenwell Green, London, United Kingdom, EC1R OHT.
Fax: (44) 171-490-4958.
NETHERLANDS, BELGIUM, LUXEMBURG: Nilsson & Lamm, BV, Pampuslaan 212-214, P.O. Box 195, 1382 JS Weesp, Netherlands. Fax: (31) 29-441-5054.
AUSTRALIA: Tower Books Pty. Ltd., Unit 9/19 Rodborough Road, Frenchs Forest, Sydney, New South Wales, Australia. Fax: (61) 2-9975-5599.
NEW ZEALAND: Southern Publishers Group, 22 Burleigh Street, Grafton, Auckland, New Zealand. Fax: (64) 9-309-6170.
INDIA: TBI Publishers, 46, Housing Project, South Extension Part-I, New Delhi 110049, India. Fax: (91) 11-461-0576.

To subscribe to the periodical *Aperture* write Aperture, P. O. Box 3000, Denville, New Jersey 07834. Toll-free: (866) 457-4603. International subscriptions: (973) 627-2427. One year: $40.00. Two years: $66.00. Add $10.00 per year for international orders.

First Edition
10 9 8 7 6 5 4 3 2 1